True Colors

Mirage

for Patricia Hill Burnett

what is the burden of that flesh?
unreadable the design of your being
behind the platitude of eyes
the lazy alluring tendrils of your soul

beauty at the surface of your being
stretched to acclaim upon the ancient bones' design
and unreachable from inside
unreadable even to you

there is nothing ordinary in you
except the maplike structure of your insides
while on the outside you excite
images in eyes that will be soured
as they wake to ordinary days

this is preposterous to you:
the burden of your flesh and the furrowed dreams you raise
in faces you cannot accommodate
this is a curse upon you:
the dance they expect you to dance
until the muscles of your comely limbs
ache with their years of toil
in that womanly frame—

men have no idea of your body
they do not see the body
they see only the dance of the body in its toil
its perspiring circles and convulsions
in a service of dreaming
beneath the golden cloth such women wear
to cover their bones' design

From *Love and Its Derangements*
Poems by Joyce Carol Oates
Louisiana State University Press
Baton Rouge, 1970

True Colors

An Artist's Journey
From Beauty Queen To Feminist

By Patricia Hill Burnett

Momentum Books Ltd.
Troy, Michigan 48098

Manufactured in the United States of America

1998 1997 1996 1995 5 4 3 2 1

Momentum Books Ltd.
6964 Crooks Road, Suite 1
Troy, Michigan 48098
USA

ISBN: 1-879094-48-7 $29.95

Gratful acknowledgment is made to the following for use of the materials reprinted herein:
 From the book *Love and Its Derangments* by Joyce Carol Oates
 Copyright © 1970 Louisiana University Press, Reprinted by Permission

 From the Book *In Retrospect* by Robert McNamara
 Copyright © 1995 Times Books

Library of Congress Cataloging-in-Publication Data
Hill Burnett, Patricia, 1920-
True colors : an artist's journey from beauty queen to feminist /
by Patricia Hill Burnett
 p. cm.
ISBN 1-879094-48-7 (HC : alk. paper)
1. Hill Burnett, Patricia, 1920- . 2. Artists--United States---Biography.
3. Feminism and art--United States. I. Title.
 N6537.H534A2 1995
 759. 13--dc20
 [B] 95-34666

This book is dedicated, with love, respect and gratitude, to my dear husband, Robert L. (Bob) Siler, and to my four children, William Hill Lange, Dr. H.A. (Barry) Burnett III, Terrill Hill Burnett, and Hillary Hill Burnett. They are my pillars of strength and my strongest sources of comfort and support.

...and it is also dedicated to the women of the world, whom I care about so much:

MAY YOU, TOO, HAVE IT ALL!

Contents

Foreword

*P*atricia Hill Burnett is a national treasure. Beautiful, talented, and defiant, she took the turns that life gave her and shaped them to her own tastes. I've known Patricia for years—in fact, I was the first woman to whom she divulged her true age. After telling me part of her life's story for a book I was writing at the time, the moment of truth arrived. "How old are you, Patricia?" I asked.

"Are you going to tell anyone?" she queried. "Only everyone who reads this," I replied. "Oh dear," she sighed, "here goes." And she did! I was truly grateful for her honesty because it gives us all hope that there's life, and plenty of it, after sixty!

A woman with her very own sense of style, to think of Patricia is to envision her. A mass of well-styled hair, completely matching clothes, diamonds, large and galore, and a Rolls-Royce she drives to the local gathering place where she holds her Saturday luncheon salons to catch up on what's going on in town. She is a sight to behold, still breathtaking at seventy-five.

Patricia has a knack for socializing that few of us have. I've observed her at parties and am always fascinated by the fact that she listens so attentively to each person at her side. Eyes wide open, seemingly fascinated by every word (however boring) and ever so gracious when parting. I have tried to emulate it, but must confess to being a complete failure.

She and her husband, Bob Siler, have the most extraordinary marriage. Their relationship says everything about the ben-

efits of mature love. They are separate beings, yet together, caring without making others in their presence uncomfortable and, above all, polite and tender with each other. There's much that we all could learn.

Her life has consisted of many extraordinary adventures. You will only learn about some of them in this book. Let me assure you, there are many, many more. But once you read about Patricia, you will never be able to forget her. Take it from one who knows. She will be indelibly engraved upon your psyche.

We are all better for knowing her. Patricia Hill Burnett enriches every breath.

Dr. Sonya Friedman
Former host, CNN's *Sonya Live*
psychologist and author

Preface

*S*omeone known as ANON may have said it best:

"Writing a book is like scrubbing an elephant: there's no good place to begin or end, and it's hard to keep track of what you have already covered." No doubt there are other hazards, too... but there is a real sense of accomplishment once you get it done!

The easiest part is identifying the person who has helped me most in putting this book together. My writing associate, Jack Lessenberry, has been indispensable in collaborating with me. This book depended heavily on his talent and skills; I especially owe him for jogging my memory and keeping me honest. I am indebted to Bill Haney, my publisher, a gentle and kind man who led me through the maze of publishing almost painlessly, with the excellent help of resourceful and cooperative Debra Peel and the rest of the Momentum Books staff.

There are certain stars in my life who I must acknowledge: First of all, my devoted family who have so generously and lovingly supported my life and work. And to my dear friends: Joyce Carol Oates, my inspiration; Betty Friedan, my mentor; Sonya Friedman, my role model; Jackie Arnold, who gave me writing tips; Joyce Fisher, who has given me years of encouragement; Marj Levin, who shared the founding of NOW in Michigan and many wonderful memories; Mary Jean Tully and Gene Boyer, my feminist musketeers... and so many more who have eased me through the years with generous dollops of affection, laughter and loyalty.

To thank everyone who has brought me joy would take more pages than this entire book contains. I can only say... you know who you are!

Patricia Hill Burnett

1

Never Say No–Unless They Ask You If You Have Enough!

*T*his is the story of a beauty pageant winner who grew up to become the very model of a perfect upper-class housewife and mother. And, it is also the story of a militant feminist who founded NOW in Michigan, has been known to hang out with liberals and lesbians, prostitutes and politicians, and knows what it is like to be called "that bitch."

You might also call this the story of a raging revolutionary who has barged into congressmen's offices in search of her rights, and has traveled around the world to fight for an agenda more radical than anything Lenin ever dreamed of—the idea that all women, whoever they are, wherever they live, should be truly equal with men.

This is also the story of a revolutionary who is partial to jewelry and picture hats and is a staunch Republican feminist who loves fashions, furs, and her silver Rolls-Royce.

My name is Patricia Hill Burnett, and all of these things are me.

If you have ever heard of me before, it may have been in connection with my career as an artist. I have been commissioned to paint the portraits of famous people from Margaret Thatcher to Indira Gandhi; from Gloria Steinem and Betty Friedan to Dr. Jack Kevorkian. Not bad for a little girl from a broken home who started painting portraits in her mama's kitchen in Toledo, Ohio, back in the depths of the Great Depression.

This is not, by the way, the story of Pollyanna. I have been manipulated and exploited—or at least people have *tried* to exploit me—financially, sexually, and otherwise. I suffered one impossible marriage and lived for thirty years in another which was far from perfect. I have fought cancer and survived it.

But this is *not* the story of a victim, either.

On the contrary, this is the story of a woman who is supremely happy—who has managed to achieve her motto of "having it all and loving it." This is the story of a woman who was far happier at seventy-five than she was at forty-five, who did it her way, reinvented herself and fully intends to be happier still at eighty-five.

I wrote this book partly to share a few interesting things that happened to me along the way, and also because my travels and my work in the feminist movement have taught me that I share a special kinship with all women on this planet.

I have learned that I feel a very real bond with the welfare mother in the Bronx, the native peasant woman in the favelas of Sao Paulo, and the weary Russian woman standing in one of the endless lines women in that unhappy country have to endure every day.

No one has ever told them—just as no one ever told me—that they have a right to want to have it all. Lots of people, mainly men, are still trying hard to keep women from realizing their potential, because that would mean a shift in power.

But we are going to get there! My wish for every woman in the world (as well as a few wonderful men I've known, especially my current husband, Bob Siler) is that you *can* learn how to have it all, accept the lumps you get along the way, learn from them, and end up loving yourselves and your lives too.

Whenever you wonder if you can do it, or even wonder if you dare to try, remember these words that I try to pass on to every woman, everywhere:

Never, ever say no... unless they ask you if you have enough!

The dreams of a very troubled woman

You might say I was born in 1920 and gained consciousness in 1969.

Let me tell you a story that for years I thought was simply hilarious, and which I now know contained a hidden grain of truth.

Flash back to the early 1960s, when I was in my early forties. I was then steadily becoming recognized as a portrait painter in Detroit, where I lived in an elegant Tudor house with my second husband, Harry, who owned a very successful business, and my four children.

One day, a Dr. Jacques Gottlieb turned up at the door of my studio in the Scarab Club. The club was a marvelous fusty old place, and I had decorated my studio with oriental carpets on the floors and tons of rich brocades—a style I call "Mafia Baroque."

The doctor was chief of psychiatry at Lafayette Clinic, and had come to my studio much against his will. The board had commissioned me to do his official portrait, and Dr. Gottlieb couldn't have imagined anything he wanted to do less!

Finally, after much persuasion, he limped in on a cane. "What happened?" I asked.

"I broke my leg," he grumbled.

"Was this just recently?" I asked sympathetically.

"No, I broke it three years ago," he muttered.

Heals fast, I thought to myself.

Somehow I got him propped up on the dais. He was an anxious man, full of nervous energy, and he was very, very bored by the whole process. He kept twitching and chain-smoking and just wouldn't sit still. Finally, after several attempts to interest or distract him, I mentioned a dream I'd had. He was *fascinated*! For the first time he sat totally still while he analyzed the dream and interpreted it for me. I actually got some work done!

Afterwards he said, "Now, anytime this happens again, that you have these vivid dreams, you tell me about them."

Well, I went home and tried as best I could to dream something intriguing... without much luck. So in desperation, every time I'd go out in the evening, I'd corner people and say, "Excuse me, but have you had any good dreams lately? And the wilder the better!"

When they'd start to stare, I'd explain about my restless psychiatrist. That seemed to make it okay for people to open up their subconsciousness to me, and soon the good doctor and I had a very smooth painter-subject relationship. I would have dreams galore for him every time he came to sit, and he was as happy as a flighty little bird sitting there and telling me what each of them meant.

Finally, the day came when the portrait was done, and I asked him to take a look at it. He smoked so much that I had painted him with a cigarette in his hand, one of the very few that I had ever done that way. I asked him to come down from the dais and take a look at it. The man who had not wanted to be painted loved it so much that he took it home and the clinic never got it back until after he died!

Yet, after he looked his portrait over for the first time, he came to me and took my hand.

"You know, Patricia, you are an excellent painter, but I am afraid that you are a very troubled woman!"

A Troubled Woman Wakes Up

That was funny... then.

Four years would pass before I would start on the path to realizing how right he was. I began to see just what a troubled woman I had been, though dreams had nothing to do with it.

What hit me in the face was the reality of the war between the sexes, and it took another client to do it. This time it was a prominent lawyer who had commissioned me to do a portrait of his wife.

"Would you mind signing it just Burnett, not Patricia Burnett?" he asked. "After all, we all know that paintings by men have more value."

Well, for me, that was the moment of truth. That awoke an anger in me that I hadn't even known was there. I was seething inside. Defiantly, proudly, I signed it **Patricia Hill Burnett.**

Soon afterwards, my friend Marj Levin and I were driving off to a funeral together, talking about men and how we'd been put down and put upon by all the men in our lives. We got madder and madder, and I said, "What do you say we join the local chapter of NOW, the National Organization for Women?"

Now I was much more passionate about it than she was, even though I was—and am—a rock-ribbed Republican and Marj is a staunch Democrat. But she had been brought up as a good Jewish girl is, to expect things of herself and believe in herself, and to move from that to NOW wasn't all that long a leap. So, she said "okay," and I called up Betty Friedan. Just called information, got her number and called her right up. She didn't know me from Eve, of course.

"Are there any NOW chapters in Michigan?" I asked.

"Congratulations," Betty said. "I now confer on you the power to be the convener of the entire state of Michigan."

That was the day Patricia Hill Burnett, feminist leader, was born.

That was the beginning of the movement that would change my life, actually save my marriage, and make me more fully myself than ever before.

But that's getting way ahead of the story. First, we have to get into a time machine and go back to the winter of 1930. We must meet a starving art teacher and visit a little tomboy whose mother was determined, for the girl's own good, of course, to turn her into a geisha girl.

2

You Have To Suffer to Be Beautiful

Is there anywhere a man who will not punish us for our beauty?

–Diane Wakoski

*M*y mother was a closet feminist and never knew it.

I wonder what the young divorcee who arranged for her only child to take art lessons would have thought if she could have known that her daughter, forty years later, would become a crusader for full equality for women everywhere.

Actually, I know the answer. She couldn't possibly have imagined it, and for most of my life, neither could I.

For I had been trained, as thousands and thousands of upper- and middle-class young women all over this country were trained, to be what really can be best described as an *American geisha*, an illusion as thoroughly designed to please masculine fantasy as anything ever was in the cherry blossom world of imperial Japan.

"You have to suffer to be beautiful," my mother told me. Nor was that all. I was brought up on sayings such as "be charming, be agreeable, be modest and you will be taken care of... but only if you are a good little girl."

Women of my generation were taught "never trust another woman, for she is your eternal rival," and that we must conceal our intelligence around men.

But most of all we were taught that "it's a man's world."

And the worst part of that one was that it was all too true.

My mother found out the hard way.

Myrtle Uline—in later years, she always insisted on being called Mimi, saying her life would have been completely different if she hadn't have been named Myrtle—grew up in Cleveland, the daughter of a Dutch Catholic immigrant. She was only twenty-two when she married a handsome young fellow four years older than she, William Burr Hill, who was still sporting the dashing uniform of a World War I officer.

He must have seemed like an ideal catch. He was a Yale graduate from an old and well–to–do New York family. The very first Yale class in 1701 had a William Hill in it, and every generation of Hills sent their sons to New Haven after that.

My grandfather was a Phi Beta Kappa and member of Yale's famous secret society, Skull and Bones, the one George Bush belonged to. I must say I wondered, back when they were hinting that Skull and Bones was some mysterious force behind the "new world order." Certainly, Grandfather Hill never let me in on any international secrets!

The first William Hill, by the way, came over on the William and Mary in 1633 and landed at Dorchester, where, he wrote in his diary, a local tribe of Indians looked after them and kept them alive that first winter. In his diary, he also mentioned that two members of the party had bizarre religious customs, for which they were eventually hanged by the other colonists. Turns out they were... Quakers!

(Wonder what they would have thought of feminists!)

Later generations of the family included Aaron Burr, who was vice–president of the United States and one of this nation's founding fathers. Burr might well have gone on to be president if, back in 1804, he hadn't caused a scandal by killing his fellow founding father, Alexander Hamilton, in one of history's most famous duels.

My parents were married during the First World War, and on September 5, 1920—exactly twelve days after U.S. women finally got the right to vote—I was born in the St. George Hotel in Brooklyn. My mother never liked me telling people that because, she used to say, she thought "it sounded like she dropped me in the lobby"—but in fact my grandmother maintained a very nice suite there.

Where was my grandfather?

Well, that's a story in itself. My father's parents had what they used to call a "Victorian divorce." My grandmother, Illinois Hill (yes, that was really her first name!... they called her "Illy") had been a rather spoiled, very rich, Brooklyn debutante who fell very much in love with a young German immigrant called Fritz.

But her family broke it up; they didn't want her marrying some uncouth character just off the boat. So instead she married my grandfather, who was a proper minister's son from a good New York family, and gave birth to my father in 1892.

As for the poor young German... he went on to found a small canning company in Pittsburgh that he named after himself. His name was Heinz, by the way, and before long he had invented 57 varieties of making money.

But he never forgot my grandmother. More than ten years later, when my dad was already a six–year–old child, he reappeared and gave her a gold bracelet with a ruby and diamond alternating on every link, with a heart on it inscribed, "'87 and '98."

You see, 1887 was the year they met and 1898 was the year he gave her the bracelet. Just think, if she had married him not only might she have been happier... but it might have been me and not John Heinz, who was elected to the U.S. Senate from Pennsylvania a few years ago. Being heiress to the H.J. Heinz Co. fortune wouldn't have been too heavy a burden either!

But back then, women, especially women of the upper classes, were expected to marry not for happiness, but to please other people. I think she never really loved my grandfather. Finally she moved to the St. George's Hotel, while he stayed at his home on Remsen Street and came over every night and had dinner with her.

Isn't that sad?

Whatever society had done to her, she was, it must be said, more than a little spoiled. She wouldn't get out of bed unless a maid was there to do her hair and put on her stockings for her. She spent six months of every year in Florence, Italy. Eventually she just withdrew into herself and was so self–centered that I think she really died of selfishness, though officially, she died of bed sores from just staying in bed so much.

Incidentally, when I say she lived at a hotel you mustn't

imagine that as being like living in a Holiday Inn! Imagine instead a luxury apartment, and in fact she had what amounted to half a floor of a truly elegant hotel.

Not that I remember it. For when I was three months old, my dad, whether to establish his independence, seek his fortune, or for whatever other reasons, moved us all to Toledo, Ohio. That, unfortunately, is also where my parents' marriage soon fell apart.

꩜꩜

My father was, I am afraid to say, charming, but apparently without the stick–to–it–iveness and drive needed to really reach for the top. I cannot, today, say that I blame him. His mother, the spoiled debutante, shipped him off to boarding schools in Switzerland when he was six. That would have seemed the natural thing to do; in their time, both she and my grandfather had been sent off into Swiss exile to be educated.

But I think that meant my father grew up without knowing much love.

My mother, too, was spoiled in her own way and wanted to be pampered further. To me, it seems clear that she had married too young.

Though she had been brought up to be the proper midwestern daughter of a high–minded Dutch immigrant, it was the Roaring Twenties, she was in her early twenties, and some of her letters indicate she was restless and wanted to experience more of life.

My father wanted her to stay at home more. She was disturbed that he did not seem to be more ambitious; he flitted from job to job; they moved, her letters complained, from one set of furnished rooms to another.

This was not exactly what she had bargained for when she married the Yale–educated scion of the descendants of Aaron Burr.

Angry words were exchanged. Eventually, after some heart-wrenching years, they separated and divorced, with bitterness on both sides. Divorces of that kind are all too common today—but could have meant total ruin for my mother back in 1924.

The world was a harsh and hostile place for divorced women back then, and she had somewhat of a hard time. For her father,

Migiel Uline, was by that time very wealthy, but he was very strict, especially in matters of marriage and morals.

For a while, at least, he cut her off cold.

He was rigid. Matter of fact, he came to America to begin with because he was upset with his father for marrying someone he did not approve of! A flu epidemic swept through Holland and killed his mother and two brothers. Then his father—to my grandfather's absolute horror—*married the housekeeper!*

My grandpa was then just a teenager, but was so chagrined he left home—and Europe—for good when he was just sixteen. Some friends had settled in Cleveland and invited him to come there to live. He turned out to be just as enterprising in a business sense as he was morally uptight. He got a job as a worker in a stone quarry, where he also had to sell the ice that formed in the quarry's water holes during the winter.

He worked hard, shoveled snow and ice on the side, and saved enough to start his own business, the Colonial Ice Co., by the time he was twenty-one.

Hard to believe that the market on the "frozen assets" in ice hadn't been sewn up long before this Dutch teenager got here in 1891, but apparently he made a killing. By the time he went into business for himself he had, or so my mother said, nineteen wagons and dappled gray horses. Two years later, he had two plants, one hundred and thirty-five horses and wagons, four ice stations and four coal yards. He expanded to Toledo, and cornered the market in ice.

He was quite an inventor too. Years later, he used to say that he got most of his ideas while playing solitaire. Instead of a brain trust; he consulted only the best available mind; his own. Eventually, he was granted no fewer than seventy-six patents during his lifetime, and one of them started him out on the road to wealth.

You guessed it—it involved ice. My grandfather was granted a patent for inventing a way to "score" ice—to take a one hundred–pound block of ice and make four lines or "scores" in it, so one chop would quarter it perfectly into four easily portable 25-pound chunks. I remember seeing the machine he invented to do it—just a simple big rectangle into which you rammed the block of ice, with two saws on each side.

That was an immensely practical invention, back when every-

one needed ice every day to keep their food fresh. His ice–cutter wasn't much to look at, but he managed to sell it for $150,000, which was an enormous amount of money back then! What's more, he continued to receive royalties on it, and before long he was a wealthy man.

Sometime while I was a little girl, he moved to Washington, D.C. He bought about half a city block at 3rd and M Streets, NE, and built an ice company. Anyone, by the way, who ever spent a summer's day in Washington before air–conditioning knows just how important a supply of ice was.

Not that he wasn't generous, in his own way. Once, he was just going to build an open–air skating rink for children to use, until it was pointed out to him that there was no way you could have ice that would last in Washington's semi–tropical summer climate! The result was that he ended up building a 6,000–seat arena, which he named the Uline ice arena (naturally). It was quite a building; one of the first such arenas in the country to use a ribbed frame without interior columns inside.

That got him launched on a great career as a sportsman, until he actually was a key figure in organizing, back in the 1940s, what would become the National Basketball Association. For a time, he owned one of its teams, the old Washington Capitols. Unfortunately, Washington in the 1940s wasn't ready for pro basketball, even though he hired one of the best coaches of all time, Red Auerbach. Granddad eventually folded the franchise, in 1951.

Don't I wish we had an NBA franchise in the family now!

But having a millionaire for a grandpa didn't do us much good when I was a little girl. My grandfather, the good Catholic Dutchman, was absolutely furious with my mother for having gotten divorced. Forget who, if anyone, was at fault; remember, he couldn't even stand it when his father remarried after his mother had died!

So as far as I was told, he virtually cut off his daughter and her baby—me. Not only did he refuse to support her, he said he didn't even want to hear from her.

That meant we were entirely on our own.

My father, by the way, was completely out of the picture as far as I was concerned. I don't remember him ever coming to see me. Nor did he send me presents—or, to my knowledge, any

money to help along. For years, I thought he just didn't care about me—though many years later, I discovered through old family letters that for years he was actually keenly interested in me, but apparently my mother kept him from seeing me, and kept me from knowing that my father was writing to me.

He also did send a little money—though back in those days, he really didn't have much. Later, he inherited no less than six estates; the Hill line was not very prolific in his time, and for all these families, he was the only heir!

After that he had more than enough so that he didn't have to work, and could devote himself to his true passion—championship bridge. But while growing up, I saw him maybe half a dozen times, at family funerals. He greeted me in the way you might greet a distant niece. Knowing what I know now, I can't fault him too much; for all I know, my mother may well have told him that I wanted nothing to do with him!

What was uncanny, however, is that looking into his face was like looking into a mirror of my own. We were that much alike. Years later, when I was in my thirties, the mother of four children and happily married to Harry, my dad turned up on the doorstep of my Detroit home. Except I wasn't there; I was off traveling in Europe with mother, and Harry, my husband, was baby–sitting the children.

Harry was extremely gracious to Dad, and talked him into staying five days. Not long after that, word came that he had died mysteriously, while playing in a bridge tournament in Texas, near the Mexican border. His body was found in the bathtub, apparently after he had been dead several days, so there was no autopsy.

Did he meet with foul play at the hands of some banditos? Or did the heart I knew all too little simply give out? Sadly, I will probably never know. Even sadder was that, for whatever reasons, he never was any kind of presence in my life, let alone as a father, which I think helped lead me to try to marry a substitute father the first time I went to the altar—with predictably disastrous consequences.

First things first, however, and financial survival was at the top of my mother's agenda in 1924. Though her father had cut her off, she did get a little money from my father's family, mainly from my grandfather, but not much.

So she set out to support us mostly on her own, as a writer, starting out by writing for one of the Toledo newspapers. Eventually, she wrote for a lot of magazines, including, she claimed, *The Saturday Evening Post*, the largest–circulation magazine of its day. She usually wrote under the pen name Carolyn Davies.

But we lived in what you might call "genteel poverty" for a few years until her writing career took off. Now, I don't want to make us sound too much like Oliver Twist. We always had enough to get by, and after a few years, we even rented a cottage up in northern Michigan for the summers. At first, however, we lived right on the Maumee River waterfront in an apartment you reached by going up a flight of outside stairs! Later, we moved to a nice white house on the corner of Collingwood Boulevard, where we stayed for the rest of our years in Toledo.

Trying to write and care for me was not easy—I must have been a handful! Fortunately, Mother had the great good luck to meet a young farm girl named Claudis Young, who was sixteen at the time. Mother made her a deal: if she came to live with us, took care of me and learned how to do the cooking and the housekeeping, she would send her to finish high school and then on to college—which she did.

That was quite remarkable, a young woman who had never worked before supporting a child and a maid. Wonderful Claudis stayed with us for twelve years, which meant that I grew up in sort of a matriarchy.

By the way, my theory—and I think it has pretty much been proven—is that all feminists come from backgrounds that were in some sense unusual.

So, maybe I wasn't so unlucky that my parents got divorced after all.

But I have to admit that in caring for me as a child, poor Claudis more than earned her money. I was something of a tomboy and certainly not the perfectly demure and feminine creature my mother might have wished.

Once she gave me a wonderful present—a slingshot. You guessed it: I ran down an alley and broke out not only a street

light, but a number of the neighbors' garage windows. I had to pay the costs out of my meager allowance for what seemed like a century, but which was, I suppose, really just about a year.

Nor was I particularly endowed with natural talents, especially the so–called "feminine" ones. I hadn't much aptitude for music. I could dance some, but it was obvious early on that Isadora Duncan didn't have anything to worry about.

But I had a gift for drawing which my mother must have noticed. I have to give her great credit for starting me off, for recognizing the germ of my artistic talent and getting me some classical training.

Besides, painting—the right sort of painting—was a socially respectable form of activity for a young lady. So my mother found a teacher who was a professional painter and showed some of my drawings to him.

"Well, she can come study with me and we'll see if we can get her a scholarship," the man said. That was the beginning of my apprenticeship, and I have to confess I don't even remember my first teacher's name!

What I do remember is that he was not a happy man. He was so beaten down and discouraged—the depression was just settling in—and he hated teaching. I went to school all day—this was winter—and it got dark quite early.

I'd go up to his "studio" at night (it was really sort of a barren garret), and we'd work by artificial light, with my mother sitting in the car outside, sometimes doing her own writing by the little dome light over the seats.

But even if he wasn't the best teacher, even if the light was poor and his attitude morose, it was still a one–on–one experience, and I knew instantly that I was an artist, that this was me—it was what I was meant to be. Whatever has happened in my life, I have always had my painting. I have always been and will always be a painter.

Make that professional artist, especially if the definition of professional is one who gets paid for her work. My first commissioned portrait came four years later when I was only fourteen. My mother was talking to a neighbor, Helen Falardeau.

"You know, my daughter can paint wonderful portraits... and she'd love to have you sit for her," she said. For a price, of course; my mother had learned a few things, and she suggested

a fee of twenty-five dollars—which seemed an enormous amount of money to me, and actually was a pretty fair chunk of change for a child in 1935.

Mrs. Falardeau rather sensibly wanted to see the portrait first. So I agreed and began painting her in the kitchen. When it was done, she loved it and happily paid up.

My career as a professional painter was launched. By this time, I had finished working with my first teacher and had gone on to win a scholarship to study at the Toledo Museum of Art, where I spent four wonderful years.

Later, I would study art at Goucher College, at the Corcoran Museum school in Washington and with a number of remarkable artists and institutions from Detroit's own Center for Creative Studies to the Institute of Allende in Mexico. You might say that I am still going to school today, except that now I am my hardest teacher, and even if I am my favorite student, I don't always get a passing grade.

Yet it was in that kitchen in Toledo that I first became a professional artist—one who is paid for her work. And though I wouldn't know it for more than thirty years, that first commission stirred what would be the embryo of a future feminist, too.

If a Little is Good, More is Better

It occurred to me when I was thirteen and wearing white gloves and Mary Janes and going to dancing school, that no one should have to dance backward all their lives.

–Jill Ruckelshaus

*T*ake a second to read this chapter title out loud.

Okay... so that may not always be true for chocolate!

But it is true for nearly everything *else* a woman has a right to crave: freedom, self-confidence, power... and especially *money.*

For earning power is the key to most of these other things. Women need to understand this—and how important it is—far better than most of us do.

The importance of money is something I started to figure out very early. From the time I painted that first portrait in my mother's kitchen, I always *loved* being able to earn my own. Years ago, I learned that the most important thing a woman can accumulate is cash. That's because it carries the power to be truly independent.

Which is something a lot of men of my generation understood all too well.

A good friend of mine told me the story of how she and her husband went to a nightclub with another very affluent couple. Eventually, the two "girls" got up to go to the bathroom. You know, funny as it seems, not too long ago women thought they couldn't go to the powder room without another woman in the group tagging along.

One of the women asked her husband for five dollars "for the

girl," meaning the bathroom attendant. But once she was there, she gave the poor attendant a mere fifty cents. Astonished, the other woman asked her why she had asked her husband for five dollars.

She looked at her steadily. "I need the money," she said.

That sounded all too familiar—and all too true.

Few things make me more angry than when you hear it said that women control the money in this country. Men jeer at us, hold this over our heads, knowing all the while how untrue it is. I've heard the figure used—it is undoubtedly too high—that women have 83 percent of the wealth in this country.

Well, so what if it *is* true—they don't control it!

Men run it for them. Whether through trusts, whether through bank accounts, or just plain intimidation. Men keep very, very tight strings on money.

Now I should make it clear that I am talking mainly about rich men. For most of my life I have lived an upper class life. I do not apologize for that, nor do I make light of what poor women have to go through. I have never had to starve or go without adequate clothing or shelter, or suffered any serious wants, and I have nothing but admiration for women who have endured real financial hardships and survived.

Yet there is a myth about the lives of rich women, which is that they have it all. What they are, a shameful number of them even today, are captive birds in gilded and not very comfortable cages. Poor women may know the despair of want. But many of them, in this country anyway, also have a kind of hard-won independence.

Poor women often tend, after all, to be alone or the single heads of households that may include a number of children. And if there is no man on the scene, the woman left behind is sovereign over whatever meager assets there are.

Poverty is oppressive. But rich women, on the other hand, know another form of bondage. For one thing rich men know: *you never, never give your wife money*—because that means giving her the freedom to leave you!

Rich men keep very tight strings on the money. They give their wives allowances. They say, "I'll give you some spending money, dear." Nice little power game at work there, too; allowances are what parents give *children.*

Another trick is to say, "Just charge what you want. If you want any clothes, or any household things, just charge them and I'll pay

the bill." Why, isn't that sweet... especially in cases where *he* is using money *she* brought into the marriage?

You wouldn't believe how many friends I could name who would buy dresses, show them to their husbands, then return them to get the cash! I had a best friend whose husband withheld all money from her. She would charge things at Saks Fifth Avenue, then return them to my account, and I'd write her a check for the money!

Which brings me back to *my* story.

The War Between the Sexes: Opening Rounds

Some years ago there was a marvelous Brazilian movie called *Dona Flor and Her Two Husbands*. The husbands were very different, and between them they defined her. Well, I've had three husbands, with a boyfriend or two in between, and struggling to keep from being smothered by the first two had a lot to do with how I defined myself.

What I did those first two times was mostly to try to marry fathers. The relationship with the husband I have now, Bob Siler, is completely different. He and my wonderful stepfather, Dr. Jean Paul Pratt, were the only two men, I think, whom I have ever allowed myself to completely love—in Bob's case because I finally grew up enough to love myself first.

But first, let's pick up the story where it left off, with me painting the neighbors in my mother's kitchen for a few dollars. I was fourteen, just beginning to blossom. My mother told me that I was not very pretty, not without makeup, anyway, and sad to say, that idea has stuck with me all my life, even after becoming Miss Michigan and second-runner up to Miss America.

And I'm not about to let you see me without makeup now!

I wasn't especially in the social swim in Toledo. We were very middle-income, and I went to Scott High School, which was a mixture of children from different classes and different colors. You might have seen me more as a future egghead than a beauty queen back then. I had gone to Fulton Elementary School, and the public school system in Toledo was very progressive; they had the idea of taking bright kids and giving them a chance to excel, a practice to which the educators of today ought to return.

What that meant for me was that I skipped one grade and

reached high school by age twelve and went on to college at sweet sixteen! Back then you could get into the National Honor Society early, but you had to requalify each year.

Well, I was a member every single year. Looked like I had a promising future as the star pupil of Toledo, Ohio.

But soon afterwards, our lives changed forever, when my mother came home and said, "We're moving to Washington. Your grandfather is going to buy us a house."

That's exactly what happened. Why, I'll never know, but crusty old Mike Uline had decided to forgive his daughter for divorcing her philandering husband and take her and his now teenage grand-daughter back into the fold. Those who know something about human nature may not be too surprised to learn that he himself had divorced his first wife and married a younger woman. How things change.

Grandpa bought us a lovely house on Ellicott Street in Washington, not far from Chevy Chase Circle, and my life was instantly transformed. I had started my college career at Toledo University. Now I was sent to finishing school instead, and I began intensive training for my real role in life—that of a first-class, top-drawer geisha girl.

I was shipped off to Goucher College in Baltimore and came back to make my debut at the Sulgrave Club in Washington, D.C., in 1939. Momentous events were brewing. World War II had begun, with all the horrors that would kill tens of millions of women as well as men. The holocaust and the atomic age were on the horizon.

Patricia Hill knew little or nothing about any of this, though later that fall I would be presented, together with all the other Washington debutantes of the season, to Franklin and Eleanor Roosevelt at the White House.

Young though I was, I felt his immense charm and her intelligence, though I have to say that this great lady was even homelier in person than in her photographs. She spoke to me, and all I can remember is that her front teeth seemed to protrude—even when she closed her mouth.

What was *I* like, then? Well, the girl who had once skipped a grade and been installed into the National Honor Society for academic excellence had gone on to earn top honors at the geisha's art. I wore lots of make-up and could prattle on for hours about absolutely nothing. I was proud that not one of my dates knew how bright I was.

My mother had raised me to be an achiever. Before I found my one talent in painting, she had arranged for me to take lessons in everything from dancing to riding to playing the piano. We did power housework that never ended; taking down lace curtains, for instance; washing and stretching them on large wooden frames studded with rows of tiny nails that caught my fingers and made them bleed... *Help!*

Her example did not take; housework is not among my ten favorite things to do, though I've been told I run an excellent household. But I was driven—still am, thanks in large part, I think, to her. Most women my age would be taking naps in the afternoon, not worrying about whether their work will take them to Europe again and then to South America before this year is over...

To me, it is a sin to say no to anything. You've got to do everything, you've got to try it all... and if a little is good, more is better.

But when it came to the opposite sex, my mother was a bundle of contradictions. She told me that I was never to tell anyone, especially, any boy, how well I did in school. If I went on a date, I was supposed to always agree with whatever he said; you might say, be on my knees mentally before the sacred male ego.

Even today, I am still enough of a geisha to hope that President Roosevelt noticed me that long-ago evening in 1939. But if he did, he could no more have imagined I would become a militant international feminist than... I could have! For you might say I was still in the stone age as far as women's liberation was concerned. But my economic instincts were much further advanced, right up to the age of capitalism. I liked earning my own money.

Always had and not just through painting. For one thing, I had modeled, starting way back at the Lion Store in Toledo. Later I was a model, registered with the famous Powers agency in New York. I liked to model and did it well, I think; I was tall, slim and leggy, which was what was wanted then. Now, too, as far as I can tell.

Modeling, incidentally, led to my next great career, which you might say was that of a local radio "pseudostar." (I know what you're thinking: no, I didn't get the job because I looked so good.)

I began my radio career the old fashioned way... I *lied* to get ahead.

I Take To The Airwaves

Fast forward a few years.

We had moved from Washington to Detroit (I'll get to how and why shortly) and I was, sure enough, modeling for Hudson's, then the city's main department store.

One day I was swinging through the dining room and George Trendle, one of the top producers at WXYZ, then the leading radio station in Detroit, was lunching there. He had, I believe, seen me model and spoke to me.

Now, my speech patterns had been affected by spending my teen years in the nation's capital, the city John F. Kennedy later said combined Southern efficiency with Northern charm. "Where are you from?" he asked with mild surprise.

"Washington, D.C.," I said, sounding, I fancy, a touch like Miss Scarlett.

"That's amazing!" he said. He was a slight man, close to elderly. "I'm producing a new radio series where we want a leading lady who is supposed to be a Washington debutante." He explained that the series would originate over WXYZ in Detroit.

"Well, I made my debut at the Sulgrave Club in Washington in 1939, and that is exactly what I am!" I said prettily.

Then he asked "Can you act?"

I looked into his eyes and I realized there was nothing to do but... LIE !

"Why yes, I went to finishing school (this part was true) and had years and years of lessons," I fibbed mightily. I had never had an acting lesson in my life.

Strangely, he believed me. "All right," he said. "Come down to WXYZ in a few days and we'll give you a tryout."

Well, so I did. I remember standing in a circle that included the director, the manager and some of the professional actors, including Brace Beemer from the already famous radio serial "The Lone Ranger." They were to pass judgment on this greenhorn.

They gave me a script. I read through the first page and looked up.

Every man in that room was laughing his head off! When they recovered enough to breathe, one said, "Lady, you have never had an acting lesson in your whole life! You couldn't be worse!"

Had it been the Borscht Belt, I might have said, "So shoot me already."

But they liked my chutzpah. "You've gotta admit, that accent is great," one said. "A perfect accent." They mulled it over, until the Lone Ranger himself came to the rescue.

"All right, I'll take you under my wing," Brace said. "I'll give you two weeks of lessons, and we'll try this again. If you make it, you can not only have this job, but you can play the female leads in the Lone Ranger program."

Nobody says no to the masked man.

Besides, who was to know the difference between a Southern and a Texas accent in those days? Nobody in Motown, pardner.

That's how I became Gail Manning, the female lead on another WXYZ show that became nearly as famous as "The Lone Ranger"—"The Green Hornet."

You know, I think there's a moral in that for many women—which is that you often can get what you want if you just have the courage to go after it. Naturally you can't walk in off the street and become a brain surgeon, but I think a lot of people have gotten into drama the same way I did.

It wasn't too difficult; what you really needed in radio was an ear for the spacing, pauses and breathing needed in speech, to make whatever was said seem as natural as possible. Not that I didn't screw up. The two shows overlapped, and, remember, back then they were all broadcast live. Once, I was supposed to duck around some corner and burst out—"Oooh, it's the Lone Ranger!"

Unfortunately... I said it on the Green Hornet show!

Oooops! But we *all* blow it, sooner or later. The point is to put your mistakes behind you, wipe your palette clean, forgive yourself—and get on with life.

Women are often, thanks to society, especially obsessed with pleasing everyone and consumed with guilt over their real or imagined failings. Forget that idea! If I have learned anything, it has been that when you do mess up, you pick yourself up, learn from your mistakes if possible, and go on to the next adventure.

And Lord, have I ever had a few!

How to Marry Off Your Mother

Had anyone ever actually called my mother a feminist, she no doubt would have responded with contempt. Remember, I said that she was sort of a closet feminist. But the word wasn't even in use back in the 1940s, and she had been thoroughly grounded in the belief that the only road to success for any woman was through a man.

There had been, it was true, a few women artists on her family tree. But none of them had ever made their own living at it. Those of her relatives and friends who had done well had done so by marrying well. Her own marriage, remember, had failed disastrously, and everything she told me indicated that she disliked marriage in general. She certainly wasn't starry-eyed about men, though she was capable of falling in love. When I was about ten she really fell for a nice Toledo lawyer, who she might well have married, except that he went fishing one day with some of his buddies.

They found the boat the next day, overturned in the lake, with four unused life jackets bobbing on the waves. She took that very hard, and even wrote and privately published a book of (not very good) poems about him.

She had made it on her own. But even though she had lived the life of what was called a bluestocking—writing to support her household, entirely alone, she wasn't going to subject her daughter to that. Little Patricia Hill grew up being told that she was going to marry well, period.

"It is as easy to love a rich man as a poor one," I heard, again and again. Whether or not I wanted to was not an issue. The way to make sure Patty snared the proper man, as Mama saw it, was to make sure that her daughter was as trained and groomed to be as perfect an American geisha as there was.

Mother was a bundle of contradictions. She had a jaded view of marriage, and yet right from the start brought me up in a manner tailor-made to ensure that I would end up in a marriage that was probably loveless on my part—to begin with, anyway—and which would be contracted for mainly economic reasons.

Without any doubt, she loved me, in her way. Once she confessed to me that all she had wanted was to have a daughter, and that having me made her life complete.

I was, in other words, the centerpiece of her life. That was wonderful—just as long as I conformed to what she wanted me to do.

For not only did my mother intend to live *for* me, she intended to live *through* me—and did for many years, throughout my entire childhood, which I define as lasting right up until I got married at twenty-four.

But though she wanted me to marry well (and I had been brainwashed into thinking that was just the thing to do), in her secret heart she had no intention of ever letting me marry... because that would mean losing me, and she had no one else.

Understand this: she was an extremely brilliant and capable woman. Had she been born a man, or been born in 1946 instead of 1896, I don't think there would have been any limit on what she might have become. She could easily have been a top-notch corporate executive. But she grew up as a sort of enemy alien trying to make her way in a man's world, and had to do the best she could.

When my grandfather finally forgave her for divorcing her husband, he not only brought her to Washington, but also decided to treat her like the son he never had. He took her into his company, trained her and took her advice.

She proved to have an excellent head for business. When he died in 1957, she was in her early sixties, and she took both his company and the arena over and improved them both. She renovated the facility; ran around the country; set up boxing matches and lured in the Ice Capades... and God, how the money rolled in!

When Mother was in her eighties, she became my personal stockbroker and made me a lot of money, doubling my income from the investments that Harry had left me.

But all that was far in an unknowable future back in 1941, when the only thing she had to run was me... and I was getting very tired of having my strings pulled. I thought I was doing absolutely fine in life. I was selling portraits; I was not only modeling, I was in *Vogue* and *Harper's,* and I was winning a steady stream of praise.

Except as far as matrimony was concerned. I could easily see that my mother loathed, just plain loathed, every young man I brought home. She wasn't about to put herself out of the controlling business, and I could also see that she had no intention, despite whatever she might say, of *ever* letting me get married.

What I needed was a plan, and she had taught me well. When it came to manipulation, I had a master's degree, from Mama's home school. Very well, if she won't let me get married, I'll see to it that *she* gets married, I thought.

Mother may not have liked men very much, but she was an attractive woman, and she had no shortage of suitors—including five more or less serious ones. What I did then was look them over, examine their teeth, kick their tires, and pick out the one I liked best. Really, it was no contest: My favorite—hands down—was Dr. Jean Paul Pratt, who was chief of obstetrics and gynecology at Henry Ford Hospital in Detroit.

Audacity, audacity, always more audacity, Napoleon supposedly said. Okay, so I didn't know that then. It still would have sounded good to me. I took Dr. Pratt aside. "I wonder if you realize that you are not using the right technique at all to persuade my mother to marry you."

He looked at me anxiously. "Listen, I've been courting her for five years. Please tell me what I can do to get her to say yes."

Well, I knew my lines. "When mother comes to Detroit, all you do is take her to restaurants. You never introduce her to any of your friends, you rarely take her to your clubs, you never show her where she might live. She's German and Dutch, a true hausfrau. She needs to know what kind of life she might have in your town, what kind of home she might have and in what kind of neighborhood it would be."

"Good tip," this graceful and gentle man said. "Just wait until you come the next time." Sure enough, we arrived in Detroit a few weeks later. Dr. Pratt took us for a drive, and finally stopped in front of a very beautiful, long white house.

"Mimi, how do you like this house?" Dr. Pratt said.

"It's huge. I pity the woman who has to take care of it," Mother inauspiciously replied.

"Well, it's yours!" he said with a grin, "I bought it last week."

Mother was *furious.*

"Jean Paul Pratt, I am really insulted! I never told you I was going to marry you. I won't even look at it. Just drive off right now."

Fortunately, I happened to be in the back seat of his sleek, dark blue Lincoln Continental. "Mother, you ought to be ashamed of yourself!" I exploded, "Here's a man who has bought you a house, and you won't even go look at it! That's the least you could do."

I marched her out of the car, and right in to what was really a wonderful house.

Suddenly I heard her muttering, "I could put the sofa here, the piano there ... "

Aha! I thought. She's hooked!

And so she was. What I didn't know is what a wonderful thing I had done. Dr. Jean Paul Pratt was the first really great male role model each of us had ever known.

What I might have been worried about was his age. "Mimi," he said later that day, "I'm sixty years old. That is twenty years older than you are now." He and I both thought that Mother had just turned forty. Mother hesitated a moment, then turned to me.

"Now Patricia," she said. "That is just too many years. Twenty years difference is just too much." Oh no, I thought, visions of freedom ebbing rapidly. "So, I think I am going to tell you both the truth. I am really forty-five!"

And so they were wed, and we moved to Detroit. Not, however, without one last complication. Dr. Pratt had gall bladder surgery, and was hospitalized longer than he anticipated. He offered to postpone the wedding, but Mother said no dice.

Either we get married now, or we call it all off, she said. So they tied the knot—right there in his hospital room. They closed off the whole floor and we all crowded into his room in our evening clothes, which seemed odd, to say the least.

Later, one of his sons carried Mother over the threshold. "This is not quite how I imagined my wedding day," she muttered. But nevertheless she was finally married again. To celebrate her new life, she immediately dropped the name she was born with—Myrtle—entirely; she had decided that she would rather be Mimi, which was what Dr. Pratt always called her, and so Mimi she forever after was. Her mother had deliberately named both of her daughters after nut-bearing trees: Myrtle and Hazel.

Maybe it *was* a blessing that the Ulines didn't have any sons...

You could say, if you wanted to be catty, that as far as strategy goes I had a much better record that year—1941—than my onetime host, FDR. I got Mother married; a few months later, President Roosevelt got ambushed at Pearl Harbor.

All in all, I had done far better than I suspected. Once Dr. Pratt recovered from his gall bladder surgery, he would go on to live and take care of Mother for nearly forty years. He lived to be just a few months short of a hundred years old.

Best of all, he really loved me, and I loved him, too.

This was the first totally healthy male relationship in my life.

What's sad is that it would be a very long time before there was a second one.

On the Boardwalk

My new stepfather had two sons by a previous marriage. One of them, Charlie, was almost exactly the same age as me—he was three months older.

But I felt *terribly* sophisticated, especially compared to him. Charlie, to tell the truth, fancied that he was a little bit in love with me. Later, he actually would propose. I let him down easy—as a matter of fact, I introduced him to a lovely girl who he would eventually marry. I liked my step-brother—but I thought, not maliciously, that I was a bit out of his league. I had lived in Washington since I was sixteen and had made my debut in society in what was, really, an entirely different world.

I was doing well in my modeling career, getting into the national magazines, and I was feeling self-confident. Enough so, that is, to pontificate on beauty contests.

"What do you think of these beauty contests?" Charlie said.

"Well, let me tell you—any woman with any intelligence could win one, no matter what she was wearing. There's nothing to it. These women are so stupid to cry and carry on when they win—all they have to do to win is to be bright."

That was enough for Charlie. "All right, I dare you," he said.

"There's a Miss Michigan contest being held on some little boardwalk, on Jefferson Beach, not too far from Detroit," he said. "Let's see if you can prove you are right."

"Okay," I said. "I'll wear my baggiest bathing suit, and you can take me there."

We got there and I blithely signed some papers to enter the contest. I wasn't at all worried; I knew that I walked well because I had modeled all my life. Then they asked me, "So, now what's your talent?" They had me on that one. "Talent? What do you mean, talent?"

The pageant officials said, "You know, everybody has to have is a talent. Don't you sing or dance? "

"All I've ever done was drama on the radio," I said. "Maybe I could tell some stories about that," I said, with a sly smile turning up the corners of my mouth. I was thinking about how just the other day we had to go over to "Tonto's" apartment and drag him out of bed because he did like his firewater a bit too much sometimes—though he surely could pronounce "Ke-mo-sa-be" so well!

"Well, okay," they said. "Talk about your radio career."

I decided to let the comedienne in me come out, as I told about some fluffs and bloopers I had made on the air, including how I inserted the Lone Ranger into the Green Hornet.

Everyone roared with laughter—and the next thing I knew, I was standing there with a huge bouquet of flowers, **Miss Michigan, 1942**.

I looked at Charlie. "My God. Now we're going to have to go home and tell Mother and Dad."

"I know," he said, hanging his head.

What we both knew was that they would be absolutely *furious*.

Today, almost any parent from any walk of life would be delighted to have a daughter who was even asked to compete for the title—except perhaps those with a militant feminist background! But that sure wasn't the case then; beauty pageants were seen a little like "wet T-shirt" contests might be today—totally *déclassé*.

Charlie and I talked about this till three in the morning, trying to summon enough courage to go home. Finally, we knocked on their bedroom door.

"I want to introduce you to Miss Michigan," said Charlie.

"Patricia, *you have just ruined your life*," Mother said with rage, as icicles formed on the ceiling. "Your Dad could lose his position with something like this."

That, believe it or not, wasn't that far-fetched. Detroit was a tight little society in those days, molded by Henry Ford with his standards firmly imprinted on the chassis.

If you worked for Henry Ford back then—especially in a higher capacity—you felt very much a vassal in a feudal kingdom. Dr. Pratt was the founding head of the department of obstetrics and gynecology at Henry Ford Hospital, and King Henry the First of Dearborn did not like anyone in that sort of position to even smoke or drink. Being mentioned in the newspaper was even worse, and the idea of associating with beauty contestants—much less harboring them in the family—was beyond imagining.

To make matters worse, within hours, the phone began ringing. The newspapers had learned that a so-called society girl had gotten to be Miss Michigan! Whatta story! Grab the Speed Graphic! Sweetheart, get me rewrite! They wanted interviews!

My mother wanted blood... mine.

"You can't talk to them! You've got to call the pageant officials

up and say you're resigning in favor of the girl who came in second," she said.

Now I have always been quite reasonable—any time a gun has been pointed at my head. So I told the contest officials, "Sorry, but I'm dropping out. Please give the crown to the next runner-up."

Ha ha. Remember all those papers I signed?

They got their lawyer on their phone. "Yes, Miss Hill. No problem. Of course you can quit... as long as you don't mind being sued by the state of Michigan, because you signed a contract saying that if you won, you would not only go to Atlantic City for the Miss America contest, but also that if you won, you would give fifty percent of your earnings for the first year to the Miss America Pageant."

Were we talking about serfdom a little while ago? They really exploited the girls financially then. You also had to agree that you would fulfill any theatrical engagement they made for you—and as I learned to my dismay, this meant sleazy dance halls far more often than elegant theaters, let alone Broadway.

Not for nothing did my feminist sisters later write a little ditty: *"Ain't she sweet? They're makin' money off her meat... "*

Anyway, the American family Pratt didn't want to risk the scandal of being sued, and Mother finally grabbed the controls once again and said, "You can go... only if *I* go to Atlantic City with you!" So, that was that.

What happened next? It was fun. They drove us around with all of the stop lights blotted out, except for narrow little slits, because this was on the Atlantic Coast, remember, in the first year of the war. At night, you couldn't leave any window uncovered. It was kind of spooky.

Understand, I never thought very seriously about winning, and once again I faced the talent competition problem. A writer from the old NBC "blue network" was nice enough to write me two scripts: one for the first run-through; the other to use if I made the final ten. Well, I knew that there was no possible way I'd end up a finalist, so I never even looked at the second script... until suddenly, there I was, a finalist.

"All right, girls," the announcer said. "You are due on stage for your talent presentation in half an hour." Remember, I hadn't even looked at it.

Well, I read it once. It was unabashedly patriotic, as you might have expected right at the start of World War II—and I memorized

it cold out of sheer panic.

No, I didn't win. But I was second runner-up, which isn't bad. I finished behind a Texas gal named Jo-Carroll Dennison and a contestant from Chicago.

Later, the famous society writer Inez Robb wrote about the contest in an old newspaper called *The American Weekly* in a way that was more than nice to me.

"The second runner-up was Patricia Uline Hill of Detroit, a tall, striking creature with dark hair and big blue eyes... rather like Rosalind Russell who had to wait for years in Hollywood and is now coming into her own... she drove one of the judges gaga, but not the boys in the gallery," she said.

She concluded that I could not have won, because I "verged on the beautiful rather than the pretty." Somehow, I guess I can stand criticism like that.

But what, to me, was most wonderful—and most significant—about that long-ago episode was not that I did so well or looked so well in a bathing suit.

What was really significant was that I began to realize how much I care about women and how well I get along with nearly all women from all walks of life—and they with me. During that contest, I met women that I never had a chance to meet before—including the first underprivileged women I had ever really known.

What I learned was that I had a mystique of truly liking women. Now a beauty pageant is by no means the best atmosphere for female solidarity. Basically it is a highly competitive atmosphere—sexually competitive, too, since beauty pageants are largely designed by and for men.

Yet in wartime Atlantic City, I found out for the first time that when I am talking to other women, no matter what their backgrounds, I think they sense that I am on their side, and I really am. What happened at this pageant was that I kind of adopted everybody, and they in turn liked me back, something that has been happening to me ever since at women's gatherings from Detroit to Denmark .

What really touched me was that the other contestants then voted me "Miss Congeniality"—which, even more than now, was seen as quite an honor. I have a picture that Miss America herself, Jo-Carroll, gave me, inscribed "To a very swell gal, one of the nicest people I have ever met. You are just some all right!"

Wouldn't it be nice to be remembered as "some all right?"

These days, a lot of my sister feminists are totally against beauty contests of any kind. NOW has protested in Atlantic City, and other women's groups have demonstrated against contests elsewhere.

So how do I feel about beauty contests now, as a mature feminist? You might be surprised, but I don't really mind them at all. My position has always been that a woman should be able to use every asset she has to make it in this man's world, and that's exactly how I saw what I was doing: as just a job.

That's right. It didn't feel the least bit strange to walk down a ramp and have people looking at me and judging me for my body and my looks. I had been a professional model, remember.

What I had, as I saw it, was a talent not too different from musical talent. Should a pianist feel embarrassed that people are looking at him (or her) and judging him by the way he hits the keys?

Sure, I was sometimes aware of the lust in the eyes of the males watching—but that was *their* problem, not mine! To me, my appearance was just an asset I could sell.

Now mother wasn't completely wrong: there *was* a sleazy side to the beauty contest game. Because I was a runner-up, I had, for a few weeks, to accompany Miss America to a number of engagements—and most of them were absolutely ghastly.

They would book us into vaudeville shows and burlesque houses, where we were often pawed and mistreated backstage. Even just a few days after the pageant, I remember a comedian backing me up against the wall on the boardwalk and my having to fight pretty savagely to successfully keep my virginity.

By the way, the reason that I—and especially mother—were so determined to keep me a virgin had absolutely nothing to do with religion or morality. My virginity was seen as a priceless asset to be employed in the course of marital negotiations.

When I was plucked out of Toledo and sent to Washington as a teenager, I was immediately thrown into so-called "society," where the girls were carefully educated, dressed and watched as befit the prime marriage material they were.

Everything was done to ensure they stayed virginal.

Those who didn't—if they were caught—were socially and economically punished to a degree no woman of the nineties can easily imagine.

Naturally, I understood all this very well in my early twenties. After all, as I might have told Charlie, I was pretty darn sophisticated.

I had been runner-up to Miss America, product of a fine finishing school, college-educated, budding portrait artist, and nationally known model.

The world might be tearing itself apart in a cataclysmic war, but I had a firm grasp on how life's rules worked.

But what I never suspected was that following the rules could be just as hazardous to my health as breaking them. Maybe, in fact, more so.

I was about to get a very serious lesson in life.

<div style="text-align: center; border: 2px solid black; display: inline-block; padding: 20px;">

4

</div>

Marital Wars

In youth, it was a way I had
To do my best to please,
And change with every passing lad
To suit his theories...
But now I know the things I know
And do the things I do
And if you do not like me so—
To Hell, my love, with you!"

—*Dorothy Parker*

*T*hank you, Dorothy dear. That sums me up perfectly... *now.*

Unfortunately, I figured things out... oh, only about thirty years too late.

But at least I eventually got there. If I hadn't, among other things, I never would have survived being booed by two thousand people. And that's exactly what happened to me when I spoke at Michigan's Republican State Convention in Detroit, my party's biggest party, in 1988.

They let me speak—and then they booed me!

You would have thought I was a Democrat who drove up in a Japanese car!

Why? One guess—abortion. Ronald Reagan was in the White

House, the religious right was on the rise, and Pat Robertson's troops were out busily trying to line up support in my state for his presidential bid.

Now I have always been, completely, loudly, totally pro-choice. Now, don't get me wrong. I am not a one-issue voter. I happily voted for Reagan and cheered when he crushed Jimmy Carter in 1980... even though Carter and I really got along; he had invited me to the White House many times on behalf of various women's groups.

But I am a feminist Republican, fighting to get this party back to its natural place in favor of freedom of choice. We always should be for civil liberties and personal freedom—what the party of Abraham Lincoln was supposed to be all about, until we lost our way on this issue a few years ago.

What really made those delegates especially mad was that not only was I in favor of choice—I was arguing against cutting off Medicaid funding of abortions!

Now let me make it clear that I completely respect and honor other people's right to object to abortion, based on their own personal religious or moral beliefs. All I ask is that those who are pro-life will let us who are pro-choice decide for ourselves, just as they decide for themselves.

But what still seems to me a quite reasonable and moderate stand was seen as anything but that by my fellow partisans then. What was even worse, for many of them, was that I was not only in favor of a woman's right to choose, but I was and am in favor of the government paying for abortions for the poor! I am sure some of my friends thought I had gone mad... or at least become a socialist.

Not at all. Believe me, I like to hang on to my money, just as you do. And there is nothing I hate more than taxes and more bureaucracy. But I also try to be a fairly rational person, most of the time. And it is clear to anyone who can count that it costs society far more to deny these poor women abortions than it does to pay for them.

So I thought: if these delegates—most of whom were men—had any idea how much it was costing them to make abortion harder to get, they might listen.

"Are you aware of the difference in cost to the state between the abortion of an unwanted baby and the cost of a live birth?" I asked. "An abortion costs $318. The cost of a live birth—including prenatal care—is $3,153.

"What is even sadder is that in nearly all such cases, the meter

only starts running after the baby is born. When you take food stamps and all else into account," I continued, "the total cost of raising an unwanted child on welfare to age eighteen would be at least $37,065. Does that save taxpayers' dollars?"

My numbers, by the way, weren't pulled out of a hat or a NOW pamphlet—they came from none other than Patrick Babcock, then state director of social services.

What I didn't add was that those dollar amounts didn't even begin to get at the real cost to society of unwanted babies, who are far more likely to end up in trouble than in high-tech jobs. Not to speak of what it costs society, financially and otherwise, if the unwanted one ends up in jail, or ends up producing another generation of welfare-dependent infants as so many of them, so tragically, do.

"What is frightening," I concluded, was that any proposal to stop welfare abortions "will set up a two-tiered morality, one for people WITH credit cards... and another for people WITHOUT credit cards."

This all made perfect sense to me. My friend Gene Boyer says I am a fiscal conservative but a radical feminist... but I don't see why that should be any contradiction at all. After all, any party that stands for economic freedom should be for greater personal freedom too, right?

Thought you'd agree!

Unfortunately, my audience didn't—and they booed me, loud and long.

What I was up against, I now realized, was sexism in an unholy alliance with religion. There are a lot of men who are not comfortable with the idea of women having control over their own bodies. (Next thing you know, I imagine they must be thinking, they'll want control over their own money.)

Denying them this fundamental right is a lot easier when you've convinced yourself that's what God wants, too. Well, after most of a century on this planet, I can tell you that if there is a God... she has a big surprise in store for a lot of men!

By the way, how did I feel when I was hooted at?

Would you believe... *amused!* I had learned by that time to be rather confident in myself and my beliefs, thank you ma'am. But it wasn't always so.

You remember, I was brought up in a cocoon.

Especially when it came to the opposite sex.

Early Adventures Among the Aliens Known as Men

Before I got married, my life had been far too easy, in a sense.

My background was not too much different, in a way, from the lotus blossom world of my geisha counterparts in Japan.

I never had any problems getting dates. Nor were there any shortage of young men eager to marry me, which in a way ought to have baffled me because they really didn't know me at all. Actually, I guess that isn't surprising... since it never would have occurred to most men that you ought to marry someone who was your best friend, someone you were prepared to treat as an equal partner.

What was I like? Well, in a way, I was terribly immature. I do remember my first "romance." When I was twelve, Mother and I went driving every Sunday with a neighbor family. Their nineteen-year-old son, Dale, usually sat in the back seat of our Packard, next to mother and me. I was the smallest, so I sat in the middle.

Secretly, I used to hold his hand under the car blanket. This was a big thrill, and I wrote in my diary of my undying love for him because he let me hold his hand.

Naturally, mother read my diary zealously. The next week, she plunked herself firmly down between us, and my first romance was over. Two years later, I had a mild summer crush on a boy named Jim who, I told my diary had "sensuous lips, probably from playing the trumpet." Alas, that love faded by the time we were out of bathing suits and back in high school.

But I always liked boys. I liked to flirt and go to parties and have a good time, and I often saw young men mainly as a means to my social ends.

For almost a year I dated one fellow I'll call Eddie, a very good looking fellow, someone who today would be called a hunk. We'd go out, and I'd chatter on... then one day a friend of mine asked me, "Do you realize how *boring* Eddie is?"

I never had noticed. So the next time we went out, I didn't say a thing and waited for him to seize the conversation... and *he never said one word*. My friend was right! He really *was* the world's most boring man.

True to my training, I can't say that I engaged my dates in intellectually stimulating conversation. Once I went out on a date with a young doctor. When we got home, my little Scottie, Heathcliff, was whimpering and whining in evident distress.

My young Dr. Kildare kneeled down and felt his stomach. "This dog is severely constipated," he proclaimed. "Quick, get an enema bag."

"How do you know so much about it?" I said. He looked puzzled. "Well, I am a *veterinarian*," he said. "What kind of doctor did you think I was?"

Biting my tongue, I went outside with him and helped hook the bag up somehow to the door of my stepfather's elegant Lincoln Continental. Before long, my dog was dashing around the front yard, ridding himself of what ailed him.

The next morning a committee of young doctors, trying to keep solemn faces, confronted my wonderful stepdad in his office at Henry Ford. "We want you to know that we are aware that you have violated the highest canons of professional ethics," they said. "What do you mean?" said a puzzled Dr. Pratt.

"Surely you know that doctors are not permitted to advertise," one deadpanned, steering him to the window and pointing at his Lincoln parked down below.

He had driven to the office with the enema bag still hanging from the door.

Well, that suitor may have gone to the dogs, but by the time I was in my early twenties, I'd received twenty-five marriage proposals. Now, I know what you are thinking: what a little scalp collector! How heartless to keep score!

Sounds, as a matter of fact, like something a *man* might do.

Actually the only reason I know how many was because that was how many proposals Mother had received before she married my father... or at least, that's how many proposals she claimed she had. So was I competing with Mother?

The truth is even stranger; when it came to dating, Mother *was* me.

Unfortunately for me, marriage to dear Dr. Pratt hadn't cured her of her desire to run my life, and she had practically picked out most of my beaus. She was, I guess, reliving her own less-than-perfect life, and she thought if twenty-five men had proposed to her, well, that's how many proposals Patricia should have too.

Image was always important to Mother—often, much more so than reality. Years later, she decided we should have a nice framed portrait photograph of the two of us together. A professional photographer came out to my home with an excellent photograph of

some new tapestries of sleek, beautiful horses from the Detroit Institute of Art to use as a background. Eventually we saw the picture, which I thought was quite nice.

But Mother went ballistic with rage. "You have to take this picture back and fix it immediately!" she told the poor photographer. What was wrong? Seems we were posed in front of the tapestry in such a way that her head was framed exactly into a horse's rear end.

The man obediently took the photograph back and airbrushed out some of the horse's behind. If she hadn't noticed, probably nobody would have—but as a result, that's horse's hindquarters are what I always think of first whenever I see that picture.

In many ways, Mother was amazing. She was much different around men; I was, and maybe still am, a geisha girl. She was not naturally flirtatious and, as I have said, saw the opposite sex with a decidedly unsentimental eye.

Yet in the years before she married my stepfather and then again after he died, whenever she was single and went out socially, the phone would ring the next day, with men wanting to take her out or call on her, and this continued down into her *eighties*. Finally I asked her for her secret: Why did she attract men so powerfully?

Good thing I wasn't leaning over a balcony when I heard her answer.

"My dear," she said. "It's the smell of bitch."

Well, back in 1944 I was straining at the leash. The allied armies were liberating Europe, and I wanted my freedom, too! I was a very assertive, extroverted young woman, and I was getting steadily more eager to get out on my own.

So how did I do that?

Naturally—I let mother pick me out a husband.

You have to understand—this was wartime—World War II— what my good friend Jean Stapleton's TV husband Archie Bunker used to call "the big one."

Most of the eligible men were away at the war. Then one day I met a man who she liked very much indeed. Dr. William Lange was a plastic surgeon, a major in the army, very handsome and totally charming. He was newly available, since he had just been divorced by one of the heiresses to the Dodge auto fortune.

I brought him home and she thought he was divine. Then, right

after we met, the army transferred him to Chicago, so for six months we carried on a courtship by mail, a courtship between two—make that three—people who barely knew each other.

Three people, because mother was at least an equal, if unindicted, co-conspirator. She even wrote some of my letters to him—or at least dictated them to me. "Now, Patricia, I think you should say this," she'd say... and I'd write it down.

Remember, I had been Miss Michigan; I was a highly successful model, and a star performer on two of the nation's top-rated radio shows.

But I was also my mother's daughter, and I had learned my lessons well. I had been thoroughly indoctrinated into obeying her on everything, and when the bell rang, little Patty, as she had all her life, did what she was told.

Mother did want me to marry well—and on paper, the man she picked seemed to fill the bill. But as far as my happiness was concerned, she might have done better to have stopped at the corner gas station and grabbed the first man wiping a windshield.

For my marriage was an absolute disaster from the start.

What I was doing—to the extent that I was aware what I was doing—was marrying a father figure. Significantly, Bill was about a dozen years older than me; about halfway at the time between mother's age and mine.

I knew he was divorced. What I didn't know was that he had been married not once but several times. But the worst part was— he really *did not seem to like women.*

He had four sisters whom he said he disliked; when I asked why, he said they had been jealous of him and persecuted him as a child.

I think that may have just been an excuse. Incidentally, you might ask yourself how many men you know who you can say really *like* women—as people, that is, rather than as someone to have on their arm or in their bed.

The answer, I suspect, indicates a large part of what is wrong with the relationship between the sexes.

I do confess that it was a very vulnerable, weak, and young woman who married William Lange a half-century ago. Nor was I completely ready for marriage either. While I wanted to be a loving and helping wife, part of the misery I was about to endure was that I had been plucked out of my busy and exciting life in Detroit and

whisked off to West Virginia, where he was chief of a veterans' hospital (this was, remember, towards the end of World War II).

What was far worse was taking orders without the right to challenge them with any ideas of my own. He had a violent temper, and he was not very nice to me.

Within two months my heart was totally broken, for the first, and I think worst, time in my life. My solution was something out of a dime novel: I would get pregnant.

Yes! You know the plot: When the husband learns that his wife is expecting, the scales suddenly fall from his eyes and he realizes how much he loves her, and everything is beautiful again. The bluebirds come and perch on the cradle...

How was I to know that some men absolutely *hate* pregnant women!

What he did when he found out was to send me home to mother. "Look, I'm busy running this hospital. Besides, I don't feel well and don't feel like being with you. I think I'm going to move into the hospital, and you should stay with your mother until your time comes. We'll get together after the baby's born."

Once I was gone, he promptly got rid of the house we were living in.

That was that—and that was the end of my marriage to Dr. William Lange. For whatever reasons—control, competitiveness—he contested the divorce and tied me down for almost three years. Significantly, I think, he never married again.

Nor did he ever take much of an interest in his only son, though he did help me once, years later, when Bill was a teenager and had a serious medical problem.

Today, however, he has nothing to do with him. If Bill calls him, he'll say, "You have the wrong number," and hang up.

Now for the truly wildest part, thirty-five years later, something happened that you'll never believe. After my second husband, Harry died, William Lange not only asked me out—he even acted as if he had serious intentions!

Whatever was he thinking? Well, I must admit that I did go out with him, a few times, out of curiosity. My guess is that, for him, it was kind of an ego trip, to prove to people, or himself, that he hadn't lost the knack.

Even today, as I write this, he is in excellent sprightly shape, at close to ninety, and as you might expect of a plastic surgeon, he

really looks good. I know this because I occasionally run into him in society. What, you may well wonder, is it like to run into this reminder of a half-century old trauma? Well, I made my peace with that a long time ago. When I do see him, I always make a point of going over to say hello—recently at the Detroit auto show I introduced my husband, Bob, to him.

He is cordial too, though if he had the choice, I am sure that he wouldn't start a conversation... but whenever we are in the same room, I sense that he is always aware of me. Whatever else he may be, my first husband is someone whom I will never completely figure out.

Not in this lifetime, anyway.

Life in Limbo

Nowadays, having been divorced is often no more of a social handicap than having a scuffed shoe. But I found myself trapped in a very different world, light-years away, when I came home to mother after my first marriage had turned into ruin.

Divorcees may once have been seen as glamorous—but not so in the far-off era where I was shut up in my mother's house with my newborn son, William Hill Lange, to whom I gave birth in February 1946. I loved him very much and was very proud of him, but I really knew nothing about babies. I had seldom been anywhere near a child until this tiny infant was put into my arms.

You might have a hard time imagining how miserable I was then. Here I was, not only back with mother, but with this new, totally demanding responsibility called a baby. Worse, I was in limbo—for almost three years, I wasn't even fully divorced.

As I have said, my husband decided to contest the divorce. This was a sharp first lesson that most relationships between the sexes are about power. Regardless of how Bill Lange felt about me, he suddenly decided to fight the divorce. So since I was technically a married woman, my mother decreed that I couldn't go out socially at all.

She did allow me to work—I might have gone insane otherwise. But my mother would *not* baby-sit.

So what I did was spend lots of money hiring baby-sitters so that I could go out to work—my only escape, except for my baby, from what had become a dreadful life. I modeled or acted, for a few

hours several days a week, and then I came home. And I quickly learned that Mother had sorely missed the few months she hadn't been able to dominate me daily and was determined to make up for lost time. I also had to cope with a growing and near-total depression resulting from my shattered marriage—what I perceived as my first great failure in life.

That built and built until one day I walked into a closet, shut the door, and sat down on the floor. For hours. I didn't cry; I didn't complain; I wouldn't talk at all and I wouldn't come out. The psychologists might have said I was essentially catatonic.

Today we'd call it being totally stressed out.

It took a while and it wasn't easy, but eventually, I got myself together and came out to face the world again.

The experience had frightened even my mother. For days after I came out of the closet, she called everyone she could think of. "You've got to do something; you've got to get Patricia out of the house!" she said.

What Mother didn't know was that Patricia was slowly building up to doing that for herself.

Mildly Wild About Harry

Harry Burnett knew who I was long before I knew him.

Long afterwards, I learned that years before we got married—before I married for the first time he had seen me out driving around in my red convertible.

Now Harry was hardly an impetuous soul. He was a confirmed bachelor in his late thirties, a chemist and microbiologist who was devoted to his family business.

But I must have turned his head. For him, it was really love at first sight. He tailed me all the way home—and was astounded to find out I lived right across the golf course from him. A neighbor family told him who I was, and he started keeping a scrapbook—every time I was in the newspaper he'd clip it out and put it in.

Right up to the day he read I was engaged to a plastic surgeon.

Then he took the scrapbook and burned it.

That was that. I think he was resigned to being a bachelor—until the day he heard that I was getting a divorce. Then he again asked the same neighbors, a family named Powell, to introduce us.

This was in early 1948, right after my divorce had finally come through.

So I went to this party, knowing that my neighbors had arranged to introduce me to this man—I had actually never met Harry before. The moment came; I walked down the stairs, I looked at Harry Burnett Jr., and I thought—

<div align="center">

never

never

never

</div>

...could I ever imagine being married to this man!

Harry was not, I thought, handsome at all.

He was a redhead, and I later realized he had a beautiful body, but his hair was thinning, and his chin was none too strong.

Later, he would put on weight and grow a distinguished beard, but when I met him, he was six feet one and weighed only 145 pounds.

Nope.

But he was in love, he knew what he wanted, and he was persistent. He sent me flowers daily, and wrote me letters almost every day—letters I am today sad to say I threw away, because I never thought I would marry him. Besides the lack of physical attraction, I felt that our personalities were just too different.

By the way, I believe just about any man can get any woman to marry him if he really works at it. If he is forever there, forever attentive—sooner or later she breaks down, no matter how impossible the match seems or how irritating his personality might be. She grows dependent on him—used to having him there, and that's what happened to me.

Harry kept at it—and though he really didn't know a great deal about women, he could be very charming indeed. You know where he took me for dinner on our first date? To Cuba! This was back in the glamorous old days of wide-open Havana, before anyone had ever heard of a scruffy bearded revolutionary named Fidel Castro. I happened to be in Fort Lauderdale, and Harry swept down, hired a plane, and flew me to Havana for dinner, then flew me back—and asked me to marry him.

To which I laughed and said, "Oh Harry, no way! We're just too different."

Yet he never gave up—even though I would never even give him a Saturday night date until after we were engaged!

But I must say that he was genuinely very kind to me and to my son, Bill, whom he later wanted to adopt—and would have, if Dr. Lange had not objected.

So I got used to Harry being around. We used to walk the golf course between our homes; the Detroit Golf Club is a wonderful set of fairways built over what were once Native American trails. We often used to stop and talk at a marvelous old tree that was said to actually have bent by the Indians to mark a path.

Sometimes I would climb up and sit on a limb of the tree that swept about four feet from the ground as we chatted.

Then, finally, one day I thought—*I think I'm going to marry Harry.*

Not that I had suddenly fallen in love with him. But it seemed to me that it was simply the best solution for me; he seemed to be a good man. I would have a father for my child, and I would get out, hopefully forever, from my mother's very heavy wing.

But even if I wasn't starry-eyed, I did think that I should get him to propose in a setting that was romantic enough to give us fond memories when we looked back on it years later—and I thought that our tree on a beautiful day would be the ideal spot.

What I hadn't counted on was having difficulty getting Harry to figure out his lines. You remember he proposed to me on our first date. Well, for months, he kept on proposing to me, almost every day. But the answer was always the same: no, non, nein, nyet, and he had just about given up.

So when we got to the spot, I dropped all sorts of hints...

...but dear Harry didn't take the bait.

Which was sort of my fault. For months, Harry had proposed, and finally, I had pretty well conditioned him out of asking me to marry him.

Suddenly, I had visions of spending the rest of my life dangling from that tree limb. Hiding my desperation, I smiled sweetly and said, "Isn't there something else you want to say to me, Harry?"

He frowned. "I dunno," he said.

Finally, he figured it out. "You mean... will you marry me?" he said, puzzled. When I said, "Yes, Harry, I will marry you," he was amazed and almost beside himself with happiness—he had just about given up hope.

That was, indeed, the year of the come-from-behind Harrys.

This was 1948, the year that Harry Truman, was running for president, and not too many people were greatly excited about *him* either, though in the end, both Harrys, Truman and Burnett, surprised a lot of people by winning what they wanted that year.

"I'm just mild about Harry," one of my fellow Republican women, Claire Boothe Luce, used to say about Truman. Well, I was just mild about my Harry too, though I did like him, and did actually fall in love with him after the wedding.

But I married him partly because I thought—correctly as it turned out—that he was stable and a gentleman. I knew that life was sometimes going to be difficult. Harry was very set in his ways—at thirty-eight, he acted at least twenty years older.

My Harry had never been married or even seriously involved with a woman before. Nor, as I would find out, did he know anything about treating one as an equal. He had been the oldest son in his family, and his father and grandfather had completely dominated their wives. Plus he was already the chief executive of his firm, the Detroit-based Difco Laboratories, founded by his father, and he was used to making the top decisions and telling important men what to do... women too, if there had been any.

Harry wasn't cruel, but he could sometimes be a bully. Part of my problem, by the way, has been one that many high-achieving women may recognize. I always felt that I should marry men who were natural leaders, men who had a lot of drive, men who had risen to become the presidents of their companies.

Those were the kind of men I have always been attracted to. My mother, whatever else she did, helped nurture a healthy ego in me. I've never married a man who was not at the top of his profession—because I think that's what I deserve.

Trouble is, men like that are the most dangerous. They are used to getting what they want by dominating those around them—and they are even more inclined to dominate the women in their lives... if only because they are the nearest thing around. You have to stand up to such a man right in the beginning.

As it only took me three husbands to find out.

When I married Harry Burnett just about all I knew about his firm was the funny little family semi-secret about the name, which had originally been Digestive Ferments, Inc. Fortunately, perhaps in the interest of everyone's digestion, someone tucked that name up into the bland Difco before I came on the scene.

But though Difco may not have been sexy, it had done very, very well, especially during World War II. Difco had in some cases been the only provider of water purification materials and certain other strategic supplies to Great Britain.

Worldwide, they had more or less cornered the market on supplying the stuff scientists use to grow bacteria in their little petri dishes. Ever have to do an experiment in biology class where you grew mold in a little dish full of agar? Well, the medium probably came from Difco Laboratories.

Not that I knew any of that when I married him—which was exactly how he wanted it. On this subject, he was a rigid, paternalistic dinosaur, who felt that women and business do not mix. Had he been Rhett Butler, he might have said, "Don't trouble your pretty little head about this, Miss Patricia."

Instead he gave me one sentence to tell people when they asked what he did. "My husband is president of Difco Laboratories and he makes laboratory reagents," I would say. I also knew that he was quite well off, though I had no idea how extremely rich he was. If he was close-mouthed about his profession, he was far more so about money. He had no intention of discussing finances with any woman, even his own wife.

Matter of fact, I never found out how much we had until after he died. What he used to do every year is fill out our income taxes, fold it over so that I could not see the totals, and give it to me to sign. Later, when I became a feminist, I started refusing to sign it. "I won't sign anything that I haven't read," I'd say.

"That's fine," he said—and went ahead and signed my name on the forms.

Now what I ought to point out is that Harry was not a monster. He was merely a man of his generation, a Victorian gentleman who was acting as he had been brought up to act, as he had observed the men in his family treating their women.

Harry was in many ways, very sweet to me. To my surprise and delight, he was very tender, caring, and enthusiastic in bed. He was overjoyed when, two years after we were got married, I gave birth to a son, Harry Jr., who we call Barry, and he was ecstatic when our daughters came along—Terrill in 1952 and Hillary in 1954. He was utterly devoted to the children, including Bill, and they loved him very much too.

And he really loved *me*—but in what you might actually call a

toxic way, putting it in terms that a chemist like Harry should have understood. What he gave me was what you might call "smother love" in that he slowly dominated me more and more, taking away my independence and with it, my self-esteem.

"Patricia, you're just not doing these accounts correctly. I'll take care of them," he might say. "And I don't like the way you are writing these checks—I'll do that." Another time it was, "Patricia, you aren't giving the right directions to the help," and he'd take over yet another little corner of my world.

Gradually, my spirit sank down to almost nothing. I hated myself, I hated my life, and everything in the world seemed to be poisoned. Self-esteem is often a fragile, fragile thing, and mine was fairly vulnerable.

Harry was ten years older than me, and I think that, as with my first husband, I was, at least in part, marrying a father figure. The more he assaulted my sense of self-respect, the weaker I became, and the more I believed that maybe he was right.

Maybe I *didn't* have a brain in my head, and maybe, apart from the physical beauty everyone commented on, I really *wasn't* worth very much.

I wrote Harry these pathetic little letters, which were sometimes quite funny in a very bittersweet way, about how perfect I wished I were. There was even one that talked about how truly perfect Harry's next wife would be, how she would rise before dawn every morning and run and get his breakfast for him, etc. and etc.

On the surface it was clever satire. But it was really filled with blood and bile and furiously pulsating with anger… none of which reached him.

He was totally blind to what was happening within me. What has to be said, by the way, is that Harry was *not* being consciously cruel.

What you have to realize was that Harry thought he was being a wonderful husband, and that society was entirely on his side. I had even gone to a psychiatrist, and do you know what he said? *He told me that I should stop thinking about my individuality.* This shrink (who I hope winds up in some Freudian hell) told me that I must be a "good woman"; that I must forget my aspirations to be an artist. He said that I should stop thinking about expressing myself; that I should devote myself, heart and soul to my husband and children.

This brilliant doctor said, in so many words, that I didn't matter as a person.

Naturally, that helped me go right down the drain. Another woman might have turned to the bottle or followed Sylvia Plath and put her head in the oven. Did Harry notice as I sunk deeper into despair? Did Gerald Ford or Michael Dukakis notice when their wives developed drinking problems?

Well, Harry didn't notice. He thought all wives complained, and paid little attention.

Until the day, twenty years after we were married... *when I filed for divorce.*

Patricia Comes Up For Air

Harry was totally, completely, shocked.

He thought everything was perfect, that I was Rebecca and our house was Sunnybrook Farm.

Why had I done this?

What I wish I could tell you was that the pre-feminist in my soul had suddenly burst forth, reasserting herself, maybe singing "I Am Woman," a la Helen Reddy.

The truth is far more humbling. I had just been so completely emotionally devastated that at this point, I really thought I'd rather die than keep on being married. Not that I was interested in somebody else, or that I wanted to go off with another man. Not on your life. I never wanted to see another man as long as I lived.

Now this was scary. You might think, "Well, so what? She was thinking about divorcing him, getting a huge settlement, and then living life the way she wanted to."

Not at all. What I knew was that if I did divorce him, Harry would do everything in his considerable power to see to it that I got as close to nothing as possible. Though I was beginning to experience some success as a portrait painter, it was not enough to live on. I had four children and no ready way to make a living.

But I was at rock-bottom.

What did Harry do next?

The one thing I might have been least likely to predict:

He fell in love with me more than ever, and fought to win me back.

That's not, however, what saved my marriage to him. No, m

marriage to Harry Burnett Jr., this conservative, set-in-his-ways dear old dinosaur who went to his grave thinking Richard Nixon got a raw deal, was saved by something else.

Not our children, not his money, and not even my feminine wiles.

Our marriage was saved by my joining a coalition that included a lot of women very much like me, but also more than a few so-called "radical" feminists, plus lesbians, more than one communist, some ladies of the evening, and maybe a "bra-burner" or two. They called themselves the Women's Movement, and from the start I loved them all. Still do, to this day—though I think that a few of them are a little crazy and a few of them think I am something from another planet.

These women really did save my marriage, too, though I strongly doubt that Gloria Steinem and my dear friend, Betty Friedan, ever realized it.

Which goes to prove once again that life is stranger than even science fiction.

5

NOW Was My Time

When she stopped conforming to the conventional picture of femininity, she finally began to enjoy being a woman.

—Betty Friedan

Woman is woman's natural ally.

—Euripides

*R*emember I told you that Marj Levin and I were driving off to a funeral of the father of a mutual friend one afternoon, comparing notes on how the various men in our lives had done us wrong in various ways, big and small?

That turned out to be the most significant single conversation of my life. It led to the founding of the National Organization for Women in Michigan and later, my working to build an international feminist network.

Most of all, it led to my happily marrying what was then called "the women's lib movement" for what will certainly be the rest of my life.

Not that I was completely "reborn" one afternoon in late 1969.

That may have been when I first *called* myself a feminist. But that day was a long time coming—and it had been building almost as long as I had been alive.

You might trace whispers of feminism back to the fourteen-year-old girl who painted a neighbor in her kitchen and found she liked earning her own money, or the young wife who refused to stay married to a man who showed her no respect whatsoever.

I now know that I always had wanted to be treated as an equal—and usually, in battles with convention or society or my husband, Harry, I had lost.

But several years before, I had won what I now realize was a very significant victory in a battle to be treated with respect by my male peers. You might call it...

The Battle of the Bathroom Door

Painting has been the one constant in my life. Painting is my career—more than that: it is my *calling.* Had Harry Burnett's family not owned Difco, I imagine that he would have gone into some other kind of business. But if I had been born dirt poor, I probably would have gone out and painted pictures on the sidewalk.

I have kept painting throughout everything that has ever happened to me—marriages and movements; weddings and funerals. When things were really bad, painting often kept me going; when I am happy, I am happiest when I am painting.

What I am, more than anything else, is an artist.

However, I quickly learned that to most people, the definition of a "real" artist is someone who has a studio. When I had my studio in my kitchen, I found that people really didn't respect me as a professional. That was as hard on my wallet as my self-esteem; if they don't see you as a pro, you won't be able to charge like one.

Back in the fifties, beatniks went to Greenwich Village and some of those seeking kicks headed for Route 66—but if you were a male artist in Detroit, you wanted one of the six studios at the Scarab Club, a quaint brick building near the Detroit Institute of Arts. Naturally, no mere woman had ever been among the chosen.

The eternally cash-poor Scarabs decided at long last to take in women members—but never, of course to allow them to have a studio of their own. In any event, when I first considered membership, every last studio space was taken.

So, for a very long time, I slyly waited.

Finally, a distinguished artist, John Coppin, retired in 1962, and an open studio on the third floor became available. They had to give it to me. I met all the qualifications, and I could pay my way... but this meant for the first time ever, five male artists would have to contend with the sheer horror of a woman painter working among them.

Ah, but these were *artists,* you say. Enlightened devotees of the new, the avant-garde, the beautiful and true. They must have welcomed you with open arms!

Ha! Dream on! Welcome to reality. They *hated* my being there. The Scarab Club had previously been an all-male preserve. You might sum up their attitude as "we may have to take you in, but we don't have to make you feel comfortable."

Naturally, I took responsibility for making my *studio* comfortable, which I did by decorating it in a style I called "Mafia Baroque." The Scarab is sort of a cross between one of those old-timey men's clubs and a bohemian pad.

Being ahead of my time, as usual, I decided to make my studio into what the hippies would, a few years later, call a "happening".

Both the romantic and the businesswoman in me thought it should fulfill a lot of the fantasies people have about an artist's studio. I am primarily a portrait painter, remember, and for most of my subjects (we call them "sitters") posing for a painting was a once-in-a-lifetime experience, and I did my best to give them the full treatment.

Actually it was a marvelous place, with oriental rugs, eight-foot windows facing north—perfect for lighting the face of a subject—a twenty-foot high ceiling, and its own balcony. I had a bed up in the balcony where, after Harry died, I actually used to spend the night sometimes, when I decided to paint far into the night.

There were Louis XV chairs, rich brocades, polished gold mirrors, and a brass candelabra. For effect, I also had a big red velvet couch, over which I threw a white polar bear rug, for a *soupçon* of kitschy poor taste. The general effect was that Rhett Butler and Belle Watling might have just left for a stroll. I had many of my favorite paintings on the walls or on the floor in various stages of completion, and strategically placed assortments of brushes, pallets, and easels.

By the way, one rule every artist really ought to follow is never to have a phone in your studio... so of course I did.

What I didn't have, however, was a ladies' room.

The Scarab Club had been built in the pioneer days of plumbing, and there was one—count 'em, one—restroom for the entire floor. A unisex toilet, you might say, even though that word hadn't yet been coined.

That wasn't so bad, but it turned out that the Scarabs also maintained an open door policy. Modesty led me to ask about, ah,

the possibility of, well, you know... some sort of security device, what you might call, a *lock* for the door?

Forget it, sister.

Frostily, I was told that the hallowed Scarab Club Third Floor Comfort Chamber had *never* been locked, that there was in fact no lock, that this was a tradition, and that this tradition would continue, madam.

Okay.

Well, I hadn't been elected Miss Congeniality for nothing. I set out to win them over. I was just as charming as could be. I set up a full bar in my studio, brought in delectable refreshments, invited everyone who walked by to come have a drink, and at the same time took pains to show them that I was in fact a serious artist.

Meanwhile, I coped with the lavatory crisis as best I could. Sometimes I sang to announce my presence and ward off intruders. Other times, I performed world-class gymnastic feats, balancing myself in such a way that I could do what I had to while keeping one foot braced against the door to insure privacy.

(Try this sometime in high heels.)

Then, one day, I went into the washroom to find, on the other side of the door—

A tiny gold lock.

When I came out, several heads were leaning out of studio doors all along the hallway. Heads of my fellow male artists. I smiled. They smiled back.

Nothing was said. Nothing needed to be. The lock said it all.

Looking back on it today, though, I realize that I was still rather innocent about the war between the sexes. I had won a skirmish— but essentially by using the traditional weapon of charm. What the men had done was not really to decide to accept women artists as equals; they had merely decided to make an exception in my case.

Now you could certainly say my victory was significant regardless, and over time, my presence would help them accept other women—which was very true.

Yet I was still very naive about the difficulties ahead. What would I have said, I wonder, if a reporter had asked me what it all meant on the day I won the battle of the bathroom door?

I suppose I would have said that if a woman kept her cool, was

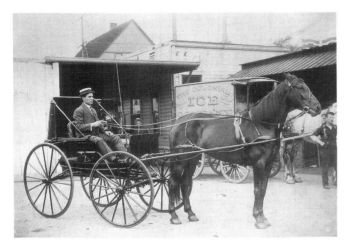

Grandfather Migiel Uline
and his horse and buggy.

Mother, Myrtle Uline Hill,
and me taken when I was
three years old.

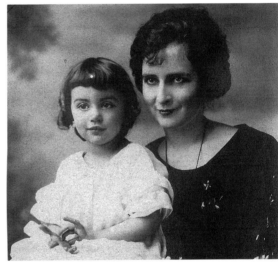

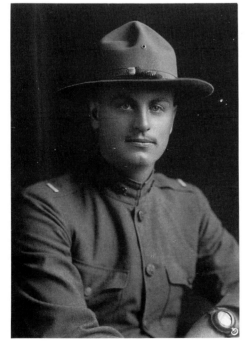

My father, William Burr
Hill Jr., looking very
dashing in his World War I
uniform.

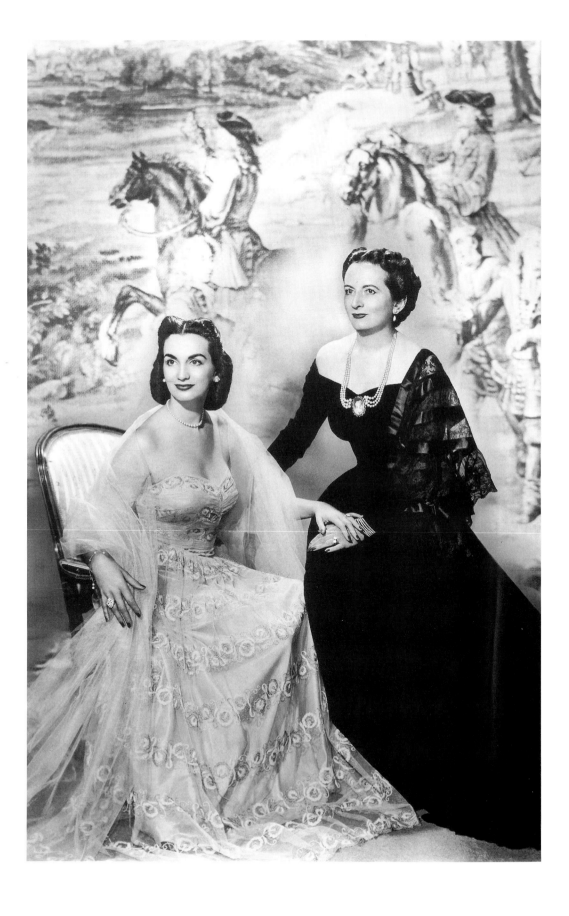

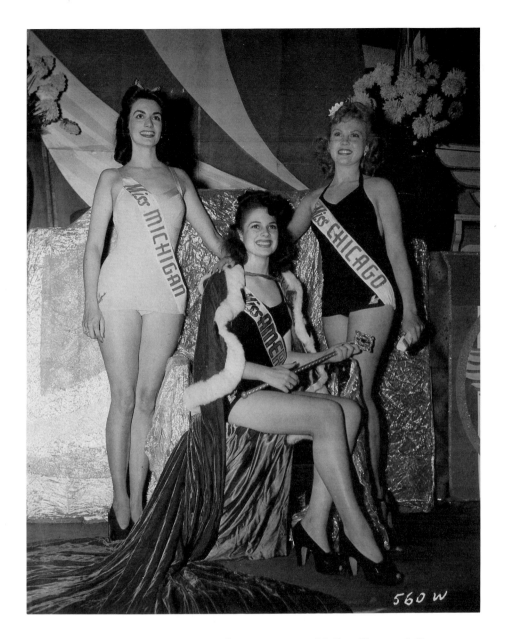

Atlantic City 1942, I was second runner-up and Miss Congeniality.
Jo Carroll Denison in the middle, Miss Chicago at right.

opposite page
Mother and me around 1948. I can never look at this picture without
thinking about the horse's brushed-out rear end.

Latest RADIO Hit V SONGS Popular

LEGALLY AUTHORIZED

VOL. 2 - No. 6.
(12 cents in Canada)

10¢

THERE'S AN F-D-R IN FREEDOM ✦ **PLEASE THINK OF ME**

BABBLE-EE BABBLE-O

I WAKE UP DREAMING

WEEP NO MORE
MY LADY

Music and Words—

*AU REVOIR,
SOLDIER BOY*

1943 Radio Hit Song

MY DREAM OF
TOMORROW

THREE DREAMS

THERE ARE SUCH THINGS

IT STARTED ALL
OVER AGAIN

THANKS FOR THE DREAM

STICK TO YOUR KNITTIN,'
KITTEN

CAN'T GET STUFF
IN YOUR CUFF

YOU'RE SUCH
A PERFECT
CREATURE

EV'RY BODY
EV'RY PAYDAY

BOMB BERLIN

ALL FOR ONE

WHY DON'T YOU
FALL IN LOVE
WITH ME?

ROSE ANNE OF
CHARING CROSS

MOVE IT OVER

THERE'S A STAR
SPANGLED BANNER
WAVING SOMEWHERE

LANA TURNER
BLUES

I'D DO IT AGAIN

VICTORY MARCH

PATTY HILL, STAR OF THE BLUE

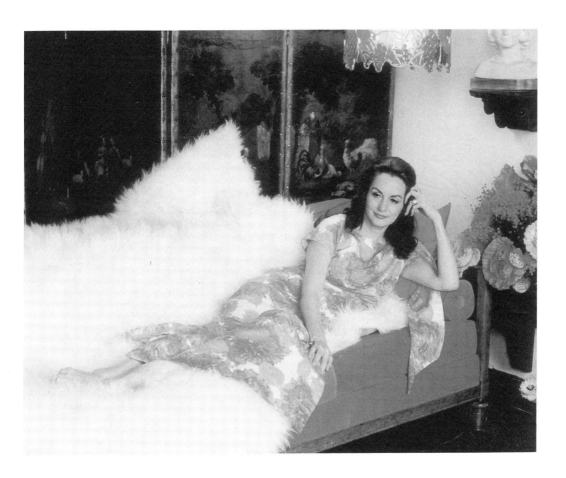

My studio at the Scarab Club in Detroit around 1965.
I liked to call the decorating style "Mafia Baroque."

opposite page
Radio Days 1943
This was taken when I was the female lead for "The Lone Ranger"
and "The Green Hornet."

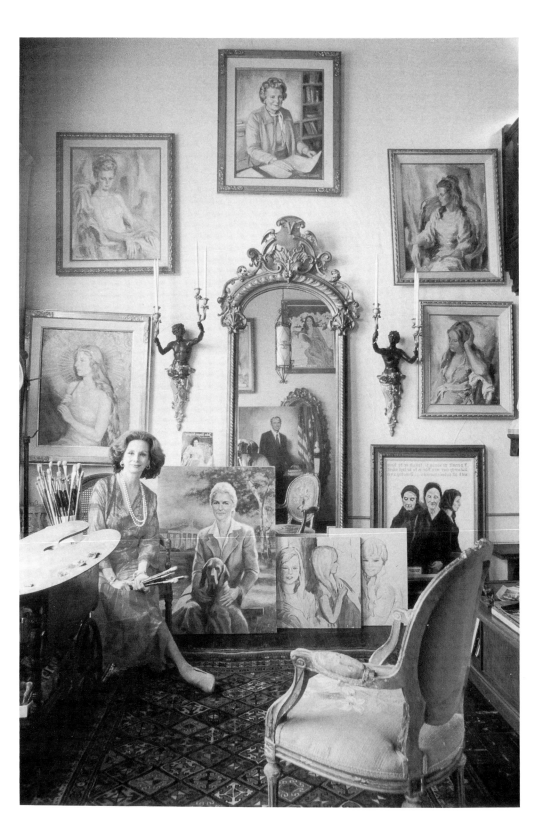

Vacationing at Eaton's ranch on Wolf, Wyoming in 1959.
from left to right
Barry, Bill, Hillary, me and Terrill.

At my 1989 wedding to Bob.
from left to right
Bill, Hillary, me, Terrill and Barry.

opposite page
My studio at the Scarab Club. I am sitting next to a portrait of Sissy Farenthold and her famous dog. This photograph was taken for a story about me in the *Detroit Free Press*. It hung in their lobby for a number of years.

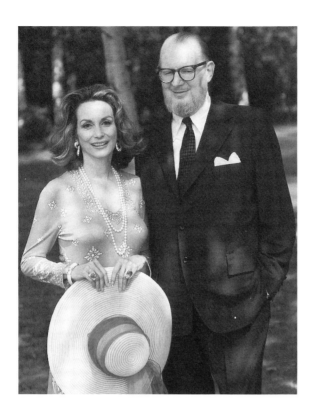

Harry Burnett and me around 1969, at our home on the Detroit Golf Club course.

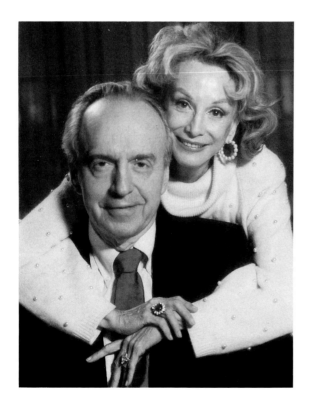

Bob Siler and me on our honeymoon in Brazil 1989.

radiant, relentlessly nice and tried a little harder than anyone else, she could do anything.

Would that it were that simple.

Barbara Walters; Superwoman; and the Way It Really Is

One day a few years later, I came home from a rough day of painting totally exhausted; clothes a mess; makeup all off. Harry was irritable and wanted dinner at once.

Two of my children were involved in some crisis that I had to solve. The Himalayan cat was sneezing and the dachshund had to go to the vet. Later that night, I picked up a magazine with a cover story on Barbara Walters, Superwoman of the Seventies, who had just signed a million-dollar contract with ABC-TV.

How does she do it? Poor Patricia turned the pages and wondered.

Lord, did I feel inferior as buoyant Barbara bubbled how easy it all is. I don't remember her exact words, but they went something like this:

"Job's great, I have no problem working a zillion hours; my marriage is perfect, and raising my daughter is absolutely no problem."

I could hear her distinctive New York accent with that slight lisp. My heart sank. I looked around; stared into the mirror.

"What am I doing *wrong*?" I inwardly wailed.

Six months later, the answer came with a blinding flash when I read that Barbara Walters and her husband had split! The world's most perfect career woman had not been able to save the world's most perfect marriage.

I felt as if *I* had been *had*... and I had!

What I really needed six months before was for Barbara Walters to tell me the truth—that it was *not* easy. I needed her to tell me that juggling a life, family, marriage and career is a very, very hard thing for any woman to do. (Many years later, when I did her portrait, I thought about bringing this up with Barbara... but never did.)

Long before I even dreamed of a "woman's movement," I had already figured out that this is a distinctly and directly unfair world. For centuries, women in the workforce have had to work twice as hard to get half as far. They have been forced to deny and suppress large portions of their true selves—and if they succeed at this, they have the pleasure of being sneered at for "not being feminine enough."

Barbara Walters, bless her, faced greater odds than most women, and succeeded brilliantly in a field where it is supremely hard to be a woman past forty. As I write these lines, she is still going strong and posting good ratings at sixty-six years young. I adore her, but she could have painted a more accurate picture.

All too often, women who do make it to the top happily mimic the Great White Male in whose footsteps they have followed—and who wanted more than anything to keep women down.

We convince ourselves that we are "special"—and many of us work hardest of all at covering up any weakness or sign of vulnerability—until at last we believe it, and "just like the boys" we too eat ourselves up with stress and give ourselves ulcers, all in the name of being "strong."

I honestly don't know if women can teach men anything, but I do know that we damn well better teach ourselves something first: In reaching for the top, you really have to reach for *yourself* too.

Doing it your way, on your terms, is more important than becoming president of your company—even if you're the type of hard-charging, Type A personality woman who has to be first.

Because if you don't do it *your* way, the success won't be yours.

Now Let Us Praise Angry Women

What my friends have always found hard to believe is how much anger I was carrying around with me. Trouble is, I am nearly always smiling. Once, when Gene Boyer, a close friend and a wonderful feminist, was interviewing me she burst out that she didn't understand "how even when you talk about the most painful things in your life, you continue to smile. I've known you many years, and I've never see you cry."

That wasn't the first time I had heard that. Years before, a baffled and exasperated doctor said much the same thing—he had just diagnosed me with cancer, but failed to deprive me of my smile.

That was, again, my upbringing in the matriarchal universe of my mother, in which I was taught that, as befits a future geisha, I should always sparkle. Getting angry wasn't ladylike. Getting angry wasn't refined.

Yet after Gene Boyer's comment, I suddenly realized how angry

I was—and began to ask the most important question any woman can ever ask:

Why?

Why was I told that I should live my life for my husband and my children? Why, if we both worked all day, was I the one who was supposed to run the house, take total charge of bringing up the children and keep all our lives on track?

Why was it expected that a woman's husband would treat her like a child? (One day, Gloria Steinem would tell me, "The first problem for all of us, men and women, is not to learn, but to unlearn.")

What I had to learn was that I was *angry...* and that it was okay to be angry.

Women have always been taught not to get angry (it isn't lady-like, dear), something that sounds to me like a diabolically male idea. After all, I'm sure that if I were a man, and I realized what my sex had been doing to women for the last few thousand years, I sure wouldn't want them to catch on and get mad!

But the idea is ridiculous. No, you shouldn't pitch a raging fit in the middle of a social gathering, not under normal circum-stances, anyway. But there is absolutely nothing wrong with right-eous anger—as long as you use it effectively, and channel and control it for constructive ends.

Or as Patricia says... do get mad...but then get even!

When I figured out at last that I was angry, I next got mad at myself for *not* having being angry for so many years. What a silly little Stepford wife I had been!

Well, no more, honey. That was the moment when, sitting there in the car next to Marj Levin, on the way to that funeral in 1969, I burst out "What do you say we form a chapter? Let's form a NOW chapter here!"

So I called Betty Friedan and when she said, "I now confer on you the power to be the convener of the entire state of Michigan," I just melted. Betty Friedan can be difficult, as I would soon learn, but that moment she entered my heart, and she has never left it since.

So I, Patricia Hill Burnett, became president of the Michigan chapter of the National Organization for Women, and I was deter-mined to run with the ball, even if I didn't know exactly how or

where. The first thing I decided to do was organize women for action. Perhaps, you may have an image of NOW as cadres of strident, middle-to-working class women and college types with a large attached corps of militant leftists.

Nothing was further from my nicely scrubbed little mind the day I joined the movement. Indeed, I wasn't even aware that "women's lib" was meant to be a grass-roots movement for the oppressed of the earth. I thought it was aimed at upper-middle class housewives and professionals like me. Those were, after all, the people who I knew and whose problems and pain I truly understood.

That's not as silly as it sounds, by the way. Many a revolution has proceeded from the top down. So what we did next was pick the forty smartest women we knew who were in the best and most influential positions we knew about—the power elite.

Marj knew who everybody in town was—she later became the *Detroit Free Press* society editor—and we invited every woman judge, every top female lawyer, doctor, college dean, and influential corporate executive in the metro area.

We invited anybody and everybody who had influence, whether we knew them or not, to a huge organizational brunch at the Scarab Club, on January 8, 1970.

Believe it or not—every one of them came, and every last one joined!

Some of these women were Democrats; some Republicans; some fat, some slim, some beautiful and others not so...

But what they all mostly had in common was world experience. They had been out there in the marketplace, and they knew they were being used and abused by male supremacy. Every one of them had achieved far more than the norm for women of their day; this was, remember, just the very beginning of the 1970s.

And they had all achieved at the cost of great pain.

They knew everything that I was talking about when I told them how I had decided to join NOW. Most of them knew it before I said it.

"What we are is a movement that will liberalize the second-class citizen of the United States—the woman," I told them. "Since the 1950s, women have been going backwards, locked into homes and forced out of careers."

Now, don't get the idea that I walked draped in a red flag, or

even in an Oleg Cassini-designed camouflage outfit. Not at all. Actually, as far as my new life as a liberated woman went, I had barely sprouted above ground.

Here's what I told a newspaper reporter the day of our first meeting:

"We're definitely not a militant group. If you want to picket or burn your bra, you'd better join a more radical women's organization. We love men and by gaining equal rights within the existing structure, we think we'll make men happier."

Those words make me blush today. The ink that printed them was barely dry before I realized that we would indeed have to picket, and march, and sit-in, and get in the face of many an obnoxious old male chauvinist.

Matter of fact, I've had a good bit of fun doing just that! But behind my naive words of so long ago, there are some elements of truth that remain with me today.

I do still love men—a few men—though there have been days, I confess, when I have had to work at it.

I still have never burned a bra and I do have to confess I have a hard time relating to some of the wilder and more radical elements that have evolved out of the women's movement. Sometimes, when I look back at some of them from my "elder stateswoman's" perspective, I am reminded of something Lillian Carter once said, "Some days when I look at my children, I think I should have stayed a virgin."

But that's getting ahead of my story. We had this brunch, where we agreed on some modest goals: to recruit at least a thousand members across the state, who would then work for the repeal of Michigan's abortion laws (this was three years before *Roe vs. Wade,* remember) and to establish day care centers for those mothers who wanted to put their talents to work... or needed to work to support their children.

Today, that sounds about as radical as establishing gas stations for those who choose to drive cars. But in 1970, the notion of mothers leaving their children to go to the office—well, many men saw that as a scary radical notion indeed (conveniently ignoring that poor mothers have always had to work, like it or not).

By the way, nearly all of us came in suits or tailored dresses. That was my idea; I feared that even a pantsuit might hint that we were among the bra-burners. I also decided that like any other orga-

nization, we should collect dues… which somehow got fixed at the munificent sum of three dollars. We passed the feathered hat, and I had $120.

"All right," I said. "I'm going to go to New York and personally present the money to Betty." Yes, I know, I know—even in 1970, the trip cost more than that. But I wanted to do it, partly for the symbolism of the Michigan chapter using its first dues to affirm solidarity with the national group—and maybe even more because I sort of idolized Betty as my feminist guru and thought I should push myself to meet her.

So I flew in, took a cab, and knocked on the door of her townhouse. Back then Betty was always surrounded by what I called her "groupies"—women who adored her and were always around her.

One of these answered the door and looked at me. I watched her lower jaw slam into the stoop. So how was I to know that your average feminist didn't show up at NOW meetings in a chinchilla hat and muff?

When she recovered, she shouted upstairs:

"Betty, you have no idea what we have down here!"

"What is it?" Betty bellowed, annoyed. She was just setting up for a major TV news conference with a huge black woman named Beulah Sanders, leader of a welfare rights organization, and a nineteen-year-old from a socialist group called the Red Stockings, who was there in a ragged T-shirt and jeans, nursing her baby.

"There's this woman in a chinchilla hat down here who says she is a lifelong Republican and claims to be a chapter president of NOW," Betty's vigilant doorkeeper shouted back. To her amazement, Betty was overjoyed.

"Oh, my God—do I ever need her!" she said, running down the stairs.

She never said a word—just grabbed me by the wrist and dragged me upstairs, where her living room was filled with bright lights, TV cameras, reporters, photographers, and general pandemonium.

"This is perfect," she finally said to me. "This is great! You're exactly the other end of the spectrum. You're going to fill this group out perfectly."

"But what should I say?" I gasped.

"Don't worry," Betty said gruffly. "Just answer the questions."

Needless to say, I was nervous. I needn't have been. The minute the cameras started rolling, the Red Stocking woman picked up her

T-shirt, defiantly exposing her bare breast, and put her baby up for a snack, which drew everyone's attention.

The very first question was, *"Do you think you are sisters under the skin with these other women, with the people you are sitting with?"*

What happened next was something I will never forget: Each one of us gave the same answer. To that question, and the next, and the one after that. We hadn't been coached; we had never met, and we had no idea what the others would say.

But we were, indeed, sisters under the skin. That press conference proved for all time that whatever our outward appearance, our universal problem was the laws and customs and myths of the world that were all working against women.

Memory can play tricks on you, but I seem to remember saying that women suffered around the world because the world is run by and for men—mainly, white men. We were saying that women had no chance to truly raise themselves up, to get equal wages and equal recognition and equal education unless we banded together to fight—now.

Suddenly, I knew this wasn't just a cause for society's elite anymore. For decades, I realized, the women's movement, what there was of it, had been patting itself on the back, congratulating itself, because women had won the right to vote in 1920. But both women's suffrage and I were each almost a half-century old when I went up to Betty Friedan's in 1970. I wasn't getting any younger—and it didn't seem that the precious vote had done very much for us, either. Women's rights had been driving off that fuel far too long, and we were running on empty.

Betty knew all this long before almost anyone else did, and the moment that press conference ended, I was ready to follow her anywhere. She was brilliant, and though she could be difficult, cranky and even sometimes seem oblivious to everything and everyone around her, she was my master mentor.

As far as Patricia Hill Burnett was concerned, whatever Betty said, went.

By the way, did she know when she pulled me into that press conference that I was the starry-eyed woman who she had granted the right, sight unseen, to organize NOW in Michigan? To this day, I don't honestly know.

What I do know was that I hung around until they practically

dusted me out the door. Then, before I headed home, I asked my new muse for marching orders. Soon, the high command of NOW gave us our first mission: to break up a conference of Roman Catholic Bishops at the old Book Cadillac Hotel in downtown Detroit.

Eight of us determined Michigan irregulars enthusiastically took on this assignment. Most of us were sheltered housewives, and most of us weren't even Catholic, I have to admit. We were out-numbered and outflanked. We realized clandestine tactics were needed. We stealthily sewed squares of torn-up white sheets on our dresses, front and back. The squares blazed with slogans, such as:

The Catholic Church Is Unfair to Women!
Why Are There No Women Bishops?
Christ's Mother Was a Woman!

We then put our coats on over our propaganda outfits, and donned frivolous little hats and thoroughly respectable white gloves, before happily trotting into the hotel and right into one of the elevators with several of the bishops.

"What are you little ladies doing out alone (meaning, without those little tin gods called men) this late at night?" one of them con-descendingly said.

He figured it out when we crashed the conference, whipped off our coats, and provoked a smash story in the *New York Times*. Surprisingly, none of us were invited to the Vatican that year. While we failed to immediately change Rome, we came away with that glowing realization that a few angry women can make things happen.

Later, we were handed another mission: We were told to go to Washington to fight to blast the Equal Rights Amendment out of the committee where it had been bottled up by the old boy network who controlled Congress.

This was especially dear to my heart because the ERA had been sponsored by Michigan's very own Martha Griffiths, a superb con-gresswoman from Detroit for many years, whose portrait I painted twice, and whom I loved dearly. By the way, I went to see her in her office, introducing myself to her as the leader of NOW in Michigan—and then for some silly reason, adding that I was a lifelong Republican.

Martha couldn't have cared less.

Fortunately, she did care very much about the ERA—but being a practical politician, she understandably wanted some reassurance that she wasn't out there all alone.

"Look," Martha told me. "I would like some visible evidence that there are women who want this out of committee, who really care enough about it to *do* something.

"What can you and your Detroit chapter do?" she said, fixing me with a piercing gaze.

I thought a minute. "Well, we could stand on the steps of Congress and just stay there," I finally said. "We can carry ERA signs and make the congressmen aware of our presence and the issue as they go in and out of the Capitol."

Boy, was *I* about to get an education! How little I then knew about the powers that be... one of which was that revered and supposedly non-political Federal Bureau of Investigation, also known as the FBI, which I had always thought of as a band of heroes that went around catching bad guys like John Dillinger.

But to the FBI in 1970, we were the bad guys... er, gals. The bureau wasn't too happy about our movement to begin with and thought less of our protest. This was back in the days of J. Edgar Hoover, who, as a new book suggests, may have secretly worn a dress on occasion, but who was in no way a lover of women.

Michigan NOW arrived in Washington and announced that we were going to stay on the Capitol steps until the ERA was voted out of committee. And we stayed all day and night.

Much to the chagrin of the FBI! They immediately roped us off around one stairway, and locked the doors at the top of the stairs so no poor congressmen would have to pass by us. They wouldn't let anybody go in and out of the door where we were standing. It was a matter of national security, I suppose, to keep people from the unhealthy sight of women who actually had an idea on their minds.

After a bit, a long black car rolled up, and a number of men came out, set up tripods and spent about an hour photographing each and every one of us.

Okay, so I would have preferred a commissioned portrait. But I shouldn't complain too much, since this marked the beginning of my now-cherished FBI file! Much later, I found that I had earned not only a folder in the FBI chamber of secrets, but the infamous Michigan Red Squad assembled a forty-one-page portfolio on me.

What really hurt is that they never even asked for my resume.

But back to the Capitol steps. Well, if they thought they could intimidate us so easily, they were dead wrong. We huddled and decided that if the congressmen couldn't or wouldn't come to us, we would be the accommodating sweet little things that they so desperately wanted us to be... and we would go to them.

I drew the baddest apple of them all: Congressman Emanuel Cellar, a Democrat from my native Brooklyn who had kept the ERA tied up in the Judiciary committee for twenty years. Cellar was then in his eighties, and had served in the House longer than anyone else then in Congress.

He was first elected when I was two years old, and so far as any of us could tell, he hadn't learned anything about women since! Somehow I knew he wouldn't be breathlessly eager to see me, so I went to his office without calling first, wicked woman that I was, and asked to speak to him. Naturally, I was told he was busy.

So I marched right past his astonished secretary, through the door, and there he was, working at a desk at the far end of his huge office. Very quickly, before he could get up and flee, I walked over to him and sat down on the inside corner of his desk.

He was a smallish man, and now a scared one. I leaned over him, shook my finger under his nose, and said, as if he were a puppy that had peed on the rug:

"I don't like your stand on the Equal Rights Amendment. I don't like it one bit, and I want you to get it out of committee." I told him who and what I was, then added, "I'm backed by the entire organization of NOW, and we are going to mobilize the women of the United States to mount a campaign against you."

Was he ever shocked! The poor man was so overcome, so upset that he was sputtering. Eventually, he finally relented enough to allow himself to take part in a discussion of the subject. I am sure I didn't change his mind, but I imagine he came away with somewhat more respect for the women who opposed him.

Soon after that, a special discharge motion did in fact force the ERA out of committee and onto the floor of the House and then the Senate, which passed it easily and sent it on to the state legislatures for ratification.

That was a major, major victory for the women's movement—even though in the end, the ERA would fall, tragically, just short of the number of states it needed to become a permanent constitu-

tional amendment. Yet the ERA changed the terms of the whole debate and completely revitalized the movement... and I like to think that my pinning old Manny Cellar in his seat played just a tiny part in making that happen.

By the way, there is a delicious footnote to this story. Less than two years later, Cellar was challenged in the Democratic primary by a thirty-year-old woman attorney. "She doesn't exist as far as I am concerned," Cellar sneered. He didn't bother to campaign. Liz Holtzman campaigned hard. She was given no chance, especially, perhaps, because she focused on Cellar's opposition to the Equal Rights Amendment.

Then, on Election Day, Elizabeth Holtzman defeated the nation's longest-serving congressman by 610 votes! Brooklyn's women had heard her, all right. When I heard the amazing news, I felt wonderfully proud, possibly for the first time in my life, to have been born in Brooklyn.

Back on the Home Front

But I'm getting ahead of my story. That famous first press conference got me—and our embryonic NOW chapter—some notice in Detroit. Soon after I got home, we started hearing from women, mainly top-level women, who were interested in joining. We got great press too. The fact that Marj Levin, my partner in crime, was a prominent newspaper woman in town certainly didn't hurt.

Most of the women who joined in the early stages were economically comfortable. Since that afternoon at Betty Friedan's, I knew that NOW was not just for the upper crust. Part of the problem was that even our paltry three dollar monthly dues were too steep for the women who needed us most.

So we decided to have "rap sessions" which wouldn't cost a thing and to which anybody could come. Within in a very short time they did.

What went on at these sessions? Well, it was a kind of free therapy; everybody shared stories of their problems and exchanged ideas for dealing with them, and expressed their thoughts about the larger issues involving all women.

Free therapy is what it was. Looking back on it, I almost feel as if *I* should have had to pay. For I may have gotten more out of all this than did most of the women who told what were often very

grim and very graphic tales. I got to hear and see women who had suffered the most horrible physical tortures, not at the hands of the Nazis or the Communists... but from the fists and feet and knives of *their own husbands or lovers.*

I would use the above line again several years later as the foreword I would write to *Domestic Assault: A Report on Family Violence in Michigan,* a report the Michigan Women's Commission would publish in 1976. Today, I know all too well how horrifyingly common physical violence is against women. But I didn't in 1970.

Back then I was, in many ways, a fifty-year-old infant. My life was totally transformed by hearing those stories and seeing women with stab wounds or whose children had been starved. Many of the women were still, to some extent, in denial about what had happened to them and why.

For me, these rap sessions were the equivalent of several college educations. During these sessions, as painful as they were, I learned to relate to women on all levels—and they learned to relate to me, too, for I was very open with them about my problems. You might have thought they would have sneered at me: "Poor little rich suburban housewife. What does *she* know about real problems?"

Not at all. Rather, they were relieved to know that I had problems of my own. Sad to say, it may be easier to like somebody you can feel sorry for in some way!

What this did, among other things, oddly enough, was help save my marriage to Harry. Remember, I filed for divorce right around the time I helped found NOW. The reasons I filed had nothing to do with being in love or wanting anybody else. Rather, I felt I could endure anything rather than stay married to this man.

But during these rap sessions when I saw these horribly battered women, I realized that whatever Harry was, he was not vicious. Even though his bullying had been terrible for me emotionally, it was still *mental* bullying.

Damaging as mental bullying is, it isn't as graphic as being bashed around. When I compared the anguish of having been denied my personhood to what being beaten up looked like, I realized that I could deal with my pain.

Over the rap sessions in the days and weeks that followed, as I talked with these poor creatures who had suffered such tortures, I decided, okay, I'll stay married to Harry as long as he wants to stay in this marriage... IF

IF he can put up with my not only being deeply involved in this women's movement, but can deal with it being the first love of my life.

IF he wants to live with me that way, great. But if not—good-bye.

Summit talks followed. I let Harry know of my conditions...

And he fell in love with me, more than ever!

What I had done was exactly the right attitude to take with Harry Burnett. What I knew was that Harry was a bully. What I hadn't known is that all bullies secretly want somebody to stand up to them and say, "Damn it, this is enough!"

No one had ever done that to him. What I had done was to say, "This is my limit, and you are not going over it, any more." He loved me for it. Matter of fact, though the old fossil would never have admitted it, he felt rather proud that his old girl had stood up to him at last.

Not that he was transformed overnight. Far from it. In fact, I later had to file for divorce a second time—and once again, he had to prove to me that he had mended his ways. He never felt completely comfortable with the women's movement, nor was he ever what might be described as a "liberated man."

But I think the movement brought a new dimension into his life. Certainly, he didn't want to be completely left out. Harry started following me to NOW conferences and trying to figure out the cast of characters. (He never really did.)

What he did understand is that he could no longer mistreat me mentally—and that was the first major victory the women's movement scored in my own life.

Many, many battles were to follow.

Just Whose Women's Movement Is This, Anyway?

If particular care and attention is not paid to the ladies, we are determined to foment a rebellion.

–Abigail Adams

*L*ooking back on those early days in NOW, I am struck by how much of what we did then had to do with not just liberating women, but liberating their *anger* first.

We had to realize that it is *all right* to feel angry.

To feel angry when men belittled us, lasciviously touched us, put us down, denied us jobs or kept us serfs in our own homes.

We had been told just the opposite, most of us, all of our lives—and this, I am convinced, was at the root of much of my own pent-up frustration. Women, especially women of my generation and class, you may remember weren't *ever* supposed to get angry—and if we ever did, we certainly weren't supposed to let our anger show.

We were simmering volcanoes in skirts, hundreds of thousands of us, waiting to explode. Actually, it is a wonder that we didn't lead the world in ulcers. Then again, come to think of it... maybe we did! After all, can we really trust the same male doctors who for decades told us that PMS was all in our heads—or who ordered complete hysterectomies for thousands of women without really bothering to explain why?

The real mystery may be why more frustrated women didn't go on violent rampages, shoot up shopping malls or run over their husbands in their Cadillacs. (Could it be that *I* still have a little residual anger here?)

Anyway, that's what was going on at these rap sessions in the early seventies. Before long, we had begun to call it "consciousness-raising." This was all very unstructured at the beginning. We'd meet in a study or church basement somewhere, and some woman, any woman, would just start in talking about what happened to her.

She might say, voice trembling, "A man pinched me in an elevator today and I was so *angry*." Another woman might chime in sympathetically, "The same thing happened to me," and then tell what, if anything, she had done about it.

Then another would speak up, and another... and it was as if Pandora's box had been opened. We learned that nearly all of us had suffered the same things, the same indignities and petty humiliations.

But now, instead of suffering them in lonely silence, as whole generations of women had before, we were starting to share our real experiences with each other, and gain a real sense of sisterhood and solidarity.

Those sessions gave me memories I wouldn't trade for the world.

Incidentally, we were sort of reinventing or co-inventing the "book" on consciousness-raising back then; none of us quite realized until much later that it was happening all over the country. What is hard to imagine now is how relaxed and spontaneous and free-floating it all was at first.

This wasn't purely by accident: the women who started those first NOW chapters were sick of rules and bylaws and parliamentary procedure—all of which they saw as more trappings of masculine-dominated society. "We're just going to gather together," they'd say, these women who were tired of regimented lives.

However, we eventually needed to establish some rules, if only for self-preservation. Sometimes some of us would get too carried away. This had been a wonderful, wonderful explosion of rebellion, but it was one that could be carried too far. This was heady stuff, this self-expression, and you could get a little drunk on it.

Sometimes a woman might get so worked up—and her audience with her—that she could be pushed into spilling her emotions in a self-destructive, maybe even dangerous way. Sometimes other women could say something that might damage a vulnerable spirit. The whole point of our sessions was to establish an atmosphere

of complete acceptance and to foster love among women who had too often been denied just that.

So one of the first rules was: No Judging. No one should deny the legitimacy of another woman's feelings.

Nor was anyone allowed to tell her that she shouldn't feel that way. Nor should anyone push a sister into something she was not ready for. Women were never supposed to tell another woman, for example, "You should leave your husband!" no matter how dreadful her circumstances sounded.

Divorce is so drastic a decision for most women—involving economic as well as emotional survival—that we felt that anyone who makes that choice must do it entirely on her own. As the sessions went on, there indeed were more and more divorces among our group, partly because some of our women began to realize that they just had to do this to get away from abusive husbands.

Sadly, some of these women hoped that the group would be able to replace their former husbands in filling their emotional needs, and, of course, that couldn't happen. Supportive as we were during the rap sessions, it wasn't the same as being there twenty-four hours a day. There was a lot of loneliness, frustration and resentment.

At times, the pent-up feelings of anger that poured out sounded like man-hating. Once, Marj Levin and I went to one of these meetings and two women came up to us. "What's wrong with you two that you're not divorced?" they said.

They were almost mad at us for having stayed married!

Curiously, the torrents of pain that I was hearing from these women affected me in the opposite way. As time went by, I realized that while my problems were in many ways just as bad, it wasn't right to wholly blame Harry.

What I had been doing was lying down and being a doormat, and allowing him to walk all over me. As I mentioned earlier, once I said, "Whoa! I'm not allowing this any more," things began to change for the better.

Men may have their problems, but women need to take responsibility for their own lives. Making men the scapegoats for all our failings isn't going to get us very far.

Which brings me back to the real reason for founding NOW. The rap sessions were just a sideline, really, if a very satisfyingly purging one.

The real purpose of NOW as far as I was concerned, to invoke a Marxian concept, was not to describe society—but to change it. I wanted to change our sexist society, and wanted to find the best way to do that.

Now that I have shocked the right with Karl Marx, let me shock the left: I really don't think the women's movement was a spontaneous, grass-roots movement of the working classes, either. NOW was started by reasonably affluent, middle-class women who had the money and the time to begin to work at changing some of our laws and attitudes.

They felt they had a mission. To me, that mission was clear: feminism, pure and simple. To me, feminism means precisely this:

True Equality Between the Sexes

Simple as that. We have allowed our enemies and our sillier sisters to steal our word and twist its meaning, so that today you have young women who stand for everything I do and we did, but who recoil in horror if you use the term... *feminist.*

Since 1969, I have made a point of always calling myself a feminist. Back in the early 1970s, we probably would have thought that by the 1990s, young women would no more hesitate to call themselves feminists than they would hesitate to breathe.

Not so. Somehow, whether thanks to blunders on the part of our friends or shrewdness on the part of our foes, we have allowed feminism to become a four-letter word—or worse, abandoned it to the super-radical left. Nowadays, you even hear young women saying things like "I'm not a feminist—I like men." Or, "I'm not a feminist—I want to have children."

Have they been sold a bill of goods! What is harder to admit is that sometimes we women have been among our own worst enemies. Some women who have been strong enough and bright enough to claw their way *to*—or even partially *through*—the glass ceiling merely mimic their oppressors once they get there.

Sometimes they are convinced that they have made it because they, and they alone, are somehow "special"; after all, others, namely men, have told them so for so many years. Many of these "superachievers" are also deathly afraid of doing anything to make themselves vulnerable. You see it grimly etched in the worry lines of their faces:

Don't let anyone know your weaknesses. You have to be strong. You have to maintain the image of strength—the corporate image. That means you come to work even when you are feeling bad, or your daughter is sick, or you have some kind of personal crisis—and you don't ever *tell anyone, for that might be seen as weak.*

Wonderful. So does this mean, in other words, that in order to succeed as women we must become "men with breasts" who ape the worst qualities and mistakes that we see in the breastless ones who dominated and oppressed us?

Let me allow a man to speak on that subject, a Mr. Stewart King. This is from a letter he had published a few years ago in the *New York Times*:

"If I have learned anything, it is that the sort of man-defined role that women speak of assuming with reluctance is no pleasure for men either."

Do you realize how true that is?

Think about the men in your life: How many so-called high achievers have drifted away from their families because of total devotion to the world of work? How many have actually lost a wife to overwork... or more than one?

For women, it is nearly always worse. For us, there are always more land mines buried in our much steeper road to the top. Not many hard-driving, overachieving men stop on the way home from a fourteen-hour day for a week's worth of groceries, do they?

Try being a corporate mom... especially a single corporate mom.

See you in the diaper aisle.

Back in the 1950s, when you might well have run into *me* in the diaper aisle, a few scruffy poets in Greenwich Village started what became known as the Beat Generation. The beatniks had a slogan, "If you win the rat race, you're still a rat."

No one would ever call Patricia Hill Burnett a beatnik, but the goatee set had a point women would do well to think about. Here's what I have learned after three-quarters of a century, four children, three husbands, two fathers, and one bout with cancer:

To reach for yourself is as important as reaching for the top.

The beatniks thought the answer to oppression was to drop out of society. My answer comes more from Frank Sinatra than Jack

Kerouac—I want to do it all, but *my* way. I want to be president of my company and the best damn portrait artist in this part of the country, if not the entire United States of America.

But not if I can't do it my way.

That's my philosophy as far as the women's movement goes, too: Every woman should have a chance to have it all and have just as many opportunities as any man. But no one else should tell her what she should want.

Some feminists are going to want to dress in frills (like me) while others will prefer slacks or maybe jeans. Women should know that they can be a Republican feminist, or a Democratic feminist or, for that matter, a Communist feminist. You can be gay or straight; celibate or bisexual. As a matter of fact, you can be a male feminist.

You just have to love and believe in women—and support their right to choose for themselves how to live and what to do.

What some women have to learn is that there is no "politically correct" way to be a feminist—and any so-called feminists who try to impose a particular political or cultural straitjacket on others only hurt our cause.

The cause of women everywhere.

"What, sir, would the people of the earth be without women? They would be scarce, sir—almighty scarce."

—*Mark Twain*

One day, my rather conventional lifestyle would make me enemies and cause me problems among the women who I thought were my natural allies. The day would come when a majority on the NOW board would think I was hopelessly right-wing and out of touch at the same time all my husband Harry's friends thought I was a dangerous commie radical who was probably frying bras and sending the ashes to Moscow.

No one imagined any of this in those heady first days of NOW in Detroit. We were united, we were growing, and if some of the "rap sessions" could get a little emotionally rugged, there was nothing more exhilarating than when the Detroit Chapter of NOW, under

Field Marshal Patricia Hill Burnett, sailed forth to meet the enemy.

We were on a mission from God... and Her marching orders were clear.

Most of our battles started with skirmishes. One evening in 1975, Maryann Mahaffey, who is now president of Detroit City Council, was asked to speak to a downtown meeting at the high-class but terribly fusty Detroit Athletic Club.

Now the DAC had a nasty little rule: Women were not allowed to enter through the front door. Apparently they were afraid we'd contaminate the portals with X chromosomes, or something. Instead we had to go in via a side entrance, which club members pointedly told us was "much more attractive." What if a woman tried to enter the front door?

She would be immediately stopped and shooed away.

So when Maryann Mahaffey, no shrinking violet, came to speak, she strode right up to the front door. The maitre d' filled the entire portal. "Ladies don't come in this door," he boomed. "You have to go around to the side."

"Well, I am a Detroit city councilwoman and I am here to give a speech to a committee meeting," she replied.

Authority was adamant. "I don't care what you're here for, lady. You have to go around the other way. Women just don't go in the front door."

Maryann Mahaffey doesn't go in the servants' entrance, either. She turned around, got in her car, and drove back to her office—leaving the entire economic group, or whatever it was, cooling its heels and munching rubber chicken sans speaker.

Word traveled fast. By that time, I had moved on from becoming Detroit chapter president to being on NOW's national board. When I heard about Mahaffey's Snub, I called my friend Mary Jo Walsh, another strong woman who had then taken over my old role as Detroit NOW president.

Like me, Mary Jo was married to a man who belonged to the DAC. "We have to straighten this out, and you and I are members by association since our husbands belong to the club. So it is up to us to go talk to the manager."

"Fine!" Mary Jo said. "I'll meet you tomorrow at nine o'clock, and we'll go in together." That was that, I thought—until I got there the next morning.

There was a whole band of people out in front. There were tele-

vision trucks. There were reporters with their little notebooks, and there were thirty or so of my troops, NOW women, marching up and down with signs, singing:

"You better move on over—or we'll move on over you!"

When they got a glimpse of me, they got excited. "Oh! Here is our leader—here at last!" they shouted. "We're ready to go in with you!"

I walked up to the Forbidden Door and paused. Then it hit me:

Patricia, I thought to myself, *Your husband is going to have a complete, total nervous breakdown over this. It might well cost you your marriage.*

So I reflected a moment, and thought...

"What the Hell!"

And I went on in. Who was there to meet me? The manager? The brass? The chief of police? The Roman Catholic Cardinal? Henry Ford II?

No. Only the black maitre d'. Minority meeting minority, in other words—(gosh, these elderly white male chauvinists set these things up so well!)

"You women can't come in here," he said. Well, his line had worked before. "You have to get out of here. What are you doing here anyhow?"

As he spoke, the reporters took down every word. I noticed that we had been downgraded from "ladies" to "women," presumably because there was a great untidy mob of maybe forty of us. Meanwhile, my very own personal mob kept on singing.

We swept past the door warden and into the club's sacrosanct meeting rooms, chock-a-block with fine paintings and sculptures, rooms previously uncontaminated by any female presence, save for cleaning women, who, of course, didn't count.

We marched up the huge, wide stairway to the landing two stories above, still happily singing. Then, all of a sudden, I heard a shocked voice cry "Patricia Burnett!"

"What in the world are you doing here with these *women?"*

I looked up to see a group of wives of club members gathered at the second floor railing. The woman who had called my name was someone I knew socially very well—and she and several of the other women were so upset they were almost in tears.

The DAC did accept women members, by the way—as long as they were ministers and were willing to pay first-class dues and be treated as second-class citizens. I smiled, waved and kept right on singing. "*You better move on over—or we'll move on over you!*" Then we all paused on the marble staircase and sang Helen Reddy's "I Am Woman!"

Why were the girls in the balcony so mad? They didn't want to face what they already knew: that they were second-class citizens. We were not only forcing them to face it and making them feel at least a trifle uncomfortable about themselves, some of them may have feared we were endangering their own comparatively privileged status.

Well, too bad. We made headlines in both Detroit newspapers the next day:

WOMEN INVADE DAC!
DAC INVADED BY ANGRY WOMEN

Mary Jo Walsh, no fool she, next threatened to lodge a formal complaint of discrimination with the Michigan Liquor Control Commission.

Within a few days, the Detroit Athletic Club announced they would allow women to enter through the front door. Mostly it was all a misunderstanding, they claimed. "Why, we've been letting ladies in the front door all along if they insisted," the maitre d' said when the reporters came around.

Right.

Incidentally, lots of women think that all those types of battles were fought and won long ago. Think again. As recently as the 1980s, I went to the Colonnade Hotel in Boston and sat at the bar, trying to get a drink.

What I soon learned was that it was forbidden. The bartender wouldn't serve me. I went right to the manager: "Why can't I sit at the bar?"

"Oh, my dear, that would not be possible," he said. "You see, we have so many prostitutes that want to come and sit at the bar. Of course—*you're* not one," he said.

Gee, *thanks a lot,* I thought. I was then just past sixty.

"Why can't I buy you—-let's sit at the table, and let me buy you

a drink," he said. No way, says Patricia, "I want to go in and sit at that bar."

"Well, you can't. You just can't. It's a rule all over Boston."

Patricia marched out, finding that hard to believe. She did her homework. She came back and said, "Excuse me, but it seems to me that they recently passed a law saying that all places selling alcohol were to treat women and men equally."

"That didn't mean *our* bar," he said.

"I shall return," says Patricia. Okay—maybe not an original line—but while it took General Douglas MacArthur three years to live up to his promise, it took me only a day. Then I came back with 1) a lawyer 2) the Chief of Police 3) Boston's NOW president. The Colonnade management didn't even whimper—and believe it or not, that one incident got so much publicity that it liberated every bar from Newton to Roxbury. Throughout greater Boston, the word went forth that women had struck off another link from the chains restricting their freedom.

The Movement Rebels Against its Mother

That sort of stuff was not only important—it was also downright fun. At least some of the time. But even when our fights against old men's club chauvinists and sexist barkeeps seemed difficult, we were sustained by the knowledge that every woman in NOW—and a lot who weren't ready to join—were totally on our side.

Yet as the campaign wore on, cracks in our unity began to develop.

Why? First of all—you cannot possibly have any discussion about NOW without discussing the woman who, as I said, was and is my heroine, Betty Friedan.

Betty Friedan, you may remember, gave birth to the modern women's movement when she published her book *The Feminine Mystique* in 1963. Three years later, she held a press conference to announce the formation of NOW, a good three years before I, in chinchilla muff and picture hat, arrived on the scene.

To men like my husband Harry, Betty Friedan is their idea of the very perfect model of a radical feminist. They see her as strident, man-hating, radical, and either a lesbian, radical leftist, or both.

Nothing could be further from the truth.

Betty Friedan grew up having far more in common with me than

any of our friends would ever have recognized. We are only five months apart in age. She was also a very bright young woman whose mother pressured her to spend less time with books and more learning how to dress. Though she later would divorce, when she founded NOW she was married and had four children, just as I did.

She wrote *The Feminine Mystique* while juggling a husband, four kids and running a household—just as I juggled my painting around Harry and the children's needs. Had I read her book when it was first published, I might have cut a few years off the time I lost wandering in the wilderness. Deeply controversial when first published, *Mystique* told between two covers things I had taken fifty years to learn.

Betty documented with devastating accuracy how smart young women are pressured first to hide, then to abandon their intellectual abilities. She chronicled the sad news that the proportion of young women seeking careers had steadily declined every year since women got the vote in 1920, the year I was born.

She showed how young women had been maneuvered and tricked into believing that the housewife role was the highest goal to which they could aspire. Women who found that stifling life less than fulfilling were being told by the millions, as that crackpot psychiatrist told me, that this just proved something was wrong with *them.*

Nothing was ever quite the same after *The Feminine Mystique.* Three years later, a woman lawyer for the Equal Employment Opportunity Commission asked to speak with her. "Mrs. Friedan," she said earnestly. "You are the only one who can do it. You have to start a NAACP for women."

Betty did not want to do it herself. She was not—and is not—either well-organized herself or a natural organizer by nature. But eventually she realized the lawyer was all too right. It was her or no one, now or never.

And so Betty Friedan announced the formation of NOW in October 1966, with two press conferences, one in Washington and another from her apartment in the Dakota, the same building where John Lennon and Yoko Ono would later live.

Few reporters paid much attention at first, (they were then nearly all men) and most of those who did tune in managed to miss how radical NOW really *wasn't.*

NOW was never—especially not then—anti-male. A few weeks

before, Betty had written a statement of purpose for NOW, which she read aloud. "To take the actions needed to bring women into the mainstream of American society—now. Full equality for women, in fully equal partnership with men."

The precise wording of NOW's name was also significant: National Organization *for* Women. *For*, not *of*; by no means did Betty want to exclude men.

Nor does she personally hate men. Far from it. Matter of fact— she flirts a little, and the feminine side of her definitely comes out when she is around me. I have seen her be very charming, and almost coy. Incidentally, she's far prettier than you may think; while she does have a prominent nose, the camera does not do her justice.

But first and foremost, she was the women's movement to me. Imagine, then my surprise when I was named to NOW's national board in 1971 after my term as founding president of our Detroit chapter—and found Betty under attack. From the board of the very organization she had created!

Newer, more radical feminists had seized the upper hand in the media and within NOW itself by the time I arrived on the scene. Betty Friedan, the woman who had started it all, was out of favor and even under siege. Betty, who first identified the despair and discontent so many thwarted women shared—what she called "the problem that has no name"—was under attack by the women she had helped liberate.

The things that bothered them about Betty were exactly the things that made me love her. They knew she was, in a way, profoundly conservative. Her idea was to help women operate within the mainstream of American culture—not to tear that culture down. Now, was Betty always as diplomatic and nice and sweet as she could be?

Not on your life. Betty Friedan can be one of the world's most abrasive people. She screams! She yells! She barks orders! She's abusive... and that's on her *good* days. Sometimes I have gone to see her and she has acted like she barely knew I was there.

However, she generally was very warm to me. I have to tell you a hilarious story about her. Once, she came to Detroit and stayed at our house.

Harry came home, and walked in to find Betty sitting on the

couch. *"Who are you?"* she challenged him. *"What are you doing in here, anyway!"*

Poor Harry! "I – I live here," he stammered.

Talk about outspoken! One of her problems, I think, is that she is more than a little paranoid—not without good reason, as you will see. Sometimes this could be quite funny. I will never forget the time I went to see her in Southampton to paint her portrait. She was working on a book, as she so often is. I came down for breakfast one morning, and there she was, bristling.

"Patricia, someone has stolen the first three pages of my manuscript," she said, voice quivering with anger. I gasped. I couldn't believe it. Was she accusing *me?*

"Where is the manuscript right now?" I asked, trying to keep calm.

"Here, it's right here on the kitchen table," she said, "and the first three pages are missing."

Hiding my upset, I started questioning her about what she had done. "What did you do this morning when you got up? Did you write anything to anyone else?"

"Well, I left a note for my cleaning woman. Why?" Betty said.

"Where did you get the paper?" I asked.

"Oh my God," Betty said, and looked in the wastebasket. There were the three pages of her manuscript with her notes to her housekeeper scrawled on them.

Brilliant people aren't always completely balanced. But still, I think I understand Betty Friedan. There is a Haitian proverb about a barrel full of crabs. One crab tries to reach out for freedom—but is immediately and savagely attacked by the other crabs.

That's what happened to Betty.

Some—the traditional women crabs—tried to pull her back down. Other radical crabs were furious with her for not moving fast enough.

But she never stopped struggling. Betty was our number one visionary—and she had her eyes on the greater prize. What she feared most was that the more strident members of NOW would manage to turn off much of the mainstream public with their shock-value rhetoric. When Ti-Grace Atkinson announced that "marriage has the same effect as the institution of slavery," Betty went through the roof. Not because she was a romantic about marriage—her own had been, it is well known, physically abusive.

She feared, however, alienating many more happily married (more or less) women who were on the fence as far as women's organizations were concerned. She felt the same way when the radicals attempted to equate feminism with lesbianism. Betty didn't care—any more than I did—whether anyone was a lesbian or not. But she knew that the vast majority of the public was not ready to embrace lesbianism.

The vast majority of the new group who came to control NOW in the late 1970s were anti-marriage and anti-mainstream. Betty gradually lost virtually all influence with the NOW leadership. The problem was not only her ideology, but also her abrasive behavior.

"There just isn't a place for her in an ongoing organization like ours," Lucy Komisar, a NOW vice president who had worked with Betty, told the *New York Times*. After Betty's second term as NOW President ended, Betty had been given the title of "chairperson of the advisory committee."

What did that mean? "There *is* no advisory committee," the ever-sweet Ms. Komisar sneered. Betty Friedan was left with no power and shown scant respect.

When I came to board meetings in those years, I saw this with my own eyes. Betty would come and be totally ignored by those in power. Yet she kept coming.

Franklin D. Roosevelt supposedly said the definition of class was "grace under pressure." That sounds like Betty Friedan, one of the greatest women I have known.

You didn't have to be a scholar to figure out that if the NOW boards of the late 1970s didn't like Betty, they weren't exactly going to shower me with love and affection. They made it clear that I was a persistent alien presence among them, one that they had no idea what to do with.

(Good thing for me NOW didn't have its own space program!)

Board members were supposed to be involved in particular projects. So I went to see Betty. "All right, Betty—what direction?" I asked her. "What committee should I be most active on?

She knew exactly what to say.

"Well, you've traveled all your life, Patricia," Betty told me, "and the women of the United States never will be truly free until all the women of the world are truly free. So form an international committee and get them to let *you* head it up. Then go to these different countries and organize NOW chapters in these countries."

There was nothing in the world I wanted to do more.

How did the board respond? They were thrilled! They were so happy to have me out of their hair! Plus, they didn't really care very much about the international feminist movement. Internal NOW politics were what they cared about.

So that's how Patricia Hill Burnett became chairperson of the NOW international committee. Shortly after that, Harry asked me what I wanted for our fast-approaching 25th anniversary. What a dear, I thought.

I knew exactly what I wanted, too.

"Honey," I cooed. "I want a three-month trip around the world..." I said, and paused... "Alone."

Communists and
Other Curious Comrades

*If you don't like the way the world is—you change it. You have an <u>obligation</u> to
change it. You just do it one step at a time.*
 —Marion Wright Edelman

I asked, and Harry gave it to
me. A three-month trip around the world, by myself, for the pur-
pose of studying, and eventually organizing, the world's women.

Naturally, he wasn't crazy about the idea. Nor was he espe-
cially fond of what his pals called "women's lib." But not only did
he love me—he had, by this time, 1973, fallen even more *in* love
with me than ever.

So much of Harry Burnett was stuffy, repressed, and
Victorian. But there was a spirit of adventure and a strong sex-
ual drive submerged deep inside him. Otherwise, he would have
married some properly safe woman. Instead, he fell madly in love
with a beauty pageant winner who he glimpsed driving a con-
vertible down the street one day. He waited for her for years, and
finally married her, even after she was divorced and had a little
boy.

What saddens me now is the realization that Harry didn't seem
truly happy, or secure, even though he was very rich, built his fam-
ily firm into an enormously successful enterprise, had three won-
derful children and achieved virtually everything he wanted.

Despite our differences, I did love him, though I am not sure he loved himself.

But Harry, I have to confess, was not the main thing on my mind when I set out on my first trip around the world alone. I was on a mission from the goddess. Patricia was my name; liberating women was my game.

However, I am getting ahead of my story. As I have said, soon after I gave up the Michigan presidency of NOW and went on the national board, I got the board to allow me to form an international committee and make me chair of NOW International.

Frankly, I think that while most of the board members when I joined in 1971 were more leftist politically than I am, in many ways they were really also provincial. They didn't care very much about women outside the United States. Some of them seemed to have little interest in women other than those involved in NOW politics.

But what truly interests *me* is not any particular organization, but *women*—all women, everywhere, and ninety-five percent of my human sisters live outside the United States. To me, they especially needed help; most other nations were even more backward than America in the way they treated women. Still are, I'm sorry to say.

To me, it was always clear that reaching out to women *everywhere* was essential to the success of women *anywhere*. I was full of energy, and for once I knew exactly what I wanted to do and how to funnel it: What I wanted to do was to convene an International Feminist Conference sponsored by the National Organization for Women.

That was such an obviously wonderful idea, I was a little bit afraid that some hotshots on the board would take it away from me. I needn't have worried—they thought it was a gigantic yawn.

But they needed to get me out of their hair. I suspect most of them felt that I was just a silly little rich housewife from Detroit who couldn't organize anything bigger than an afternoon tea, and they may have figured that I would fall on my face if I tried. Besides, as I later learned, they didn't really care about the international status of women. Domestic politics, especially internal NOW politics, were their game.

So finally, very reluctantly, they told me in effect, "All right, all right, go ahead and organize this conference." Or, *run along, little girl,* in other words.

Lord, did I ever!

Where and how did I start? Remember, no one had ever had a world feminist conference before. Well, I got from somewhere a tattered little list of about thirty women who were supposed to be feminists from countries all around the world.

My list was certainly not up-to-date. I had no idea who were the right people to invite. But I got to work with my secretary, Sara Lee Pearl, still a good friend, and sent letters to all the women on the list. I asked them if they would be interested in coming to such a conference.

Nearly every one of those letters had a strange adventure of its own. For example: I sent the one to India to a poor woman feminist who no more could come to Massachusetts for a conference than she could fly. But she gave it to her boss, who gave it to her boss... and finally it came into the hands of Lakshmi Raghu Ramaiah, the wife of the man who was then prime minister of India. Now *she* could afford to come!

That sort of thing happened a lot; the people I had sent the invitations to often kicked them upstairs to women who could really afford to travel. Other women wrote in, suggesting more feminists who in turn suggested other feminists. The next thing I knew my tattered collection of names had become a powerful mailing list of 5,000 women across the world.

"Would you come to this conference if we put it on?" I asked them.

"Yes, yes, we'll give anything we've got to get there!" they wrote back, in English and French and Russian and Spanish and Japanese. Letters poured in.

Suddenly I realized that we might get a huge onslaught of women from everywhere, and it dawned on me: I needed a suitable place to hold this conference!

Well, I had an angel to turn to, the one who inspired me in the first place. Betty Friedan told me during that mesmerizing first meeting we had in 1970 that the women's movement would never be successful if it was focused on the United States alone. Women of the world had to unite for one common goal: liberation.

Women had to unite, to change the patriarchal, sexist society that has kept them down for thousands of years on this planet.

Otherwise, a puny political victory in one small country wouldn't do much good, or last very long.

I knew instantly she was right. Now, nearly four years later, I needed her help again. I turned to Betty and said "I don't know exactly where we should hold such a conference, and I don't have the power to get the location once we find it."

Betty did. She immediately called up Derek Bok, the president of Harvard University. "I want you to let us have this conference on your campus. You've got various colleges and plenty of possible space. How about maybe one dorm and the chapel to hold our formal sessions in?"

Naturally, he agreed, if for no other reason than his admiration for Betty. He made the facilities of Lesley College and Harvard Divinity School available to us from June 1-4, 1973. Now we not only had a place, but were essentially being sponsored by the most famous and prestigious school of higher learning in America.

No sooner did we start sending formal invitations out than replies came pouring back in. To this day, I have stacks of correspondence from many of those women, letters heartwarming to read, as are the proceedings of the conference itself: Such as Betty Friedan's remarks in her opening welcoming address.

"This is a momentous day in the massive unfinished revolution of women of the world toward full equality, human dignity, individual freedom and our own identity in the family of man. We who meet here today as women, across the lines of nationhood, political ideology, economic development, religious differences, are propelled by the unique circumstances that have forced women at this moment in history to move into their personhood, to demand their human equality."

Betty promised that we would be "the largest, most revolutionary force this world has ever seen."

How naive we were... how naive nearly all revolutionaries are.

Later, we were inspired by Elizabeth Duncan Koontz, a wonderful black woman who was a former president of the National Education Association.

"Who can judge what or where women are? Only the women in each country," I remember hearing her tell us. "Choices— that's what it's all about, the many faces of feminism. The right

to choose for yourself what kind of woman you want to be."

Yes, I shed tears of joy.

Not that every moment was intensely serious. John Lennon and Yoko Ono came too, listing their address as c/o the "Nutopian Embassy" in New York. Yoko not only started each day of the conference by singing to us (in her less than Metropolitan Opera quality voice) but she also wrote songs for us. We would wake up to find hundreds of mimeographed copies of her songs—enough copies for every woman present—laid out in the pews of the Harvard Church where we gathered each morning.

What about her husband, at the time perhaps the most famous singer on the planet? Ono refused to let Lennon sing a note—he was only allowed to play the guitar.

So there you are. More than anything else, the International Feminist Planning Conference was simply fun. At last, sisters from around the world had gotten together. But as for doing the organizing beforehand, I can say that getting there was anything but half the fun. Particularly when it came to dealing with our very own state department.

To make this a real, legitimate, and truly international affair, I decided I had to have women from every part of the globe, but most importantly, the Soviet Union.

Now you may remember that back then, ordinary people from the Soviet Union just didn't come to the United States. We were afraid they were spies. Moscow was afraid they would defect. *Nononono*, both sides said. But I don't take no for an answer.

So, I bugged them. (Oops, that means something else. I nagged them, let's say.) I called the Soviet embassy in Washington time after time. "Now are you sending me a group of women for this conference? It's very, very important."

The Soviets had no idea who or what I was. Finally they called the State Department. You can just imagine... "Excuse me? Ivan here. Please to tell us who is this little housewife from Detroit, Michigan, who is trying to get us to send a delegation to some international feminist conference in Cambridge. Is this some clever CIA trick? Comrade Brezhnev is not amused."

Neither was the U.S. Department of State. They called me up and yelled at me. They didn't want any free-lance diplomacy,

thank you. (They had quite enough trouble with Watergate, which was ruining the Nixon presidency at the time.)

What they finally did was order me to come to Washington for a three- or four-day briefing session on how to conduct myself properly in "international matters."

La de dah! I took the entire organizing staff of the Feminist International Conference with me to Washington, which is to say I went by myself. White men in pinstriped suits sat me down.

"There are certain things you must realize," one of them told me sternly. "For example, if you are asking women from Israel and women from Jerusalem to come to the same conference, you must never, but never, put them near each other. You must never bring up any controversial issue that will cause them to be in any kind of conflict with each other."

They were haughty to the point of being downright nasty. Unfortunately, as a rule, the more important they were, the nastier they were. This was during Richard Nixon's administration, remember, and paranoia was running wild—paranoia against blacks, hippies, and, naturally, feminists.

Patricia tried the logical approach: "Don't you realize that the reason they are coming is because of feminism, something that is above politics? Feminism has nothing to do with politics as you know it—it transcends it."

They got very, very mad.

"You listen to us or we're not going to let you put this on," one of them said.

I suppose they could have done a lot of mischief, but I wasn't quite that naive; I had a lot of practice coping with attitudes like that. I listened dutifully, smiled and nodded, demure Miss American Geisha all the way. Then I went back home and did exactly what I wanted to. I continued sending letters off to women across the world exactly as I had been doing.

Washington be damned, everything was a smashing success. Two hundred and seventy women eventually came to Cambridge from twenty-eight different countries. An Israeli came and a Palestinian Arab, two countries that still are the bitterest of enemies.

By far, the dramatic high point of the conference came when the Israeli and Palestinian women came to the altar in front of the delegates, meeting in the chapel, and embraced in a show of

solidarity for the peaceful goals of the world feminist movement. In that moment, we were transformed by our honest love for each other.

We know that it is men, after all, who make these wars.

Sorrowfully, less than four months later Israel would be again involved in a bloody, full-scale war with all the Arab nations, the one that broke out at Yom Kippur.

But the conference was a tremendous success—so much so that we made two major decisions: first, to have a much larger conference, second, to establish as many NOW chapters throughout the world as possible. We would do this, as I said at the time, "to achieve social, political, and economic equality for all women, everywhere."

We had no idea what we were in for. But for the present, everything seemed full speed ahead. We formed an international board at our first meeting there at Harvard, and elected a Norwegian woman, Berit As, as its chair. She took over the task of setting up an International Feminist Conference, which was to have been held in September 1975 in a country other than the United States.

Meanwhile, I asked for my famous trip around the world, alone. You see, I was a self-appointed field marshal in the international women's struggle, the leader of NOW's first International Expeditionary Force. Like any good general, I knew I first had to assess the condition of my troops. I needed to study the condition of women around the globe.

So I ended up using Harry's "anniversary present" to visit fourteen countries on that one trip, seeking to raise a little consciousness and lay the ground work for trying to organize feminist chapters in each one. Where did I began? With a nation so exotic that today it is extinct—the Union of Soviet Socialist Republics.

One thing you could say for Communist countries—officially, they believed in the emancipation of women. That was good. What was bad was that the Russian government thought full equality had already been achieved. Far from it. But I have to say that in some areas, they were ahead of us at the time.

Now, you won't find a bigger anti-Communist than Patricia Hill Burnett. Not out of any silly ideology, either—other than one key principle: I want to hold on to my money, dears. Nothing

wrong with that. Besides, Communism doesn't work and free enterprise does. All I want is an equal playing field for women to get out there and try to make their best deal.

Having said all that, I have to say that the Communists were very shrewd about some things, and starting with Vladimir Lenin, they had recognized the political potential of women. Promises to fully liberate Russian women were a key part of the Bolshevik Revolution of 1917. Alexandra Kollontai, a female crusader for sexual equality, played a major role in the Revolution's early days.

Sadly, that all changed once the Bolsheviks seized power. Kollontai was given a minor diplomatic post and shoved out of the way. Other important women were exiled or executed. I have heard that when Lenin's widow complained to Stalin about the way she was being treated, he stared at her and said, "We can get another widow."

She got the message, and kept her mouth shut for the rest of her life.

Professionally, however, women had done better. By the time I got to the Soviet Union in 1973, women were officially equal—and had made greater strides in the work force than women in the United States. More of them were working and many more jobs were open to women than was true in the United States.

They were way ahead of us on day care—at the time I was there, every new plant was setting aside ten percent of its space for a child care center, or at least that's what we were told. At the very least, day care was something the Soviets realized was vital if mothers were to hold jobs, which most women, indeed, already did, though they weren't the top jobs. For many years, a majority of Soviet doctors were female, but most were general practitioners. The top specialists and scientists were almost invariably male. The prestige of being a physician had diminished, we learned, as the ratio of women doctors increased.

Politics were the same way. Women were well represented on the party councils and committees at the local level, and in the provinces. But in all Soviet history, only one woman ever sat on the ruling Politburo, and she was there only for a very short time. Things haven't changed, by the way; Boris Yeltsin didn't earn a reputation for surrounding himself with top women advisors.

Why did these hardened Communists allow me to barge into

their country to investigate the status of women? Naturally, because they hoped to co-opt the female leaders of the women's movement by convincing them that Communism was better for women than capitalism was. The Soviet government was seldom noted for its hospitality to capitalist crusaders, but they were wonderful to me.

I was assigned an interpreter who traveled more than 8,000 miles with us, and while I am sure her job was primarily to keep an eye on me and several other women I was traveling with, she was really wonderful, too.

Although I made a lot of friends, Soviet women were a bit of a disappointment. Revolutionary rhetoric aside, they really were not feminists at heart.

"Equality for women is not a problem in our country," said Lilia Filippova, one of the two women the USSR sent to our planning conference in Cambridge. Did her husband do housework? Well, no, she admitted. But once capitalism was overthrown elsewhere, everything would be fine.

"Equality cannot be achieved through reform, but only through the radical restructuring of economic institutions," she said, reciting flawlessly from the party line.

As she hinted, Soviet men weren't any better than their Western counterparts, and maybe even a bit worse. Russian men do *not* do housework, do *not* take care of children and will *not* use contraception.

To keep families small, Russian women mainly rely on abortion—it was common to meet women who had six to eight abortions. I am totally pro-choice—but abortion should be a last resort; six abortions are a bit rough on anyone's body.

What all this meant was that in many ways, women in Russia had it worse than their capitalist counterparts. They had to work a full-time job and then be a full-time housewife and mother. The "babushkas" (grandmothers) were then forced to become part-time mothers. You might have thought they would be ripe for revolt.

Alas, no. What they wanted was not for Ivan to get off his revolutionary rear end and run the vacuum; that would have been beyond their imaginations. They wanted the state to supply more baby-sitting services.

Often, Russians did get divorced—but much of the time,

divorced couples still had to live together because of the terrible housing shortage.

I left Moscow feeling a trifle sad.

But I was exhilarated, because I believed I was on my way to the one country in the world where women were truly, completely liberated, so much so that they served in the army and had possessed equal rights from their nation's beginning. This was a country where a woman was even currently leader of the government.

I wondered, as my plane landed in Tel Aviv, was NOW even needed in the women's paradise called Israel?

Did I ever have a lot to learn!

Patricia Discovers Not-So-Liberated Israel

Marcia Freedman, a former American who was then a deputy in the Knesset, Israel's parliament, helped set me straight.

Incidentally, as for my prejudices, you could label me "pro-Semitic" if that is a word. I grew up, not with the mild anti-Semitism that was unfortunately common among my class, but with a sincere admiration for the Jewish people. I've met many upper-class Gentiles who have inherited money and who are content to be idle. I could never stand that, and one reason I have always had a strong admiration for the Jewish people is because most of them seem to have been brought up to achieve.

So many of our intellectual, cultural and entertainment figures have been Jewish, as are many of my best women friends in Detroit. Coincidentally, I had been succeeded as president of NOW by a brilliant feminist named Joan Israel—and I was eager to see women flourishing in the country that shared her name.

But what I had overlooked in 1973 was that this valiant country was heavily influenced by political parties that today we call the "religious right." Women had equal rights on paper, mainly because the Labor Party, which governed Israel for its crucial first decades, was rooted in democratic socialist traditions. The Kibbutzim, the famous collective farm settlements on which many an American boy or girl has spent a summer or two, did offer a substitute for the male-oriented nuclear family.

But Orthodox Jews do not tend to be raging feminists, to put it mildly. Orthodox Judaism is a patriarchal religion. Women's

rights in Israel have been threatened even more in recent years, as the religious parties have gained more power and immigration from non-western countries has increased.

Golda Meir, to be sure, clawed her way into the prime ministership. But how did she do this? The praise of her admirers gave her away: She did it by being, in many ways, as they said "tougher than any man." Worse, while she was undoubtedly a great leader, she did not use her power and example to help her sisters. Her attitude seemed to be classic elitism: *If I can do it, any woman can.*

The record proves her wrong. Golda was not only the only woman ever to lead the country, she was also, in her lifetime, the only woman ever to serve in the cabinet.

I was next startled to learn that even apart from politics, Israeli women were actually behind their American sisters in the working world. Less than a third worked full-time, and those who did were smashing into a thick glass ceiling of their own.

Why? Seems that neither Asian nor Western Jews much liked their women working—and when they did work, Israeli society liked even less paying them fairly for it. I haven't checked recent figures, but back then women, regardless of whether they were in public or private service, made only two-thirds of what their male counterparts did. That was just about as bad as the ratio in the United States at the time.

True, Israeli women went to college—exactly half the graduates were female. But then, they seemed to vanish. Only two percent of the full professors in Israeli universities were women, and just seven percent of the lawyers and five percent of the engineers. (These numbers have improved greatly in the past twenty years, and many Israeli women are now successful in jobs and politics.)

Ah, but what about the famous fighting women of the army? Guess again. Yes, they are drafted. Yes, women fought side by side with men in the guerrilla warfare that led to the birth of Israel in 1948. But what few realize is that even today, they have been pushed into clerical and other non-combat tasks.

Socially, it was even worse. I learned to my absolute horror that 90 percent of Israeli women took part in a ritual bath called a *mikvah* before they marry. The reason for the *mikvah* stems from primitive beliefs that a woman is unclean during her men-

strual period. Worse, anyone party to a suit involving marriage or divorce had to go to a religious court, where only men could be judges and only men could testify.

By the way, no woman in Israel may be divorced without her husband's consent, and a deserted wife cannot remarry in Isreal at all! As for the widow of a slain soldier—she cannot remarry until her husband's body has been recovered.

What about the laws? I seethed. Marcia Freedman, wiser about her adopted country, gently told me that equality wasn't something that could be entirely solved by legislation. "What we need is a re-education of *all* people about what women can do."

Next I went to Iran. Now remember, this was not the Iran of the Ayatollahs. This was the western, pro-American, Iran of the Shahs. I wrote in my journal, "It saddens me to see veiled faces everywhere despite the government ruling that they could be put aside."

Little did I know that the dark age was coming. Think of Iran, my sisters, today's Iran, where women are stoned to death for not wearing the veil, whenever someone tells you no one can set the clock back.

Don't ever believe that it can't happen here.

East Against the Sun

You might have expected the opposite, but things improved as I traveled east, against the sun. Thailand was like a breath of fresh air in many respects. Yes, the flesh trade is scandalous, but unmarried women at least were the equals of men in many respects; they can own property, even strive to be a judge in some lower courts.

True, a married Thai woman could not make a legal contract without her husband's endorsement, unless she got a prenuptial agreement allowing her to do so. That didn't stop the many ambitious ones, though: they merely got their husbands drunk, got out the necessary piece of paper and a pen…

A woman even owned and ran the largest bus and trucking firm in Thailand when I was there.

Thai women are truly terrific! They really run most of the businesses, especially those connected with transportation, even if they are forced to have an often "dead-weight" husband as the titular head. Many worked part-time; Thais strongly believe children need their mothers, and there were next to no child care centers.

The mayor of greater metropolitan Bangkok was then a woman, although she got her job only because the male contenders couldn't agree on a candidate.

Yes, women were and are oppressed in Thailand. Somehow, though, the same oppression seemed lighter in this gentle country where laughter was about the strongest weapon women have. But their laughter has not been perfect medicine; most Thai women were and are overworked. While they had made some progress towards winning their rights in the courtroom, these laws were seldom enforced.

Thailand holds a special place in my heart, but the nation that most intrigued me on my first round-the-world trip was India. Except for China, no nation has as many people—and hence, as many women.

Not surprisingly, women are kept firmly in their place throughout most of India. This seemed to me even more true in the middle classes, where many young women have western educations. Ancient moral codes are still rigidly observed. Men expect unmarried girls to be virgins. Pregnant and menstruating women are thought of as "unclean" and are forbidden to cook.

(Wait a minute... does getting out of the kitchen for nine months sound so bad?) Seriously, India is divided rigidly into a man's world and a woman's world. While women are never lonely and hardly ever alone, the society is so stifling that the barriers to true female independence seem overwhelming.

Still, incredibly, many Indian women manage to finagle far more actual freedom than many American women have. What I observed also is that there is a particular upper slice of truly achieving women in India, women who hold firm sway over their lives and over the lives of their families. Many of these women

really run fiefdoms of up to a hundred people, arranging their lives, births, marriages, and deaths.

When a woman becomes pregnant, she often leaves at once to wait it out in her family home. She can also choose at any time—pregnant or not—to move in with a parent or sibling who "needs" her. What if her husband doesn't like it?

Too bad. Family demands come first. However, don't feel too bad for poor hubby. If they can afford it, men often have two or three wives, so that one can always be on tap for his basic needs or gang baby-sitting, you might say.

What really gladdened my heart was to learn that in a few southeastern provinces of that vast subcontinent, women do really run the show. They are the wage-earners and the real heads of their families, while their husbands stay home, hunt, look after the children and cook. The women of Rajastau are especially famous: many of them are traveling construction workers who work as far afield as New Delhi.

You haven't lived until you have seen women construction workers in their hard hats, gracefully walking the beams over-head. In the province of Nagavand, women set the rules for sex, and the money is all in the women's name. If a woman wants to divorce her husband, she merely puts his sandals outside the door with a stick—and he knows and has to accept that it is all over.

Unfortunately, only a small minority of Indian women are so lucky.

I traveled on—through Japan, Hong Kong, and China. Everywhere, I found variations on a theme. Women were better off in some ways in some of these countries; worse off in others. But they were all oppressed in one way or another.

Tokyo was, in a way, the most surprising, perhaps because we think of Japan as so advanced in so many ways. But when I met with a few brave feminists, they said, "We'll get together some women in a warehouse late at night."

"Pardon me?" I said.

Wearily, they assured me "It'll be dark and gloomy—and for just that reason, it will be the only place they will come to."

They agreed to meet me at my hotel and take me there. Suddenly, one of them looked at me and said, "Just make sure you are wearing slacks."

Slacks? Patricia Hill Burnett doesn't travel with slacks. The appointed hour came, and so did my Japanese hosts, who looked at me with considerable consternation. "We have to get on the subway, and Japanese women simply aren't safe on the subway in skirts," they told me timidly. Seems some Japanese men have a very bad habit of running their hands up inside the legs of women wearing skirts on the subway.

Charming. Finally, they hit on a solution: they surrounded me. There I was on a fast-track train, with five women encircled, protecting me.

Eventually we arrived at what was indeed a dark building. We went up the stairs in complete darkness. When we got to where everyone was waiting, there was just a single candle glimmering for light. I could faintly make out a few dozen Japanese women silently sitting around the floor, some in traditional kimonos, some in Western wear. They started to tell me their stories—two of the women spoke excellent English, and could translate. I heard horrible stories about women who were wives, mistresses, and call-girls, all of whom had been used and brutalized by the system.

What was most interesting to me, however, was what they told me about conditions in the workplace. Many Japanese women could only find clerical or department store jobs at a fraction of men's wages. Nicknamed "flowers of the workplace," it was common for these "flowers" to be expected to quit, or be summarily fired at twenty-five—when they were considered too old to be perfect decorations any longer.

After listening for a long while, I had an idea. "You know, I remember a strike that one of the militant groups had in the United States. All the women took their children and went to the mayor's office—and simply sat down. They had a sit-down strike with their babies, and it nearly drove the men crazy!"

Suddenly I heard excited whispering. I had given the flowers of the marketplace something to think about. Lo and behold, a few days later... they did it! They organized a march. The Japanese papers had a story about women who came and packed the mayor's office with their children, putting three babies right on his desk!

Perhaps that didn't bring enlightenment to the east, but it was a start.

Problems varied, but gradually I came to recognize two common problems of women the world round. First, women from Tbilisi to Tokyo find themselves tied to home, because of their responsibilities as mothers and housewives. But economics also dictate that many of them also have to work for wages—meaning many of the world's women are really stuck with two full-time jobs.

Next comes modern technology, which oddly enough, may have hurt, rather than helped, the cause of sexual equality.

That's because the industrial revolution tends to intensify the different roles of the sexes. By dividing work into little pieces, industrialization has helped to further segment society—in the process, dealing a serious blow to the values, goods and services traditionally produced by women. You cannot industrialize child care. As a result, those who value industrialization tend to demean the value of child care.

Meanwhile, technology—or I should say, those who run it—have tended to restrict women to non-skilled subordinate jobs, which further reduces women's value.

When I came back after three months in motion I was full of energy, fired up, and eager to act on what I had learned. I knew exactly what needed to be done next, and I knew exactly what I wanted to do: We'd have our second, much bigger international feminist conference—and then I would get down to the serious work of setting up, chartering and organizing NOW chapters across the globe.

The only trouble was that I had forgotten about two things: jealousy and politics.

Women Can Be Women's Worst Enemies

Early on, I should have realized that we weren't going to achieve utopia overnight. Remember, my International Feminist Planning Conference elected a board, which was headed by Berit As of Norway. She took over with the specific charge of planning and organizing a much larger follow-up conference.

Brussels was and is a major international gathering place, and Lily Boeykens, a prominent Belgian feminist, helped get her country to not only offer to host the meeting but also to put up a great deal of money towards it—many thousands of dollars.

Well, so what did Berit As do? Turned it down cold. Why? Seems she was running for office in Norway, and there was a dispute between Norway and Belgium. She didn't ask the board, didn't ask any of us. Naturally, when we found out about it, we immediately voted her out of office, but it was too late.

International feminism had lost a major opportunity, and she had gotten cheap political points. But the worst was yet to come.

<center>֍֍</center>

So here comes Patricia Hill Burnett back to the NOW board meeting, fresh from her three-month jaunt around the world trip, carrying a sheaf of newspaper clippings: Patricia giving speeches and being interviewed on women's rights in Japan! Patricia speaking in Hong Kong! Patricia in Nepal! Patricia being written up in Paris and London! Patricia addressing a session of the state legislature in Hawaii!

Naturally, I was so proud of these clippings—proud not only for me but for NOW. I admit that I wanted recognition and approval from my fellow board members, my fellow feminists—and I thought I had earned it.

"Everybody is bound to think I have done a good job," I thought, as I sent these clippings around the table. But when I looked at their faces, I realized immediately that I had made a huge mistake.

They were jealous. Actually, NOW hadn't had much idea what I was doing. All of a sudden, they realized that I had been very active, had gotten a lot of press, and had a wonderful time doing so in the bargain.

Well, they got even: within a very short time, they voted to toss the international chapters right out of NOW.

Why? To them, this was only a sideshow, and I was one of the pawns in the transformation of the board. The radical wing of NOW, which was growing stronger and stronger throughout the early and middle 1970s, not only actively disliked me—they focused on me—my appearance, what I stood for—as a symbol of everything they didn't like about the moderates—which included, by the way, Betty Friedan.

Well, fine—I really hadn't minded being their target at all,

because I had by then developed a pretty thick skin. I had gotten a lot tougher during my years in NOW—more pragmatic, more worldly, more capable of directing and controlling my life. Life is, I had learned, fundamentally a struggle for power.

Power struggles define the terms of a marriage, of a business, of anything political. NOW had fallen victim to this common sickness, just as every organization I have ever encountered does, sooner or later. NOW was getting quite a lot of broadcast air time on the news and space in the newspapers, and many women yearned to have a position of controlling just what our group stood for.

I didn't mind fighting—what surprised me was that I couldn't finally win.

Not that they destroyed me. True, when the international chapters were dropped, I felt that a dream of Betty's and mine had been destroyed. I was very much aware that this was a political move to repudiate both Betty and me.

But what I learned was what defeat tasted like, and that you can make something positive out of it, too. What I found was that the struggles of NOW gave me good training for the battle of life—and I've blessed my political enemies ever since for the strength they gave me!

They hurt me, but they couldn't break my heart, because I had set my eyes on a far different star than they. Personally, I had won my victory long before they tried to humiliate me—I had found my identity.

I had found by this time that I had a spine of iron, that nobody could crush. I had found that I could argue and be unpleasant and not feel guilty about it.

And best of all, I had found I had *character* within me that I had never defined before. I found my identity in the women's movement, and I will never lose it again.

Nor have I ceased to dream. Even now, even after everything, I still have a sense of idealism about the movement. Even now, I have a deep feeling that true international solidarity among women from Angkor to Zanzibar will come to pass. Maybe not in my lifetime, and whatever progress we make will involve a lot of fancy stepping, backward as well as forward.

The trick is... never stop trying to dance.

Taking Charge of the World Feminist Commission

Naturally, the women who had joined my international NOW chapters were a bit bewildered, not to mention hurt, when the national board so cavalierly dumped them over the side. They wrote to me, and to members of the board we had picked to plan the second international conference, and finally some of them came to see me.

"Would you chair a new organization, the World Feminist Commission, and keep us going—keep us in touch with each other?" one after another said. Clearly, Patricia Hill Burnett had not been the only woman spiritually transformed by that great coming together in Cambridge.

So what else could I say?

Florence Kennedy once said it better than I could. When they get you down, "don't agonize—organize."

So I did. Believe it or not, I have done it ever since, with the help of a secretary, or sometimes two. I correspond with a few women around the world—5,000 or so—and act as a network for them. I can't do the things I could do if I had the resources of NOW backing me. But I still am president of the World Feminist Commission—and as such, I do whatever I can to keep women in touch and keep the lines of communication open.

Salary? You might call it the greatest unpaid job in the world.

There are other and more important compensations. The fringe benefits are pretty good. I think I can go to just about any country on the globe and see friends. Without even trying, I can think of 27 countries where I can find a bed to lay my head on and never have to even see a hotel.

What the future holds, I'm not sure... except that we *will* win. Someday. Women with more time and energy than I have will have to fight this battle to the end on six continents, and maybe even in outer space before we're done.

But I will always work for women, in my own way.

And you can bet that if and when I am called on, I'll be there.

Women's Work is Never Done; Battles at Home and Abroad

If you want anything said, ask a man.

If you want anything done, ask a woman.

—Margaret Thatcher

Bringing It All Back Home: The Michigan Women's Commission

*A*s important as the status of women around the world was—and is—to me, all my international activities did not mean that I had lost interest in the lives and struggles of women here in the United States, where everyone is supposedly equal.

I know exactly what some of the radicals on the national NOW board must have thought when they heard of my World Feminist Commission. You can imagine the sneers, "Yes, that's the place for dear Patricia, the privileged feminist in a picture hat. Off to be a do-gooder in Thailand, where feminism won't risk her family fortune."

Naturally, my opinion is quite different. I fear that for every new feminist the radicals attract, their rhetoric and tactics drive three moderate women away. How else do you explain that today's college women, in survey after survey, are in favor of equal pay for equal work, but refuse to call themselves feminists?

Some of the current leadership of the "Women's Movement" also are often outraged at me for another reason: because I am a stalwart Republican. How in the world, they say, can any "feminist"

be a member of the party which killed the Equal Rights Amendment—and which is officially committed to rolling back abortion rights?

To that I say—the Women's Movement desperately needs to infiltrate the Republican Party! For one thing, tens of millions of U.S. women, including the most economically successful ones, either identify with, or at least vote for, the GOP.

Do we automatically want to write those women off?

That's not to say that I endorse the GOP's current stand on abortion, or on the Equal Rights Amendment, or on women's rights generally—I do *not*.

"The Republican Party has been remarkably slow in recognizing women's rights," I told our national platform committee back in 1972. I began by saying, "I was Miss Michigan and runner-up to Miss America, and I am a feminist." Those remarks that got me on national TV, but sadly didn't sway my fellow Republicans.

Things in that regard are even worse today. But while the Democrats have been much better at paying lip service to women's rights, I don't really believe the good old boys leading the Democratic party have actually done very much for women.

No, while I may be a fiscal conservative—as my good friend Gene Boyer once said, I am a radical feminist to the core. My mission, I believe, is to be a thorn in the side of my party pricking its conscience.

Michigan's governor, John Engler, excellent as he has been on reducing taxes and putting our state's economy in order, is one who has felt the barbs of Patricia Hill Burnett. There have been Republicans so bad on women's issues that I just haven't been able to support them. But I am convinced the best way to bring about change is to work for it from within the tent—rather than throwing stones from outside.

While the NOW radicals were turning their noses up at me, I was doing what I could for the issue that *should* have been nearest and dearest to them: trying to physically protect millions of women whose lives are at risk, right now.

They are cut with knives, run over by cars, crushed with iron pipes, kicked in the head, burned, axed and beaten senseless. Are these tales of horror from victims of war? No, they are the life situations of American women, battered in their own homes.

I wrote those lines as part of the foreword to a book that is one of my proudest achievements, *Domestic Assault: A Report on Family Violence in Michigan.* I chaired the commission that held the study that led to the book, and that led to massive changes in rape laws in Michigan—changes for the better for women.

Not a bad piece of work for a housewife and portrait painter, eh?

Actually, all this came about because we had a terrifically enlightened Republican governor in my state in those days: William Milliken, whose wife Helen, is not only one of the finest women I know, but a true feminist.

Milliken became governor in 1969, the same year I founded Michigan's first chapter of NOW. Three years later, when I was on the national NOW board, I heard that he was looking to fill a number of seats on new commissions. I sent my resume in to him, with a note somewhat timidly inquiring if there was any room for me.

Immediately he asked how I would like to be on the new Michigan Women's Commission, which was composed of women from both parties and a variety of professions. Not only did my interests fit in, the commission was also very happy to have a member who represented the arts. By the way, I've learned there is one nice thing about being an artist who wants to get involved politically—you are not likely to have much competition; very few artists want to do anything as time-consuming as that!

Well, I did put in my time on the Michigan Women's Commission—ten years. I worked very hard and had what I thought were a lot of good feminist ideas as to what we should do. Before I knew it, I was named the chair.

Those were heady days. You have to remember that I was still rather young and innocent then—barely fifty-five—and I often went around with a euphoric feeling that we were really making a difference, were really affecting laws and attitudes.

The most important thing we did was to hold hearings in cities across the state in October and November of 1976 on domestic assault. We heard testimony from more than a hundred women in

a pioneering effort to expose the horrifying and dangerous lives so many Michigan women lived—and I fear, are still living today.

Some of the stories we heard made us weep. Others were so bizarre we didn't know whether we wanted to scream with rage or laugh. One woman told us, "My husband and I were arguing. I ran for my life. He got in the car and ran over me. Then he stopped the car, turned around, and ran over me again."

We must have had dubious looks on our faces, because she looked at us and said, "You don't believe me?" With that, she lifted up her dress, and there were perfectly preserved black and blue tire marks across her abdomen.

We saw women whose husbands had pulled whole tufts of hair from their heads. Women with broken bones and burns and bullet wounds.

I am proud to say that in at least one case we made a difference. A Detroit police inspector had handcuffed his wife to a chair until her arms swelled to her elbows. Then he beat her in front of the neighbors. "I'm just teaching my wife that she's got to behave," he told them. His earlier "lessons" had included kicking her in the breasts. She testified that when she went to the county prosecutor's office to complain, she was told to drop the matter because her husband was up for promotion.

An assistant prosecutor went on to tell her that her husband "had probable cause to beat her." Fortunately, after our hearing, the Detroit papers did write the story. While the man never went to jail, at least he was fired.

We learned of a place in Detroit that rents leeches by the jar to women who had been beaten by their husbands. The leeches burrow into the flesh and suck blood out of a swollen bruise. One woman testified that yes, the leeches were more horrifying to her than the black eyes her husband repeatedly gave her, but she had to use them because she would be fired if she came to work with a disfigured face.

When our hearings first became public, we got a nice hospitable message from Marquette, one of the biggest cities in Michigan's Upper Peninsula: *Don't come.*

"We don't abuse *our* wives up here, and you are not welcome," they told us. So of course I arranged to go anyway.

When we got to our hotel we found the ballroom, where the hearings were supposed to be, completely deserted. Finally the

manager hustled up to me. "A lot of women have arrived," he said, "but they're afraid of having their faces or their names publicized in any way. So they are all down in the kitchen."

The management set up microphones for them down there, so our panel could hear what they had to say without the women having to come forward in public. One case we learned of was in the town of Gladstone, where a man beat his wife to death and then burned his house down, incinerating his two kids in the process.

The authorities were so upset they put him into an insane asylum ... for ten months. Then he was set free. On the other hand, we learned that four Gladstone women had "accidentally" killed their husbands. One, as I recall, "accidentally" went to move her husband's gun while he was sleeping and it accidentally went off... six times.

Every one of these women was acquitted of any crime.

Gladstone, we concluded, had a *most* original system of terminating an abusive marriage.

Our hearings led to the establishment of a "safe house"—one of the first—for women who ran away from abusive marriages. Despite our pleas, the papers printed the address of this building. The very next day, one of the women who had taken refuge there came out of the building and was shot dead by her husband on the steps.

When our book came out, it caused quite a stir and some sympathy so I saw our chance. I was able to get our board to start brainstorming about some possible drastic changes in state law. What could we do for women? What new laws could we achieve? Very quickly, we decided to fight for a tougher law on wife-beating and rape.

"How about writing one on our own?" I suggested "Let's just sit down and put what we want in it, and then run it past some friendly legislators and see if they have anything to add. Or we'll find out if they think there are any reasons why it can't pass."

We were lucky the timing and the climate were right. The state legislators wanted to have to their credit a bill that would look good to women, while not making most men too mad.

What we ended up promoting was an eight-point Domestic Violence Bill. We had no problem with the lawmakers except on one point.

The last section would have given women the right to sue their husbands for rape within marriage.

How surprised are you that our mostly male legislature wouldn't pass it? Could it be that we had stirred up a guilty conscience or two?

Nevertheless, we had done some good. When we were finished, I decided to try to be elected to the National Association of Commissions for Women, the "mother board" which presides over the women's commissions in each state.

Not only was I elected to this board, I soon became president of it as well. This was in the late 1970s, when Jimmy Carter was in the White House. Whatever else he did, President Carter was a true champion of women.

Soon after I became president, I contacted the President, and asked if he would invite our national commission to the White House to talk about the Equal Rights Amendment, which was then facing a life-or-death struggle for ratification.

Did he ever! President Carter ended up meeting many times with us. He would get on the phone while we were with him, and call up governors in the states that had not yet ratified the ERA. We listened as he talked to them, trying to get them to persuade their state legislatures to pass the amendment that meant so much to us.

Sadly, it was all in vain. While thirty-five states did vote to make the ERA part of the U.S. Constitution, time ran out before we could get the last three we needed.

What finally doomed the Equal Rights Amendment was something more powerful than any governor or even president—economics. Men were behind the failure of the ERA. I truly believe that the corporate heads woke up and realized how much money it was going to cost to pay women at wages equal to those paid men.

That was a force too powerful for any governor, or even a president, to stop. But President Carter tried, and for that, he will always have a place in my heart.

Governor Milliken and his wonderful wife, Helen, also remain special to me. Before he left office after a record 14 years as Michigan's governor, I was commissioned to paint his official portrait, which still hangs in the State Capitol.

Later, I also painted Helen Milliken, who became and remains a close friend. Nearly twenty years ago, she formed a group of twelve like-minded women with whom she could really feel free to talk without worry that she would be misquoted. We've been meeting ever since, and seeing her is always a true delight.

Ladies of the Evening... and a Princess or Two

Now I have a true confession to make: The best thing for me about the women's movement has always been... women! Getting to meet women on every continent, from every social background and every walk of life.

Sometimes they were astronauts, sometimes they were first ladies, other times they were the rulers of their nations... and sometimes they were scrubwomen on the Moscow subway. But honestly, truly, I have loved them all.

Well, *almost* all.

My husband, Harry, had a harder time. Though he was a tremendously successful businessman, he was sometimes painfully shy and was terribly conventional.

This caused him a few problems back when he would travel with me on some of my international expeditions. As I have said, the women's movement actually saved my marriage, even though I had to file for divorce twice before Harry finally got the message that the world was changing. I stopped the divorce suits when he started to change, and the result was that our marriage was better than it had ever been.

But Harry, I fear, never really understood what the women's movement was all about—though, to his credit, he truly did try. Every year, I would travel to some different part of the world, and wherever I went, I would set up meetings for local feminists by inviting them to tea in whatever hotel I was staying in.

Once, when I was in London, Harry surprised and delighted me by showing up. I was staying at the Hilton, and before he arrived, I had invited two activist groups to visit me on two consecutive days. Harry arrived in time to meet the first group.

There they were—filling the second-floor tearoom, surrounding me, looking like a nest of harpies. Their hair was flying; their clothes were shabby and unkempt; their voices loud and shrill. "Who *are* these people?" Harry muttered disapprovingly. "I can't believe you invited them to the Hilton!"

"Well, you know, dear, the British government gives special wages to housewives who have to stay home and take care of their children while their husbands work," I said sweetly.

"So?" Harry said gruffly.

"These women think they are entitled to the same thing. They call themselves 'Wages for Lesbians'."

They represented, incidentally, the far left wing of the London lesbians; most of the British lesbians I met were well-groomed and handsomely tailored by some of the best suit-makers in the world.

Somehow Harry survived the experience. The next day, he found me in the middle of an utterly different crowd. They were beautifully coifed, gowned and manicured. Their voices were low and conventionally ladylike.

"Now this is the type of woman you should be with," Harry said. "What group is this?"

"This is the Decriminalization of Prostitution Organization," I told him. "Each and every one of these women is a prostitute and proud of it," I said.

Harry, as I recall, found some Difco business to attend to in a hurry.

That was too bad, for the leader of these prostitutes was one of the more entertaining women I had met. Margo St. James, the founder of COYOTE (Call Off Your Old, Tired Ethics) was, and probably still is, the best-known living prostitute in the world. She has lobbied Congress for decriminalization of prostitution and has probably been on more talk shows than anyone except Henry Kissinger.

We first met in Mexico City in 1975, at the first United Nations Decade for Women Conference. I was entranced by her right from the start: She was colorful, intelligent and amusing—and had these wonderfully fake, perfectly white teeth.

Once, when we were talking, television cameras showed up. Quickly, she pushed me out of camera range. "Patricia, you shouldn't get mixed up in my politics," she said—though I was happy to be seen with her. I think prostitution should be decriminalized, so that women can practice the world's oldest profession legitimately.

Why? Isn't prostitution demeaning to women? The hard fact is that prostitution is going to be practiced anyway, and it would be far better to allow those who choose to practice it to do so as safely as possible, with health issues regulated, and with measures in force to protect the women from exploitation by pimps.

AIDS seems to have set the cause of legalized prostitution back a bit. But Margo still puts out a fascinating and sometimes hilari-

ous monthly newsletter, also called COYOTE, and I run into her from time to time at women's conferences.

I honestly admire her very much.

Politics and Pawns

Margo and I were both in Mexico City for the kick-off of the United Nations' first International Women's Year. That was when I really got an education. While there were more than a thousand U.N. delegates and foreign women present, they were far from enough to fill this truly enormous meeting hall which we were assigned.

So the Mexicans brought in armies of very well-dressed, very nice-looking women, and also cleverly sent in about a dozen men with megaphones, who took up positions on the sidelines, along the walls. Everything was fine, until a poor Mexican woman came up to the stage and began trying to tell her story, "I'd like to tell you how badly I've been treated in this country... "

Boom! Immediately, the men with the megaphones gave a signal and hundreds of these well-dressed women would stamp their feet to drown out anything they didn't want heard. Our agenda had been seized; the Mexican government had taken over our meeting. The few women who were allowed to be heard were pawns of the men, of the Mexican government.

The meeting was a simply pathetic disaster. We came away with barely anything for the benefit of women, except for one very important lesson. We had learned, first-hand, how politicians could manipulate, twist and destroy the simple goal that women long for: true equality with men. We were prepared to start at any level, even the lowest, depending on the conditions in any particular country.

But now it came home to us how unwilling most men were to give an inch.

Patricia's Tour with the Guerrillas

One day during the conference, I received a mysterious message. A group of women left word that they wanted me to come to their meeting place, which they said was "a little outside of town" and talk to them about NOW. This was, I imagine, when I still had some hope that NOW would again be open to international chapters.

Meet us on such-and-such a street, they said, and we'll pick you up. That seemed fairly reasonable. Harry was with me, so I told him, "Harry, some women are going to pick me up and take me to a meeting. I'll be back in time for dinner." By then he was used to me jaunting off on short notice, so I doubt whether he even rolled his eyes.

Naturally, I was wearing a beige cape, trimmed with fox all around. I usually wear rather elaborate clothes, having been brought up that way, though I must say that I would have fit in a lot better on Fifth Avenue than I did on this rundown little street in Mexico City. Eventually, a dusty old beat-up truck with no side windows appeared. The back opened up, and two peasant women stepped out.

"Are you Patricia Burnett?" one said in English. I admitted it.

"Get in, back here," she ordered.

As I climbed into the back, I noticed there was nothing but straw on the floor. Three other women were sitting there in serapes and bandannas, very typical Mexican women.

No hablo Ingles, one said. Great. They slammed the back of the truck shut, and there I was in total darkness, me and my fox cape, sitting on the straw.

We drove and drove and drove. I could feel us going higher and higher into the mountains. "Oh my God, I'm never going to be back by six tonight," I thought, thinking of the wrath of Harry. No one spoke to me. I couldn't see a thing.

Finally, after a good hour and a half, they stopped and swung open the back door of the truck. There I saw caves that had been cut out of the mountain. Along the perimeter, there was a ten-foot tall iron fence with barbed wire around the top.

"Will I be a prisoner here?" I wondered. There were men everywhere with guns. They escorted me into a cave that had been made into a room and fitted with a door. There was one chair, which I was given, and one electric light, that shone into my face. Women were sitting around the corners, peering at me. It felt like the Spanish Inquisition.

They brought in an interrogator and a translator. They began asking me rapid-fire questions one after another, translated into English.

What was NOW all about? What were our goals? How did we organize? How did our "party cells" communicate with each other?

Some of the questions were very sophisticated. Abruptly they stopped talking to me and began talking among themselves.

Suddenly the leader turned to me again. "Does NOW relate at all to the writings of Karl Marx?"

"No, this is not a Communist organization; this is a women's organization," I said. I was frightened, but I kept my cool.

"Well, this is a Marxist cell, and we don't think you are radical enough. We don't care to join NOW."

After the long ride, the nervous anticipation, the inquisitorial grilling, suddenly it was over. Except for the long quiet ride back to the city.

I finally got back at around ten o'clock to meet a Harry Burnett who was pacing the floor, out of his mind with justifiable anger and fear. Naturally, he had called the police, and he was too frightened to leave the hotel in case I turned up. Let's just say we did not have a particularly pleasant evening.

Going Back to Houston

That wasn't the first time I had been in trouble in Mexico; back in the late sixties, I contracted hepatitis while on vacation there and had to spend months in bed. What that taught me is that while I may look good in red, I look *terrible* in jaundiced yellow.

Two years after the political fiasco in Mexico City in 1975, Bella Abzug, the New York congresswoman with the loud hats and the louder voice, had managed to get a little money out of Congress to convene a women's conference in Houston. Mexico City was only one of a series of celebrations of the International Decade of the Woman, and we felt we could do much better than we had in 1975.

Well, if Mexico was the pits, Houston was heaven. In a statewide election I had been chosen one of Michigan's delegates, which I considered one of the greatest honors bestowed on me by the women's movement.

The Houston Conference was a wonderful experience, thanks in part to Ann Sommers, one of the most gifted chairs I have ever heard, anywhere. She set the tone the moment the conference opened, and she was introduced as "Chairman."

"I am not a chair *man*," she said. "I have never been a chair *man*, I will never be a chair *man*." The audience roared its approval—and millions of women watching via TV in their kitchens cheered too.

Those present included the wives of every living current or former president of the United States. I had met them all, at one time or another. I knew Betty Ford, who is from Michigan, and Rosalynn Carter. I had met Lady Bird Johnson and had worked on committees with her daughter, Lynda Bird Robb, who was also there. Betty and Rosalynn remembered me; Pat Nixon and Lady Bird really didn't.

What struck me though was that this was the only time I had ever seen Pat Nixon showing any spirit at all in public. I grieved inwardly for her, for what her life must have been like married to Richard Nixon. She was such a silenced woman.

I remember reading that she once said, "I have given up everything I consider of value for my husband's political career." Soon after the conference, she had a stroke and was seldom seen at all after that, until she finally died in 1993.

But the glowing part of that conference is that women's work and wisdom were celebrated everywhere—their art, their books, and their memories. Everything from quilt-making to handicrafts was on display.

I spent a lot of time in Houston discussing how the arts draw us together. Arts unify all people across all cultures, not just women. Yet since women are a majority of the artists in the country—sixty-one percent, according to one study—they are creating the most art and probably pay more attention to art then most men.

Naturally, women artists often still face discrimination.

Recently, through modern X-ray techniques, art historians discovered that Franz Hals' 17th-century masterpiece "The Laughing Boy" was really painted by a nineteen-year-old female pupil of his. Three hundred years later, a man could still think nothing of asking me to sign his painting just Burnett, blithely adding that, as everyone knows, a painting thought to be by a man would be worth more.

Houston, by the way, was the first time I ever saw oral history being practiced on the spot, as a science and an art form. Historians and journalists would catch you as you went by, and ask, "What do you remember about the women's movement that should be worth recording for history?"

I did my own recording on film, taking hundreds and hundreds of pictures.

There were many stars in Houston. Bella Abzug got the biggest share of the limelight, of course, but the real mover was Kathryn "Kay" Clarenbach, who made everything work from behind the scenes. Helen Milliken, too, spoke up more and got more attention—all well deserved—than she ever had before.

We resolved another important issue, too: Lesbian feminists were very much in evidence in Houston, with huge banners dropped from the balconies and signs and posters everywhere. Women's conferences before then had often been divided over the proper place and role of our lesbian sisters. Those divisions ended forever in Houston, where the entire body made it clear that lesbians are our sisters and should join us—something that was a buoyant, uplifting, truly beautiful experience.

Hundreds of us left Texas with a new sense of unity and newly strengthened in our feminist beliefs. We also had our consciousnesses raised about something else, too—the power of the media in today's society. The Houston conference got a lot of national attention, and it did so precisely because it was heavily covered by the media.

Many of us came away determined to use our life experiences to advance our cause in the press and on the airwaves. Soon afterwards, I got a great shot.

Phil Donahue had the number one-rated talk show at that time, and he was about to do a broadcast with a man who was moving to ban the broadcast of any and all beauty contests on public TV in Great Britain—where most TV *is* public TV.

The British man was against the contests because he felt they were demeaning to women. What's more, he had the power to ban them from the air because he was the head of the British Broadcasting Corporation, the famous BBC. Donahue wanted a feminist former beauty queen to appear by his side and take part in a rousing debate on the issue.

So his secretary immediately called Ellie Smeal, then the national leader of NOW, and asked if there were any beauty queens in the NOW movement. Turns out I was the best one (actually, the only one), and so she asked and I agreed to do it.

Four of us went out on stage the day of the show. Although my opinions about beauty pageants have since changed greatly, at the time I was opposed for all the expected reasons. That put me on the side of the British gentleman. Supporting pageants were the current Miss America and the woman who runs the pageants.

Donahue did a double-take when he saw me; we had actually met not long before, when I painted his wife, Marlo Thomas' portrait.

None of us saw him until fifteen minutes before air time. Nor did the other two women realize I was going to be on the opposite side of them. I had met them in the hotel the night before and had dinner with them and never once told them what I was about. Donahue came to see us just before we started.

"Now, you women," he said, "if you want to have any part in this show, it's up to you. I am not going to be helping you in any way. I'm going to be helping the audience with their questions. You have to jump in and be forceful."

Getting my bearings took me awhile. Finally, halfway into the show, I finally got my act together, stood up, and said what I then believed: that modern beauty contests were degrading to women.

It was not showing off your skin that bothered me. No, it was that so many young women spend their youth getting ready for the Miss America contest—a contest very few of them ever get anywhere near. You remember, I won Miss Michigan almost by accident, entering on a whim after being dared to by my stepbrother.

In recent years, it had become much different. I pointed out that the average number of beauty contests a Miss America contestant has been in is seventeen! What a waste. Imagine the time, energy, and expense to first be "Miss Refrigerator" or "Miss Long Island" or whatever, in order to have a shot at representing your state at Atlantic City!

What's more, I said, the talents needed to win Miss America are rarely talents the women can use afterwards. Singing and dancing and strutting in a bathing suit seldom pay the bills. Even the winners have little more than one glorious year.

That's what I tried to tell the Phil Donahue audience. But oh, was that Miss America mad at me! She felt like I had defiled the whole sacred contest. Too bad.

Once I finally got the microphone, I wasn't about to let it go. I had my two daughters, Terrill and Hillary, and my daughter-in-law, Sallie, in the audience. I got them to stand, which they did reluctantly, probably wishing they had a normal mother. "They wouldn't *dream* of being in a beauty contest," I triumphantly said.

That won me points because they are all tall and quite lovely enough to have been beauty contestants. Each of them told the

audience that *they* wouldn't *dream* of wasting their time on such a narrow field of activity.

Excuse me for bragging, but every one of them has academically gone miles past their mom. Terrill, my eldest, has four academic degrees, and is completing her doctorate in international law and diplomacy. Hillary went on to get a bachelor's degree in art, and then attended Harvard Divinity School. She had planned to become an Episcopal priest, but to my delight eventually decided her calling was to be a painter. Sallie, my son Barry's wife, is one of the nation's few psychiatric nurses, I imagine, who also has an MBA.

Would any of them, I asked, have gotten that far if they had allowed themselves to become preoccupied with their face and figure alone? Incidentally, all are happily married and among them have eight lovely children.

The confrontation on the "Phil Donahue Show" was very interesting. But for much of the time, the audience wasn't on my side. I received absolutely no applause until I told them how old I was—and that I was runner-up to Miss America in 1942.

But in the end, after I put my slightly embarrassed daughters on display, we won the audience over. What is ironic is that since then my opinion has entirely changed, and I am no longer adamantly against beauty pageants.

Certainly, it seems to me that there are many more worthwhile things a young woman can do. But my attitude now is that if a young woman wants to do this, and can do it without taking too much time out of her life and without being manipulated by anyone—all power to her. I firmly believe a woman needs to be free to use any means to promote herself.

I thought that I had done a pretty good job during my year as president of the National Association of Commissions for Women. We were familiar faces at the White House and other seats of power.

Not only that, I was unopposed for re-election… or so I thought.

We were about one-third of the way through our annual conference when I got a tremendous shock. A woman from New York suddenly came forward and said, "I am running for the presidency." She had quietly set up a stealth campaign. All her New York

friends were there. She had counted noses; I hadn't. She was ready; I wasn't prepared.

I was soundly defeated. That was a real test, because then I had to conduct the rest of the meeting and try not to let my terrible hurt and shock show through. Somehow I did it, possibly because I knew, deep down, that the only vote that counted was my own.

What I learned through all of that was that I have a very strong backbone, that people can bend me so far, and cause me just so much pain... but no more. I knew, somehow, that I could take anything—and that nobody, but nobody, could break me.

Looking back on it now, I wonder if losing wasn't a blessing in disguise. I had one glorious year, and I was still involved with the Michigan chapter and remained leader of the World Feminist Commission.

Giving up the presidency gave me something I have never had enough of—more time. I would use that time to once again pursue my first calling in life, the vocation which has given me the opportunity to meet some of the greatest and most famous women on the planet.

That is to say, once again I had time to paint.

Every Picture Tells A Story

My definition of a portrait is a painting with something wrong with the mouth.

—John Singer Sargent

*H*ave you ever had a fantasy about having two lovers?

Thought so. Now imagine having two great loves in your life and each brings out the best of two very different sides of you. Not only that, but they get along with each other—and help one another to work for your greater glory!

Well, I've been that lucky. The women's movement was the second great love of my life, one that will be with me until after the day I die.

But my first passion was painting, and to my great delight, I have found that being a portrait painter in addition to a feminist, has given me a sort of "dual citizenship" that I can use as a passport to virtually every strata of society.

Nearly always, I manage to slip in a little feminism in the course of painting one of my portraits which was commissioned for strictly corporate reasons. I may not always make a convert, but at least I have made a few men think.

But besides this attempt at "guerrilla palette" warfare, my feminist credentials have won me commissions to paint such amazing women as Valentina Tereshkova, the first woman in space; Gloria

Steinem, Margaret Thatcher, Indira Gandhi, Corazon Aquino, and my own wonderful mentor, Betty Friedan.

Portrait painters cannot get by with being artists alone. If you are going to keep a normally busy person contentedly sitting hour after hour, you need to be a psychiatrist and a psychologist, a mother confessor, a bartender, an advisor on all subjects from cosmetics to stocks, plus a few other things thrown in.

Unfortunately, my duty to keep professional confidences and my healthy instinct for self-preservation (i.e., natural cowardice) mean I cannot tell you everything I learned while painting portraits. I *will* say that if my studio had been bugged throughout my years at the brush, a few governments might have fallen.

So would many more marriages, political careers and business deals. Sometimes, I had to hold my tongue and keep painting. Once or twice in my younger years, I had to hold my wet brushes under the chin of some Lothario who assumed that the painter herself was sort of an *hors d'oeuvre* he was free to sample.

No, I won't name names. But what I do want to share with you now are a few stories of some of the more interesting personalities I have painted. Most of these people will deservedly be remembered long after anyone would care which mayor was impotent or which local executive liked to wear his wife's underwear.

Let's start overseas. My work on behalf of the international women's movement has helped gain me the chance to portray some of the most inspiring women in the world on canvas. Here are a few details that I couldn't capture with my palette:

Valentina Tereshkova

Women were thrilled worldwide on June 16, 1963, when the Soviet Union announced that Valentina Tereshkova had become the first woman in space.

Launched into orbit by herself, on a now-primitive, one-person Vostok spacecraft, Tereshkova spent three days in space—more than twice as long as any American man had at that time. For the Soviets, it was a propaganda coup. The United States, which up to then had not a single woman astronaut, was deeply embarrassed.

Years later, the Soviet Women's Committee commissioned me

to paint her official portrait. Naturally I was honored, and when I finally met her I was awed.

"What," I finally asked, "was outer space like?"

Miserable! the former cosmonaut said through her interpreter.

That startled me. Later, when she got comfortable with me, I learned the rest of the story: Her great historic flight was an accident. She was the understudy for another astronaut who became ill just before lift-off.

Trouble was, Valentina was ill, too. She had a very bad cold and protested that she would have trouble breathing. Sorry, comrade; this is a decision of the state. She was shot up above the clouds, vomiting along the way, for seventy hours and fifty minutes.

That was the end of her space career. More than twenty years would pass before the next woman, the American Sally Ride, would be selected for space flight.

For the Soviets, Valentina Tereshkova may have been a token female astronaut, but she would also be a heroine for the rest of her life. The woman herself had an appealing personality, one you might call shyly affable. Physically, she was pleasantly handsome; I thought she resembled Betty Ford a bit.

While we spoke through interpreters, she could speak English fairly well. In my experience, even prominent Russians who speak our language fluently tend to use interpreters, perhaps to make sure they are not quoted off the record or so they can later blame a "faulty translation" for something they said.

Gorbachev Didn't Turn Me On

Anyway, that was the way it was in the bad old days of the evil empire called the USSR. I haven't been back since communism went into receivership and the old firm dissolved, so I don't have any idea how Russians behave today.

Incidentally, I met—but didn't paint—the man who may have done more than anyone to put the Soviet Union out of business, Mikhail Sergeyevich Gorbachev himself. What may surprise you most is that I may just be the only foreigner who didn't fall in love at first sight with the communist who really did turn out to be the Man Who Changed the World, as Gail Sheehy called him in her marvelous biography.

Hollywood drooled over him; even sensible Margaret Thatcher,

one of my heroines, swooned a little when he first came on the scene. But to me, he seemed just another communist, albeit one who could put on a charming *soignée* shell, which is what we constantly saw on our television screens while he was in power.

Well, I saw something much different in the summer of 1986, when I was invited by the USSR to be a guest of their government at the World Women's Congress. Gorbachev was the keynote speaker, and while the occasion was mainly ignored by the American press, he gave a speech to make old Joe Stalin proud.

He ranted and raved against the United States, which he presented as the cause of all the world's evils. Gorbachev blamed us for the bloody war his nation was conducting against Afghanistan. He presented our government and leaders as simultaneously weak and malevolent. He blamed us for unemployment, starvation, superpower tensions, Iran, Iraq, Israel, all the problems in the Middle East, and probably for iron-poor blood and the heartbreak of psoriasis as well.

Later, when he talked with us, it was a shock to find he was capable of slipping the old charm suit back on again, right over what seemed his very real dislike of us. From that time on, I always felt that deep down, he was a total communist, dedicated in his heart to conquering the world, although history turned out very much different.

Raisa Gorbachev, his wife, was much different. I did agree with the popular and favorable opinion of her. She was bubbly, energetic, and even seemed to be somewhat of an American type in that she was assertive to the point of being aggressive. Had things worked out differently, I would have liked to have painted her.

I might have given her some advice to pass on to her husband, too.

Exposing Myself to India

My most thrilling commission was also my most embarrassing. Thanks to my work setting up the International Feminist Conference at Harvard in 1973, I was commissioned later that year to paint Indira Gandhi, prime minister of India and at that time, perhaps the most powerful woman in the world.

I was to do her portrait in her palace in New Delhi. While I worked, I stayed with her chief minister and his wife, Lakshm

Raghu Ramaiah, in their "modest" little home with a mere twenty full-time servants. (Intrigued, I actually counted them.)

Lakshmi had been one of the first women who agreed to come to our Cambridge conference. She saw herself as a philosopher; one of her servants merely followed her around all day, ready to take down any pearls of wisdom that might suddenly spring forth from her mistress. My hostess had already written six books, every one of them awful... at least in our Western view.

Even worse, none of them covered the fine points of how to put traditional Indian clothing on. Or, I should say, keep it on. For my first meeting with Mrs. Gandhi, I decided to wear a sari, since I had been told that she was most pleased to see foreigners adopt her native dress. Well, I got the sari on, and I do think I looked *quite* nice. . . until I bent over to mix my paints. That's when about a yard of chiffon fell into my palette. *How was I to know that I should have pinned the flowing end of the sari to my shoulder?* Embarrassed, I quickly sprang forward to try and wipe the globs of paint off of it, and I immediately stepped on the seven folds of my skirt, which also should have been pinned, and which, of course, weren't.

Six yards of sari promptly fell to the floor. Thank God I wasn't painting the ayatollah. Mercifully, I wasn't quite naked; I had on a tiny blouse and a petticoat.

India's tough-as-nails ruler looked on in astonishment, as Madame Giri, the wife of the nation's president, sprang forward to try and put me back together, winding cloth around me and pinning me up like a baby in its diapers. Indira Gandhi, was, I could see, struggling to restrain herself. Then she dissolved into peals of laughter.

Once I had been taught how to keep my clothes on, everything went smoothly. I did a lovely painting of Madame Gandhi which she proudly hung in the palace; it was there at least until the sad day in October 1984, when she was assassinated.

Usually I keep photographs of my most important commissions, blown up to the size of the actual painting, or nearly. But one of my great regrets is that I was not allowed to photograph the painting of Indira Gandhi, so I have no copy to remember one of my most important commissions by. Recently I asked Lakshmi what had become of the painting, and she wrote me back that no one seemed to know.

For years everyone used to ask me what Madame Gandhi was

like, this woman who had entered life as the timid daughter of the father of Indian independence, Jawaharlal Nehru, and then gone on to become a major political power in her own right. This was a woman deeply loved by many of her subjects, yet hated and reviled by others.

Well, whatever else I am, I am not an expert on the politics of India. I can say this, though—Indira was the consummate politician. She would pose for me for fifteen minutes at a time and then, while I worked, conduct very regal, half-hour "audiences" with citizens (they seemed more like her subjects) who wanted favors from her. They would ask, she would listen carefully—and never once say either "yes" or "no."

But I had an even more interesting adventure while painting in India. I soon became friends with Madame Giri, the woman who saved me from diplomatic disaster by helping me get my clothes back on, and she, too, requested that I do her portrait.

Painting her portrait was like traveling to the movie set for *The King and I*. She had me paint her in a relatively small but incredibly majestic room in the palace with arched and latticed windows overlooking a courtyard around which elephants were parading. I saw something move on the balcony; next thing I knew, I was being eyed by a monkey. While I worked, monkeys casually skipped in and out of the room.

The room seemed to have been arranged by Cecil B. DeMille. A tall Sikh warrior stood guard in each corner. They seemed seven-feet tall, which they probably were if you counted their plumed turbans. They all had magnificent oiled beards, which they had braided, caught in a hair net and tied under their turbans. Their livery included white silk shirts, red cummerbunds, white satin knickers, and leather puttees.

Madame Giri wanted me to meet her children, so, as she sat and I feverishly attempted to sketch her, she kept calling for one after another of her daughters. One by one they glided in, each with diamonds and jeweled rings set firmly in their noses, and each with at least two children of her own, or so it seemed, clinging to her skirts.

Eventually, the room was so crowded that we were almost nose to nose. By the way, Madame Giri was not minister of family planning. "You have a large family," I said admiringly, sometime after more than a dozen daughters had been presented.

"My husband spent seventeen years in prison as a political prisoner," she said gravely. "Each year he was allowed to come home, and I bore him a child. Today I have seventeen children," she said, rising and approaching me.

"And you are my eighteenth!" she said, embracing me as she clapped her hands. A footman came into the melee with an armful of flowers from the florist (it was considered *déclassé* to give a guest mere flowers from a garden).

I took the flowers, the chattering monkeys looked on with envy. She clapped again, and a footman pushed his way in, this time bearing a velvet purse studded with semi-precious stones. If that wasn't a once-in-a-lifetime experience... I don't want to know!

When I finally and regretfully left India, Lakshmi, my host, pressed the manuscript of her seventh and latest book into my arms, asking me to submit it to Doubleday. As I remember, it was just as bad as its six forerunners.

I did what I was asked, though, as I expected, the publisher proved to have traveled insufficiently far on the road to enlightenment, as Lakshmi might say. Doubleday—*very politely*—turned her down.

Greek Tragedy

Where do you suppose I met Margaret Papandreou, one of the most important and interesting women in modern Greek history? Amazingly, in my home town of Detroit, one day in the early 1980s when she was on a visit with Melina Mercouri, the enchanting actress made famous by the once-risqué movie *Never On Sunday*.

Melina was then here not as an actress but as a top government official; she had gone from playing a prostitute to become Greece's national minister of art and culture.

Margaret, a native of Oak Park, Illinois, was Greece's first lady. How did that come about? Simple. She had met a dashing young Greek named Andreas Papandreou, the scion of a famous political family, who was teaching economics in the United States after fleeing the Nazis in World War II. Eventually they married, he returned to Greece and founded the Pan-Hellenic Socialist Movement, and, in 1981, his party won power and he became prime minister of Greece.

You may not be surprised to learn that I never cared for much for the Papandreou's politics, which were so strident and so far left

that they seemed sometimes more communist than socialist. Margaret herself has marched in and led many protest demonstrations bashing the bad old U. S. of A.

But possibly no one since ancient times has done as much for the rights of the female in the nation where Western Civilization was born. Women have seldom been treated as equals in any civilization, but at least comparatively speaking, they certainly shone brightly in ancient Greece.

The goddesses of ancient Greek religion—Aphrodite, Hera, Diana—were, I think, at least as appealing as the male gods. Sappho, the poetess of the island of Lesbos, was a strong independent voice in literature. Even in the militaristic city-state of Sparta, women had more property rights than they do in many modern countries today, including the right to bequeath and fully inherit property.

Some historians think women reigned supreme in the even earlier and enchanting Minoan civilization of Crete. But sadly, the Greek tradition of feminine independence was lost, and for centuries, Greek women have been shackled under a host of repressive laws and customs—until their cause was again taken up by a magnificent Hellene... from Oak Park, Illinois.

Margaret Papandreou accomplished miracles in a few short years—influencing the banishing of dowry requirements, legalizing abortion, and making divorce much easier and much fairer. She caused a number of prominent women, like Melina Mercouri, to be appointed to top positions, and did what she could to help others.

We instantly realized that we had a common bond, regardless of political differences. When she invited me to Greece to paint her portrait and to meet other Greek feminists, I accepted with pleasure. When I arrived, Margaret moved into a lovely hotel on the outskirts of Athens where she also had me ensconced.

She stayed there for an entire week, accompanied by a retinue that included grandchildren and nursemaids. That was charming; what was less charming is that I was expected to appear each morning by 7:45 to swim with her and the babies, which was a tough assignment for this night person!

But a little sacrifice was well worth it. One evening, Margaret threw a party for me at her home in Athens and invited two hundred of the top-achieving women of Greece to meet me, because of my feminist connections. This was truly thrilling, and it warmed

my heart considerably to see how these women had overcome the highly restrictive mores of their society to succeed as lawyers, doctors, poets, and even heads of government departments. Many owed a lot to Margaret Papandreou—and said so.

Unfortunately, her own life took a turn for the worse not long afterwards, in a way familiar to women since Eve. Her husband began not only carrying on with a much younger woman but took her with him everywhere, making gossip columns from Athens to *People Magazine.* Instead of being humiliated, Margaret conducted herself with great dignity and battled successfully to keep her home.

Eventually they divorced—and the resulting scandal may have helped topple her ex-husband from power in 1989. Though he got back in power four years later, Margaret Papandreou will always be the real winner, as far as I am concerned.

Corazon Aquino

The world will long remember this amazing soft-spoken little woman for leading the almost bloodless "People's Power" revolt that toppled brutal Philippine dictator Ferdinand Marcos after he tried to steal an election from her in 1986.

But what I will always remember is that her portrait was the only one I ever painted during a military coup, with planes dive-bombing and machine guns rattling and firing on the presidential palace. Probably I should have been scared, but after all, the bad guys are always given strict instructions not to shoot portrait painters...

Aren't they?

This all came about when the International Women's Forum elected Cory Aquino International Woman of the Year and inducted her into its Hall of Fame in 1987—a considerable honor, given that the only other woman previously accorded similar treatment was Margaret Thatcher.

Twenty-two forum members flew in to witness the awards ceremony. Later, as we were walking through the palace, she told me that she was dissatisfied with her official state portrait. *Gee, I thought. Guess what I do for a living?*

So, somehow I managed to bring the subject up. She quickly read my biographical material, and then asked if I would paint her official state portrait.

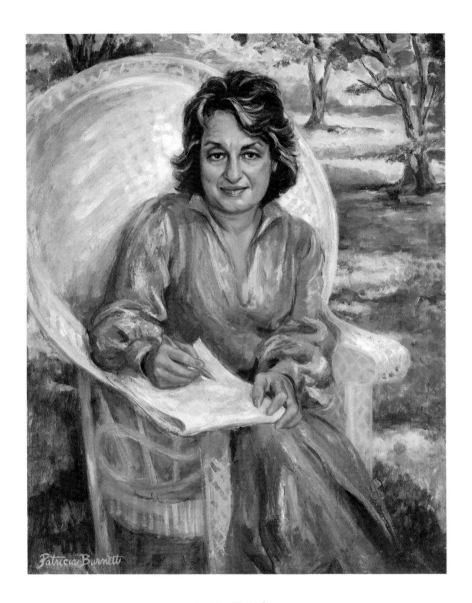

Betty Friedan
Feminist and Author

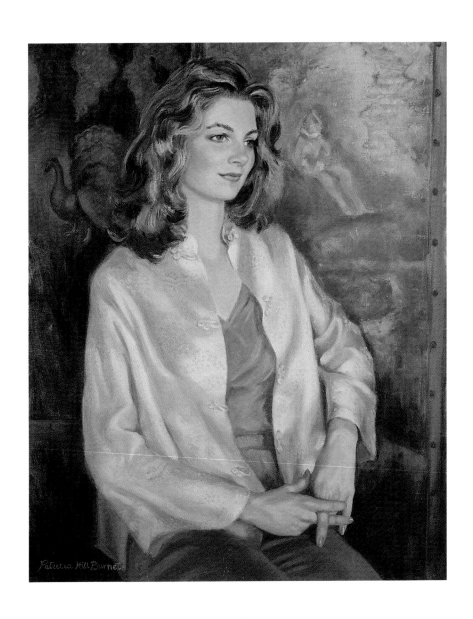

Hillary Hill Burnett

Terrill Hill Burnett

Marlo Thomas
Actress

Barbara Walters
Newscaster

I permit no woman to teach or to have authority over men. She is to be kept silent with all submissiveness +++ Timothy 2:9-15

Feminist Protest Painting
(Letter from St. Paul to Timothy)

Gloria Steinem
Feminist, Author and Publisher

Honorable Helen Wilson Nies
Judge of the U.S. Court of Appeals
for the Federal Circuit

Robert L. Siler

Rosa Parks
Civil Rights Leader

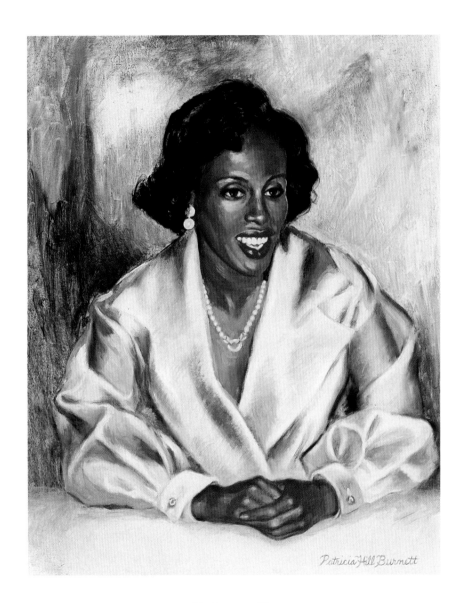

Jackie Joyner Kersee
Olympic Gold Medalist

William Milliken
Former Governor of Michigan

Max Fisher
Business Leader and Philanthropist

Coleman Young
Former Mayor of Detroit

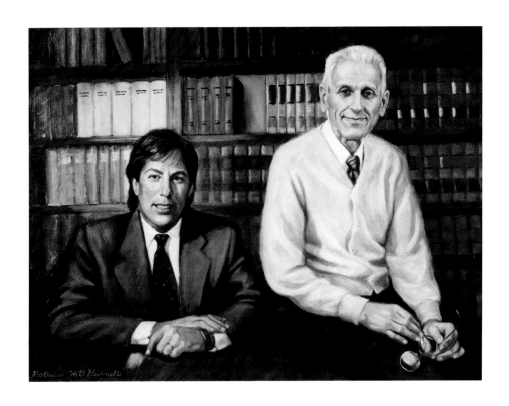

Geoffrey Fieger and Dr. Jack Kevorkian

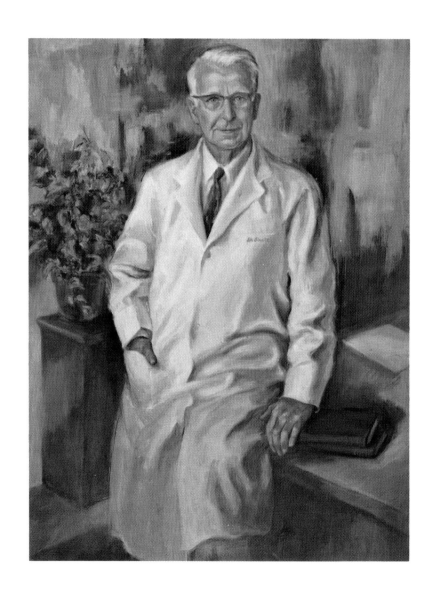

Dr. Jean Paul Pratt
Chief Emeritus of Henry Ford Hospital

Naturally, I was honored. I returned to the Philipines shortly after to start the painting. Just as I was mixing my paints, a full-blown attempted military coup broke out, led by a renegade army colonel. President Aquino's son was wounded and three of her bodyguards were killed. The revolt was finally stopped only 300 yards from the presidential palace and my palette.

Was she shaken? Absolutely. Did she cancel or even postpone her sitting with me? Absolutely not! Earlier, impressed by her inherent decency and the ladylike manners she had polished in a Philadelphia finishing school, I had told friends "Aquino is good almost to the point of being foolish," but now I saw that I had underestimated the strength that she concealed beneath velvet gloves.

As I sketched, marveling at her character, she told me how all her male friends, her cabinet, and even some family members had warned her that no woman could ever govern the Philippines, a rough-and-tumble tribal society.

"I am so glad that I had the last word," she said sweetly, as her troops carted away the bodies of her enemies. I did a portrait that I hope captured her presence and warmth, and gave it to the Philippine ambassador to present to her in Manila that fall.

Though I painted her in Malacanang Palace, she never lived there; she decided to stay in a much more modest government building two blocks away. She was a widow, remember, who had lived her whole life serving tea at meetings chaired by her husband, Benigno Aquino, who for years was Marcos' main political opponent.

Cory's husband was assassinated on Marcos' orders when he attempted to return home from U.S. exile in 1983. That brutal act set off the chain of events that led to Marcos' eventual fall—and Cory's astonishing rise to power. But it seems safe to say that whatever else Benigno Aquino expected, he never dreamed it would be his modest wife who would go down in history as the president of the Philippines.

Incidentally, Mrs. Aquino (who preferred that title to "President" or Imelda Marcos' imperial "Madam"), not only did not live in the presidential palace, she decided to leave the palace exactly as the Marcos clan had left it.

I managed to wrangle a complete tour of what was a stupendous monument to greed, bad taste, political corruption... and incontinence.

Incontinence? For all his denials, Marcos, who suffered from lupus and kidney failure among other problems, couldn't hold it. The royal couple's enormous bedroom was filled with adult diapers and an adult potty chair, plus a hospital bed.

Imelda's famous mirrored dressing rooms and five thousand pairs of shoes have become the stuff of legend. But what repulsed me more was—in their bedrooms—the twin vast portraits of the two of them, each twelve feet high. Marcos had himself portrayed, naturally, as Adam, nude of course, striding through a field of wheat with the fronds (thank God!) tastefully high enough to hide his private parts.

Cory served out her whole term and peacefully handed over the reins to her successor, Fidel Ramos, the general who had protected her from numerous coup attempts while she restored a measure of dignity and honesty to the Philippines.

As for women with an appetite for shoes, well I confess that I have been known to show off my shoe closet to a few friends, though I don't quite have five thousand pairs (though my husband might challenge that).

Margaret Thatcher

Few women have accomplished as much as Margaret Thatcher, Great Britain's toughest and strongest prime minister since Winston Churchill. For this shopkeeper's daughter to rise to the top of the political heap as head of the conservative party in the stuffy class-dominated world of Great Britain was even harder, I think, than it would be for a woman to be elected President of the United States.

Yet she astonished everyone by first becoming the Tories' leader in 1975, and then going on to be prime minister for more than a dozen years straight. Her party won every national election held during the years she ruled, in large part because she got inflation down and Britain's financial house in order. She is a genuine heroine.

So you can imagine that I was totally thrilled when the International Women's Commission commissioned me to paint her portrait. I met her for the first time in 1990, at the most prestigious address possible—Number 10 Downing Street.

Was I a little nervous about meeting the woman the press always referred to as the "Iron Lady?" I don't remember, because

she was far different from the way she was portrayed in the press—she was effervescent, charming, talkative, and warm.

Unfortunately, she was, as you might expect, also extremely busy. She gave me some carefully chosen photographs with instructions to use the color from one, the pose from another, the hair the way it appeared in a third, and so on; she had no time to pose for the six sittings I usually ask for. I was, however, to be granted one last sitting just before I presented it to her.

Tough assignment—but my duty to the crown, or at least the House of Commons, was clear. Do you know what mothers told their daughters about sex during Victorian times? "Lie there and think of England," was as much instruction as some of them got. Well, my assignment was to think of England and *paint.*

Months later, my then-new husband, Bob Siler, and I returned to England. We went to the Royal Academy of Arts for what was supposed to be a brief sitting in which I could make any slight changes the Prime Minister desired.

Only after that, would come the formal presentation. Ho Ho. The time on the schedule for the sitting had mysteriously evaporated; if I hadn't known better, I would have thought she had a country to run, or something. So I crossed my fingers.

The moment of truth arrived—September 25, 1990. I was told to cover the painting with my velvet cloth and unveil it with an appropriate flourish when she arrived, trailing reporters and television cameras.

I held my breath, tried to control my beating heart ... pulled off the cloth ...

And she loved it!!!

Margaret Thatcher flushed with pleasure. "Oh my!" she said. "Oh my!" She studied her likeness, and then sent it on to her home at 10 Downing Street, rather than to a Parliament building where it was originally scheduled to go. Photographs of the portrait, the Prime Minister, and Patricia flashed around the world, and I was on front pages from London to Rome to San Antonio the next morning.

Who says painters don't have power!

<p align="center">◎◎</p>

Now don't think I have gotten *too* high an opinion of myself. Matter of fact, most of the people I have painted abroad were not rich and famous. Some of the time I wasn't working for fancy commissions, but merely for myself.

Every time I take a major trip, I take along a blank sketch book that gradually evolves into a diary of my expedition, with watercolor miniatures of scenes from my trip—whether gorgeous bodies on the beach, rich tropical flowers, waterfalls, and mountains, or dignified Spanish Senoras.

Besides my illustrations, I include handwritten commentary and photographs that I get developed at one-hour processors as I travel.

The entire sketch book gets finished the day I return. I have more than twenty of these now. Making them is great fun, and I find that I refer to them again and again, both for sentimental reasons and whenever I need to give advice to some friend who is traveling to Venezuela, or Russia or wherever.

Incidentally, most foreigners, even more so than Americans, are fascinated by the sight of a painter at work, and will stand silently by for hours, just watching. If you doubt this, just get out a sketch pad in the middle of a piazza in Italy. Every eye will be upon you. Europeans, especially, still have a wonderful reverence for art and the artistic process.

You can, however, overestimate your attraction. Once an adoring (and somewhat adorable) young man hovered as close to me as a bee to a passion flower for hour after hour. I found myself wondering whether he was truly enraptured by my wonderful artistic skill or if he found me devastatingly attractive as a woman.

Either way, I could cope.

Finally, I decided, it had to be both. He loved me for my art as well as my beauty. Ah, these cultured Europeans, I thought, gazing off into the distance, granting him the generous gift of my full profile.

As I looked up, I gave him, indeed, exactly what he had been longing for...

The *perfect* moment to steal my camera.

Artists, Authors, and Presidents Who Have Known Me

Artists who paint portraits must be psychologists.
−Patricia Hill Burnett

*A*wfully arrogant of me to quote myself, isn't it? Reminds me of the old woman who got caught talking to herself. No, she wasn't senile, she said; she had just been brought up to always address the most important person in the room.

Well, I don't feel that way! But I do want to share a few secrets of my profession with you. My portraits, by the way, are designed to make their subjects look good. They will never be confused with those of Pablo Picasso. I am aware that means some critics will never regard me as a "serious" artist.

Too bad! I think that my job as a portrait artist is similar to that of a psychologist—to allow my subjects to see themselves in the most favorable way possible. That doesn't mean that I would paint Roseanne Barr with the body of Meryl Streep; my goal is to reflect the sitter's own opinion of her or his appearance.

You know very well that you may wake up some mornings and think you look great... and on other days, feel as if you looked like Dr. Kevorkian's next client. I believe in accenting the positive.

I think a portrait—as well as the experience of being painted—should be an experience that provides a healthy boost for the subject's ego. My portrait of Margaret Thatcher was done, as mentioned, nearly entirely from photographs.

I have met people who raised an eyebrow at the idea. *Painting from snapshots, eh?* you hear them thinking. That's not real art. To me, that's like saying "real" cooking should always be done on a wood stove. I am in favor of any technique that will help capture a true and aesthetically pleasing image of your subject.

With one exception, that is: though I have met artists who do it, I frown on enlarging photos and tracing their outlines onto canvas. That, to me is what is known as commercial art. True portrait artistry involves drawing with a free hand.

What I use photos for is to establish the pose and show my sitter how much of their body will be included in the final painting. Yet the art of portrait painting is meant to be far deeper than achieving a mere physical likeness; if that were the only goal, we wouldn't need painting; photos would be more than sufficient to do it all.

Reality, however, has many different layers. Once I painted a six-foot portrait of an exquisite woman in a flowing coral gown. The mood was one of overwhelming gaiety and action... or so I thought. When I presented it to the sitter, she paused and said, "I love it because it shows the hurt in my eyes."

Nor was she just projecting her feelings onto the portrait; when I examined the painting dispassionately, I could see how it showed she was deeply unhappy, beneath a magnificent façade. My brush—not for the first time nor the last—had played a trick on me, painting far below the surface that I saw with *my* eyes.

Leonardo da Vinci, who won a little notice for his art five hundred years before I was born, said the key to successful portrait painting was simply this: "You do not paint features. You paint what is in the mind." Not bad, Leo.

Then sometimes, you paint what affects the mind. Once in my Scarab Club days, I had a busy executive who just could not stay off the phone during his sittings? You remember that I said that one of the most important rules for any artist is to never have a phone in the studio? Well, this was the time I really regret having broken it. He was on the phone, off the phone, on the phone. I couldn't get started.

Finally, in desperation, I asked him what he drank. "Gin on the rocks," was the answer. Well, okay. I went and got a bottle and a bucket of ice. "Now, mix yourself as many as you want, whenever you like," I said. "But please try and stay off the phone!"

That did the trick. Soon he was happily tranquilized, the perfect sitter. Then came the glorious day when the painting was almost done, and I invited his wife in to inspect it. This, I have found, is the most efficient way of taking care of such concerns as "his eyes aren't quite blue enough," or, "there seems to be something wrong with his lips."

This time, there were no complaints. She stood in front of the painting, transfixed. "That's him! That's my Bobby!" she said.

Then she frowned. "But I can't figure out how you captured that adorable little dimple in the corner of his mouth that he only gets when he is *really* plastered."

Ah, yes. You may well ask, then, how could I have rendered a decent, honest and revealing portrait of Margaret Thatcher after having met her only once—just long enough to do a few brief sketches?

The answer is... a lifetime of training, as an artist and a woman. What I have found over and over is that the first impression I have of my subject is almost always right on target. Personality, style and manner of dressing, physical appearance are all right there, and no impression is as powerful as the first.

James McNeill Whistler, an acclaimed American artist, actually believed seeing too much of your subject could be a bad thing. "At first all went well," he wrote of one particular case, "but after I got to know my sitter in a few sittings, I lost the resemblance." Granted, it might take more than one meeting to get a real sense of the personality of a shy housewife. But most of my clients who have limited time for sittings are also people with considerable personalities, men and women who have been greatly successful in their chosen fields.

Margaret Thatcher was not exactly unknown to me when I met her, and one personal experience gave me enough of the electric current of her personality to enable me to do a portrait of her that even *she* thought captured her remarkable essence.

Having said all that, let me now appear to contradict myself: Actually, I would far rather paint from life. Whenever possible, I do insist on doing the hands and face from life. I enjoy getting to know my sitters (most of them, anyway) and I firmly believe that the more time I spend with them, the better the painting.

Besides, it gives me a chance to catch up on all the juicy gossip, spread a little feminist propaganda around, and generally make my presence known.

Whether I get one session or six, I try to get a few key questions asked:

How do you see yourself? Are you an indoor or an outdoor person? What colors appeal to you most? Do you prefer sports clothes, evening attire, business suits? Sometimes I even ask the color scheme in the room where the picture will be hung.

But the personality of the sitter is always the most important thing. Let me share a few of my experiences with a few of the most powerful and interesting ones.

Joyce Carol Oates

Many artists and writers really do resemble their art.

Norman Mailer, who has been our next-door neighbor at our summer place in Provincetown for years, was very much the enormous ego presented in his books and articles. Quite apart from the infamous incident in which he stabbed one of his several wives, he was frequently not a very nice man... until he conquered alcohol. Today, dry and happily married, he is a much more pleasant human being.

Joyce Carol Oates, however, is not at all like you might expect from her books. This world-acclaimed author is famous for violent, anguished works of fiction. Marriages are torn apart; people are shot, stabbed, and burned to death. Some of her writing seems almost as macabre as the amateur paintings of another of my subjects, the famous Dr. Kevorkian, whose canvases are slaughter-houses—though fascinating ones—filled with horror, ruin, and tortured and decaying flesh.

Yet you cannot imagine a gentler, more loving and tranquil personality than Joyce's. (How she is capable of creating such fiercely violent scenes is a mystery to me; Joyce is in many ways a very private person. She does say, however, that contrary to the expected stereotype, she had a very happy and well-adjusted childhood.)

Joyce and I met in the early 1960s, when she was the brightest light on Detroit's literary scene. She was a professor of English, first at Wayne State University, then at the University of Windsor, who in her "spare" time turned out reams of short stories, poetry, and award-winning novels.

We started lunching together occasionally. I was very proud to be her friend, but it was with mingled pride and dismay that I began

to notice something. It seemed that bits and pieces of my life were turning up in her work, though fortunately in highly distorted forms, scarcely recognizable . . except by me. Was it really happening or was it just my desire to be important to her?

One of my sons, Barry, went through a difficult time, as did about ten million American kids in the turbulent sixties. Joyce and I once talked about his adolescent turmoil. The next thing I knew Joyce had published a fictional story about a young man whose physical appearance was similar to Barry's, with grotesque events taking place in our neighborhood and on our street.

Fortunately, truth is less strange than fiction. Not only did Barry never take part in events such as those she described, he survived his teens, as we all did, going on to graduate from Wayne State University's medical school, becoming a successful physician and a dedicated father in Colorado.

Joyce Carol Oates influenced me and stimulated my mind immensely. One day she announced that she knew very few couples where she liked both the woman and the man equally, so she had decided to give dinner parties to which only one member of each couple would be invited.

How *avant-garde*, I thought adoringly. Much later I learned this was mainly directed against Harry Burnett, my husband, who she just did not like.

Just in case I missed the point, this truly great writer dedicated an entire novel to me a few years later. This was an enormous honor, but one with a hidden message. *Do With Me What You Will* is about a vague, disoriented blond, married to a tough Grosse Pointe lawyer who is an unsympathetic character. She finally gets the courage to leave him, only to be seen on the last page in hot pursuit of another man.

This disoriented *me*, so I asked Joyce "Is there a message for me?"

"Yes," she said. "Leave Harry!"

I didn't take her advice, but I did paint Joyce's portrait. You may remember her looks, which were vaguely those of a French waif—pale skin, large eyes and dark hair. I found her beautiful, because of her fragile, perfect features and amazing mind.

While she sat for me she seemed to go into almost a trance. While many sitters squirm restlessly while I work, Joyce didn't even seem to breathe. I wondered if she was conscious; she plainly was, because after the experience she wrote a poem about it:

Portrait

There the face is growing.
No part permanently shaped
but growing out of strange raw colors—
turpentine wash—
the eyes molecules that do not see me
and are wise with being immortal.

Here, I sit by the window.
In a big mirror behind the painter
I can see the face growing, my face
growing free of me—
it is floating free of me in the room
somewhere between the artist's darting mind
and my body.
My fate is outside me and I am afraid.

Shaped to the canvas in sure relentless strokes
it is myself being born from me,
the surface of myself peeled from me,
the facial skin reclaimed for that canvas.
The mystery of all our faces is here!
I think they are sinister and lovely,
growing over our blunt bones.

That is a face more delicate than the one
I would claim. It does not even breathe.
Light feeds it; small shots of lightning in the skin.
Beneath the harsh brush the pores
do not need to breathe, the eyes will never
close, the lips have nothing to declare.
It is at peace, being immortal.
It is a terrible fact.
I see how the fact of myself is a puzzle of parts
forced into a certain shape,
a tiny void filling an ordinary canvas.

> From *Love and Its Derangements*
> Poems by Joyce Carol Oates
> Louisiana State University Press
> Baton Rouge, 1970

That was more honor than I had any right to expect. But she went on to write a poem just for me, which appears at the very beginning of this book.

Detroit couldn't hold her forever; she was destined to be closer to the New York literary and publishing world. Joyce Carol Oates moved on to Princeton University as writer-in-residence in the 1970s, where she remains today.

She also remains a special friend, as well as one of the most impressive of all the people I have attempted to try and capture on canvas.

Rosa Parks

Rosa Parks is a true immortal—the small, quiet woman who earned a permanent place in American history by starting the modern civil rights movement. The world was changed forever by this little seamstress who refused to give up her seat on a Montgomery, Alabama, city bus to a white man, thus igniting a revolution.

After the bus boycott that followed, she became convinced she could never again find work in the South. She fled to Detroit in 1957 and has lived here ever since, despite urban blight, a major riot, and her own mugging. Years ago, one of Detroit's major streets was renamed Rosa Parks Boulevard in her honor.

So it was quite a thrill the day Rosa came to me to be painted as part of a series I was beginning of famous women. Using a cane and appearing quite feeble, she crept slowly into my studio. She needed a companion's aid to even get up on the dais.

Dignified but tired, she seemed centuries ancient. Her smooth grey-white hair was drawn into a bun, back from her handsome, well-lined face.

Curious, and with great respect, I asked her how old she was. To my amazement she was only seven and a half years older than me! Without thinking, I blurted out, "Shape up, Rosa! We're not old!" Her face lit up with a big smile.

While I worked, she told me the story of that day in December 1955, when she refused to give up her seat and go to the back of the bus. I can still hear her saying in her quiet, small voice, "Even if I had wanted to, which I certainly did not, I couldn't have moved... my feet hurt too much!"

She burst into laughter, so I will never know if she meant it.

Coleman Young, the city's first black mayor, was the one man white Detroiters loved to hate for twenty years. Not surprisingly, he

had more than a few choice comments about whites, most of which turned the air blue, but he and I got along wonderfully. I painted his portrait (naturally) and he gave a party for me. We used to look forward to occasionally seeing each other before old age, emphysema, and general cantankerousness slowed him down.

Coleman and I probably disagreed politically nearly all the time. But on two things we saw eye to eye: we loved Detroit, and we respected Rosa Parks. We were both horrified when in August 1994—as I began to write this book—word came Rosa Parks had been beaten and mugged in her own home, apparently by a drug addict.

My heart ached for Rosa—and, once I knew she would be all right—even more for Detroit. The fact is that I love the city. I lived in Detroit for decades after most white people had fled for the suburbs. The metropolitan area has perhaps the most beautiful places to live—at reasonable prices—of any city in the country.

But Detroit has become the Rodney Dangerfield of cities; a place that "just don't get no respect." That is largely unfair, but I think that like Dangerfield, we don't have enough self-respect to counter the myth.

Perhaps that's because we are often our own worst enemy.

An Edsel With Class

Detroit's new aristocracy is largely black—politicians, performers, and athletes. When, after I had lived for nearly half a century in the city, my husband Bob and I decided to move to a condo in Bloomfield Hills, I sold my house on Detroit's fine old golf course to one of our city's world-class talents—Aretha Franklin.

But the Detroit to which my mother and I came in 1941 was an automobile aristocracy from top to bottom. This was a small town—less than 300,000 people—in 1900, just before Henry Ford figured out how to make a whole lot of cars in a hurry.

By the time we arrived it had six times as many people, and while General Motors may have been bigger, the Ford family sat atop the pinnacle of car culture.

So it was a mark of social distinction to be commissioned by my stepfather's institution, Henry Ford Hospital, to paint the official portrait of Eleanor Ford, almost always known as Mrs. Edsel Ford, for their boardroom.

Eleanor had been married to Henry Ford's only son, and the old

man had made his boy's life a miserable one, totally dominating him and keeping him under his thumb until he helped drive Edsel into a premature grave in 1943. Despite her private sorrows, his widow went on to become a true *grande dame* of Detroit society.

I was thrilled with the assignment to paint her, especially perhaps because she was a generous patron of the arts—particularly, the renowned Detroit Institute of Arts.

I portrayed her raising a teacup to her lips in an easy, natural position. Unfortunately, I had to be out of town for the unveiling. So I sent it off to the hospital, hoping to hear rave reviews upon my return.

When I got back there was an urgent message to call the hospital—IMMEDIATELY. Naturally, I did the correct thing—I panicked. What could be wrong with the portrait? Stan Nelson, the director, came to the phone right away.

"Patricia, you will have to take the portrait back and fix it at once," he said in a stern voice. "Mrs. Ford is *quite* upset."

"Why?" I stammered.

"You have left out her most important possession," he said. "You left out her wedding ring!"

Patricia and palette sped to the hospital. Successful reconstructive surgery was performed in minutes, and a simple gold wedding band graced her hand to her complete satisfaction. Today, Mrs. Edsel Ford's likeness is among nine of my portraits to hang in Ford Hospital.

By the way, I don't want to give you the idea that she was just a society wife. We now know that she played a significant role behind the scenes in persuading her son, Henry Ford II, to take the reins of what was a slowly dying Ford Motor Co. right at the end of World War II—something that saved the company.

Former Secretary of Defense Robert McNamara stirred up a lot of controversy with his book about the Vietnam War, *In Retrospect*, (Times Books, 1995) but I was personally most fascinated by his account of Eleanor Ford's reaction to his decision to leave the presidency of Ford to join the Kennedy Administration in 1961.

"Mrs. Ford was particularly upset. She was convinced that her father-in-law, Henry Ford, had caused the death of her husband by placing him in a business environment so stressful it was certain to kill him. It did. She was determined that her son would not suffer a similar fate and had looked to me to shield him."

No one ever thought of her as a feminist but Eleanor Ford was another example of a strong woman who may not have ever known how important she was.

A Few Outstanding Contemporary American Feminists

The women's movement gave so much to me that I wanted to do whatever I could for it. While I could, and did, give money and time, I always wanted to do something for feminism with my only real talent—portrait painting.

Eventually I decided that I would paint a series called "Outstanding Contemporary Feminists," which I had originally hoped would grace the Women's Hall of Fame in Seneca Falls, N.Y. But sadly, the building doesn't have wall space for all my paintings. The Schlesinger Library at Radcliffe College in Boston wants to permanently display some of the paintings, including Rosa Parks.

However, it now looks as if my feminist paintings may never all hang in the same place—but maybe that isn't so bad.

What I do know is that my work will never be done and for that I'm glad, because the number of worthy subjects continues to grow. As of this writing, I have painted more than a dozen, and I am happy to say that doesn't even scratch the surface of contemporary American feminism.

Who do you suppose was the first woman in the series? No, not Betty Friedan, though my portrait of her remains a favorite of mine. It was of a too-little known woman named Ann Scott, once a legislative vice president of NOW.

Ann was no more the stereotypical comic strip feminist than I am. She was a beautiful and privileged woman who was born to luxury. Her parents owned the elegant St. Francis Hotel in San Francisco, where she lived with them. I painted her there, in a beautiful apartment filled with rich antiques. She was no armchair radical, but a veteran of the front lines of our struggle.

She took on Senator Birch Bayh—the Indiana Democrat who liked to style himself a liberal—and helped persuade him to fight for the Equal Rights Amendment. She also pushed hard for affirmative action for women as well as racial minorities. She accomplished much, got little credit, and set an example that deserves to be known.

While I painted her, we had a chance to talk in depth about

feminist issues, and I became convinced that she would be a leader whose greatest days were yet to come. Tragically, it was not to be; she died far too early, of cancer. We lost a great mind when she left us—a woman who was a true seer, who could actually glimpse the future.

Moscow Nights

Frances "Cissy" Farenthold was another highly impressive, forward-looking woman, but for a brief moment she made me fear that too much of our future might be spent in a Soviet hospital. Nationally, Cissy first won notice when she got more than 400 votes as candidate for the vice-presidential nomination at the wild Democratic National Convention of 1972, the one that nominated George McGovern and Thomas Eagleton. (Actually, the Democrats might have been better off with Cissy; Eagleton was soon dumped after it was discovered he had been treated for mental illness.)

Cissy next went on to stun the professional politicians by almost winning the Democratic nomination for governor in her native Texas, where she was one of a very few women in the state legislature. The prestigious *Almanac of American Politics* marveled at her showing, noting that she had run as a pro-choice liberal in a deeply conservative state in an era where it was risky to support safe and legal abortions (this was before *Roe vs. Wade*). She ran as a woman in a state of cowboys, a Catholic in a state dominated by Baptists and with little money and a campaign organization thrown together at the last moment. Yet, she did well. Why?

"Farenthold's main asset," the *Almanac* said, "was a powerful one in scandal-conscious Texas: honesty. Everyone knew she could not be bought."

Naturally, though our politics were different, I admired Cissy very much. We in the women's movement knew her as a president of Wells College and the founding president of the National Women's Caucus, so I was very proud to be invited, together with Cissy, to represent women as the guests of the government of the USSR in 1974.

My flight into Moscow was a pleasant one. Throughout my life I have seemed to be surrounded by doctors (my first husband, stepdad, son and son-in-law) and now I found myself seated next to a handsome, personable one, Dr. Bill Eden, who turned out to

be none other than the nephew of Sir Anthony Eden, the British prime minister who succeeded Winston Churchill, meaning that poor Sir Anthony had the misfortune to suffer comparison ever afterwards.

But the minute we landed, Cissy came down with flu, and lapsed into a deep melancholy along with it. She took to her bed for three days. I was a bit alarmed; at the time, I did not know how low she often was. Her friends, in fact, called her "La Madonna Dolorosa," because of her seeming inner sadness.

Fortunately, I had found out that Dr. Eden was staying in the same hotel. After three days, poor pathetic Cissy had experienced quite enough of Soviet medical wizardry. She called for me and showed me her back, which was covered with rings of deep blue bruises; a Russian doctor had applied heated glass cups to her back, a primitive method designed to bring up the mucus from her lungs.

She wasn't feeling any better, and she was, frankly, frightened. What, she worried, might be next? Giant leeches? Siberian flu camp?

The poor thing asked me to bring Dr. Eden to see her—and gallantly, he came straightway to her aid, after a few minutes' parley with the ugly gorgon who was minding our floor. (Every floor of every hotel where foreign visitors stayed had one of these creatures sitting there, usually scowling, in the bad old days of Communism. Their job was to dispense tea and spy on the guests, not necessarily in that order.)

What Bill Eden managed to do was get a large pot of tea from the gorgon, in which he poured the equivalent of a cup of sugar... plus the contents of a secret flask hidden in his pocket. He entered Cissy's room to find her laying flat on her bed—pale, perspiring, sick. "Ms. Farenthold, you must drink the entire contents of this tea pot. We will sit with you—for all night if necessary—while you drink it," he said.

Cissy moaned slightly. Dr. Eden got up, pulled a cap out of his pocket, and put it on a hook on the wall on the far end of her bed. He drew up a chair, sat down, and got her to drink one cup of his potion. Gently, he asked her about politics in Texas.

WHAM! Her head came up. Nothing can revive any politician faster than the opportunity to talk politics. She drank another cup, a little faster. Her face grew flushed, as she began to animatedly lec-

ture our good doctor, first on the politics of Texas, then those of the United States... finally those of the rest of the world.

By 2:00 a.m., just as she finished analyzing worldwide political strategy, the last of the tea had been drained. Dr. Eden stood up and pointed to his cap.

"Do you see two caps hanging there?" he asked Cissy. "If you do, you are cured! In England, we call this the "double cap cure."

Well, at last I understood where the term "nightcap" came from! The next morning, Frances Farenthold was up and around, good as new. That made me breathe a sigh of relief, for the Soviets had a nasty habit of quarantining any tourist who was ill for the entire length of their planned stay in the glorious motherland. The average Soviet hospital, by the way, was about as clean and inviting as the average inner-city gas station.

Only later did I learn why she was so depressed: her husband's son from his first marriage had gotten involved with Houston drug dealers. His nude body, showing signs of torture, had been found in the Gulf of Mexico just before Cissy left Texas.

Later, I tried to capture Cissy's complex personality in a portrait, done for the college she ran. I painted her with her dog, which had sort of become the Wells College mascot after he fell ill and miraculously recovered after a long stretch in which the students kept watch while the canine got round-the-clock care.

Painting her was an honor; merely knowing this dynamic and complicated woman was a gift I felt lucky to have been granted.

Gloria Steinem

Gloria Steinem has been one of my heroines for more than twenty years. We have marched together, laughed together, and our paths have crossed at numerous feminist conferences. I regret that though she always has been very nice to me, I never knew her quite as well as I might have liked.

Part of the problem was that often, when I ran into Gloria, I was in the company of Betty Friedan, my all-time mentor, and sparks often flew between the two of them. I have to confess that though I was closer to Betty, most of the "blame" for the antagonism didn't stem from her rival.

Gloria Steinem is a woman so centered and sure of herself that she is never jealous of anyone. She is not only bright, cool and self-possessed, she is innately kind.

Unfortunately, Betty Friedan is just the opposite in some ways—just as brilliant intellectually, but inwardly insecure, tormented by doubts hidden in her overactive mind. Her fights with Gloria are amply chronicled in Betty's own articles and books.

Naturally, when I first thought of painting a series of great living feminists, Gloria Steinem was one of the first names that came to mind. Generously, she immediately agreed to pose, and asked me to come to her offices at *Ms.*, in New York. She was then the editor of what was seen as a very radical magazine.

Was I thunderstruck when I arrived and was shown into a small room which served not only as her office but also as the office for no fewer than four *Ms.* executives. What's more, two of them had toddlers bumbling around the office in their diapers. It was *Ms.* policy to allow mothers to bring their children to work, both as a symbol of the disadvantages women faced and as a solution to a practical problem. This was back in the 1970s, remember, before day care was readily available.

Well, if I could paint in my mother's kitchen, I could paint in the middle of an editorial day care center. I set up my easel as best I could, stopped every few minutes to retrieve a brush from some sticky little fingers, and painted a sketch which was the basis for my completed portrait of this very compelling lady.

Whatever You Do, Don't Call Me Edith

Soon after that, I painted another famous woman who, however, is mostly famous for being somebody she isn't—and somebody she doesn't even like.

I am talking about Jean Stapleton, whose blood pressure still shoots up whenever a fan comes up to her and says something like "Aren't you Edith Bunker?" naming the character Jean played in the early seventies on the hit TV show *All In the Family.* Edith was the nice but ditzy nitwit wife of the bigoted chauvinist Archie Bunker, played by Carroll O'Connor.

Naturally, the real woman is far more complicated than the one-dimensional character she made immortal. Jean invited me to her home in Pennsylvania, where her late husband then ran a summer playhouse in which she and her children starred.

Jean's story was truly fascinating. When she was fifteen, she found herself the sole support of her family in Brooklyn. This future

actress's first job was as a typist with the USO during the war. The staff loved to put on plays to entertain the soldiers, and, since it was an all-male staff except for Jean, she was pressed into service as the female lead in all the plays.

Presto! Instant stardom! Her career took off.

What impressed me most about her was her warmth and genuineness. We have stayed in touch, and one recent Christmas she sent me a pair of Reeboks with a note that I simply *must* exercise more.

What really bothered me was that she was absolutely right!

This book would be a lot longer if I talked about all the other wonderful feminists I have painted, wish I had painted, or fully intend to get around to painting some day... when I am just a little older.

Mary Jean Tully, for example, who so generously gave a sizable grant to the Schlesinger Library at Radcliffe to preserve the oral history of some pioneering feminists, one of whom just happened to be me.

Another who I just have to mention is Gene Boyer, the woman who kept NOW's books in the early days, and who in 1991 taped hours and hours of interviews with me for the oral history project. I owe Gene an enormous debt both personally and on behalf of NOW. We had no sense of how to run an organization at the beginning and Gene kept us afloat.

She got us organized, turned our behavior around where it needed it, scolded us (and rightly so!) when we went over our budget, and made new women of us all. Nor do I mean to imply that she was a little clerical fuss-budget—far from it! She was always a joy to be with, someone who radiated wisdom.

But even more significant to me personally was her three-day interview of me, which when transcribed filled more than two hundred pages. While I can't imagine anyone except me ever wanting to read it, Gene has assured me that it contains some valuable material about women and my time. On a selfish note, it turned out to be invaluable as raw material for my own book. That's the essence of Gene Boyer; no matter what the mission, she inspires us to go on to better things.

Her incredible problem-solving talents and organizational

skills are echoed in another of my more recent sitters, Muriel Fox. They could have coined the word "knockout" for Muriel—both physically and professionally. She had to walk a tightrope for years; she was a top public relations executive for a major corporation at the same time she was quietly spearheading NOW's legal and educational fund.

What a fighter she is! She has a brilliant, well-disciplined mind and a superb gift for organization, which she happily threw behind the women's movement. I think of her, to this day, behind her desk, simultaneously wearing her corporate and feminist hats and constantly helping any of her sisters in any way they asked.

As I write this, I am putting finishing touches on my portrait of her. In it she is wearing a gently colorful and flowing sari, outdoors in the gardens behind her home in upstate New York. This portrait was done for the Radcliffe College painting collection as well, but Muriel—who is not selfish in the least—gave me one of the greatest compliments of my career.

She told me she liked her painting so much that she cannot bear to give it up. So we worked out a deal where she gets to keep it in her home for her lifetime, after which it goes to Radcliffe. I hope the library has to wait a long, long time!

What Marlo Thomas Looks Like Naked

Great. You had to ask? Seriously, why did I bring this up? To get you to keep reading, of course. By the way, forget the popular caricatures; in my experience, most feminists have been quite attractive. When the mind is vibrant, the body often follows.

We are also still fighting the old myth that most women can either be brainy or beautiful—but not both. Many men and some women would undoubtedly be very surprised to discover how attractive Betty Friedan can look when she wants to. And if you did a "man-on-the-street" interview and asked people to list a few "feminists" off the top of their heads, Marlo Thomas is usually not among the names that comes up.

But she is a powerful woman in her own right, one I feel honored to have known and have painted. Marlo Thomas is more a natural feminist than a professional one; a woman who has done things her way and succeeded admirably on her own—not nearly as easy as you might think for the daughter of a famous father.

Marlo's popular 1960's TV sitcom, "That Girl," gave many young women and girls the idea for the first time that it was all right for a woman to want to have a career.

I was commissioned to paint Marlo for the Women's Hall of Fame sometime in the 1980s. I dutifully schlepped off to Marlo's estate in Beverly Hills, laden with paint box, easel, lights, cameras, and backdrops.

Marlo greeted me, and I could see that she was excited and a bit nervous. She took me to her dressing room—a tiny space about, oh, the size of my living room—and asked me to choose the best dress for her portrait.

Finally, after plowing through racks of outfits, I came upon a shimmering coral chiffon dress and whirled around to hand it to her—

And to my astonishment, there she stood, absolutely *nude*, ready to put it on.

For some strange reason, I totally lost my bearings. Now I have painted scores of young women in the nude, including one very scrumptious one as a bachelor party present. But when confronted with this famous body in the buff, I didn't know what I was supposed to do or where to look!

Fortunately, she loved the dress, slipped it on, and we were in business. Incidentally, Marlo, who was well into her forties at that point, had a figure like that of a sixteen-year-old—maybe even a trifle too thin. Her magnificent eyelashes were her own, as was her cascade of wonderfully full-bodied hair.

To my surprise and delight, when the painting was finished she and her husband, Phil Donahue, liked it so much that I ended up presenting her with a framed, life-size photograph of the painting that is almost indistinguishable from the original.

I loved the painting I did of her in that dress so much that I have a copy in my house... even though my husband probably wishes I would have painted her *before* she slipped the dress on, though he is too much of a gentleman to say so.

Sometime after that, I was pleasantly surprised to run into Marlo and her husband at Eden Roc on the French Riviera. Phil Donahue had just been persuaded to move his popular TV show out of the Midwest, something he had never wanted to do.

"Marlo, how in the world did you persuade Phil to leave Chicago for New York?" I shouted to them from across the terrace.

"Good sex, that's how!" she shouted back.

Presidents Who Have Known Me

No, I have never painted a president—unless, of course, you count common garden-variety corporate and bank presidents. But I did do the portrait of one of our first ladies—Betty Ford—and looking back over my many adventures, what does surprise me is that I have met six U.S. presidents, and most of their wives.

Ironically, the president who I came to know best—and who, you may remember liked me enough to invite me to the White House no fewer than *nine* times—was a Democrat. None other than Jimmy Carter, that is.

Whatever else you can say about him, Carter was committed to women. He made a major effort to pass the Equal Rights Amendment, something I deeply appreciated. He and I spent a fair amount of time together mainly during the year I was president of the National Associations of Commissions for Women.

By the way, you may be surprised to learn that I found President Carter to be actually quite sexy, a quality that didn't come across on television the way John F. Kennedy's charisma apparently did. But Jimmy Carter was a very warm and good-looking man. And after all, he did tell *Playboy* that he lusted in his heart.

Franklin D. Roosevelt, was, as I have told you earlier, the first president I ever met, back when I was a debutante and had the political sense and knowledge of a goldfish. For a long time indeed, he was the only president I had ever met... until I ran into another Democrat, one Lyndon B. Johnson, at a fund-raiser for some forgotten cause in Washington in the mid-1960s.

Jimmy Carter may have lusted in his heart, but with LBJ, everything was much closer to the surface. We spoke together briefly, and I had the feeling that I was being sized up like a pork chop in the butcher's window. I don't remember much of what he said, but it was sort of uncomfortably suggestive. (By the way, don't think I am trying to imply that the divine Patricia Hill Burnett was so irresistible he couldn't help himself. We since have learned that he behaved like this with nearly everyone who had an X chromosome to her name.)

LBJ had a purely barnyard sense of humor: "I don't feel right until I put my brand on them," he supposedly said about the women who worked for him. Another time, when JFK's legendary

sexual exploits came up in conversation, he groused, "I slept with more women by accident than Kennedy did on purpose."

Lady Bird, on the other hand, was very gracious, very much a lady. As I recall, she and I talked briefly about her project to do away with the unsightly billboards that cluttered the nation's highways, one of the real contributions she made to this country.

Now, I wish I could tell you that all my beloved Republican presidents were far more nobler specimens of humanity. Alas, it is not so. For decades, the world tried to figure out Richard Nixon, so let me add my own observation. I was a Nixon watcher for years before I ever met the man, which I finally did in 1968, in Miami, right after the Republican National Convention nominated him for president for the second time.

I was very active in GOP politics at the time, as precinct delegate, local party treasurer, workhorse on the state central committee... and avidly sought contributor to party coffers. Work has its rewards, and one of the perks for my efforts was the opportunity to spend a little time with the newly nominated candidate.

Well, we didn't exactly have a wild and crazy time. My previous impression of the man was completely confirmed: Nixon was the very definition of stress, as rigid and constrained as LBJ was expansively crude.

While he talked with me, Nixon's every move was uptight. I don't at all remember what he was talking about, but I will never forget his body language: His restless hands, his wagging, seemingly unmanageable fingers, the stiff smile that would appear for an instant and then vanish. He seemed to have no sense of humor at all; something not surprising, given that he was brought up in a Quaker household where *piety* was more prized than *levity.*

I did not need a psychology degree to recognize a man trapped in paranoia and anxiety, and though no one then could have dreamed of what would happen at Watergate, it came as little surprise to me that the man I met in Miami got caught trying to bug his opponents and then lost his job... for bugging himself.

Pat Nixon, as I discussed in an early chapter, must have been one of the saddest women to inhabit the planet. However, there was one thing you can say I did admire about Richard Nixon: his dogged determination to succeed at all costs, to win the presidency, and then—after he had lost the White House because of his

own personality defects—he fought just as tenaciously to regain respect in the public arena.

Towards the end of his life, he did win a measure of it back, and was regarded as a valued elder statesman on foreign policy issues. Some say that he and Pat grew closer in their later years. Like millions of other Americans, I was startled to see him crying openly at his wife's funeral in 1993. Ten months later, Nixon joined her, taking the riddle of his baffling personality with him to wherever he has gone.

His successor, Gerald Ford, was an affable man who I had known slightly for years, since he was from my state. He was the only man from Michigan ever to become president, something that happened by pure accident. Ford certainly never would have gotten there on his own. He was, essentially, a jock; a one-time assistant football coach at Yale who managed to get through law school, win a safe seat in Congress, and later become president in a crazy time.

Ford was, however, blessed with an amazing wife. Her successful battles against breast cancer while she was in the White House and then alcoholism later inspired many women to get checkups and to put a check on their own drinking, or fight the alcoholism of their loved ones. Betty looks youthful in the portrait I did for her; it reflects, I think, her resilient and refreshing spirit.

With presidents, as with so many other things in life, the best should be saved for last. Ronald Reagan is now thought of mostly in light of the tragedy of his Alzheimer's disease, but in his prime— that is, when he was *my* age—he was one of the most appealing presidents we have ever had. He had impeccable timing, a skill no doubt honed in Hollywood, a very genuine sense of humor, and a modest demeanor.

He also gave a nation badly starved for optimism some hope for the future—which is why I think even people who disagreed with him politically often loved him. My first real chance to chat with the Reagans came at his inauguration in 1981 when I was invited to watch the parade from the lair of a Democrat—House Speaker Tip O'Neill. The President and Nancy dashed up there just before the parade started, to press the flesh—and to go to the bathroom. That was a glorious day; they were in a state of high good humor and

excitement. Whatever the tabloids may have said, it was obvious to all that Ron and Nancy Reagan were very much in love.

What, people sometimes ask, might I have done differently if I could live my whole life over? Usually, I say: *not a thing.* I have had it all and loved it.

I will, however, let you in on a little secret: many years ago, after I had been Miss Michigan, some politicians came to try and recruit me to run for the state legislature. Back then my parents were scandalized by the idea and I was politically asleep, and so nothing ever came of it. But if I could do that over, I would.

Today, we often speak of politics as being disgusting and corrupt. But I see politics as a glorious adventure and only hope I live long enough to see the first woman president. Were I a few years younger, you can bet that I would be right in there running for something. But on the other hand, if the next Republican presidential nominee wants to add a little wisdom to his ticket, maybe enhance its appeal ...

Well, you know my motto: ***Never Say No!***

Traveling Against the Sun—
Alone and Unafraid

Just remember, we're all in this alone.

–Lily Tomlin

*W*hatever differences we had, my husband, Harry, and I eventually found ourselves brought closer together by a foe that strikes men and women alike—cancer.

Both of us—like millions of people every year—eventually got the diagnosis everyone dreads. Fortunately, I won my struggle, thanks to the wonders of surgery and—I am firmly convinced—a positive attitude. My doctors couldn't get over it; I kept a smile on my face even as they told me that I had cancer and would need a hysterectomy.

Now there were times earlier in my life when my sunny disposition may not have been such a good thing, as when it prevented me from openly confronting my anger. That may not have been healthy—but at other times, I think a positive spirit has saved me. I decided I was going to beat cancer, and I did.

Napoleon once said something like, "I am surrounded and hopelessly outnumbered by superior forces. The only thing to do is... attack!"

That's my philosophy of dealing with a major crisis—you might say the flip side of "never say no" is "never say die." Never give up! On the other hand, the night before my surgery, I looked back and thought that if something did go wrong, I could be content to think that I had a mostly wonderful life, full of all sorts of adventures.

You hear about people who say on their deathbeds, "Oh, if only I had taken that trip to Italy" or "If only I had possessed the courage

to try to get into medical school." Actually, when it was my turn, I found that having cancer was somewhat easier for me... because I felt I had died years before.

Back in the 1960s, when I got hepatitis so badly in Mexico, I spent weeks—months, really—very near death. Near enough that I expected to die; I had said all my prayers and set my soul to rest, more or less.

When I came back, I was so amazed and delighted to be alive that I decided: *Every day from now on is a present, a sheer bonus, and I am going to live so that if I die, I'm not going to regret it a minute. When I go to bed every night, I say to myself: Have I had a good time today? And if I haven't... by God, I'll have one tomorrow!*

So when I finally get to the end, what I really want to be able to say is, "Wasn't it grand! I loved it! I've lived to the utmost degree that I possibly could, and I'm really ready to go. I don't regret a thing that I've done; I just wish I could do a little more."

But I'm certainly in no hurry to get to what will either be the end... or maybe an intermission. I want the show to go on forever... as long as it is enjoyable.

Sadly, Harry's show was not nearly long enough. When he was barely sixty, he was diagnosed with prostate cancer. We fought the beast together, and got nearly ten years that we otherwise wouldn't have had. We discussed options and looked for the best doctors together, all around the world, and the experience brought us closer.

I truly cared for him, and in a way, there was a total change in our relationship. He needed me for the first time—needed someone to care for him.

I had always had a feeling of continuity with Harry, but for the first time, I found within myself enormous wells of compassion for him. I liked having him in my power; I babied Harry and took the very best care of him that I could. But finally, his cancer spread, and in June of 1979, I found myself a widow.

Regrettably, near the end, I wondered whether he doubted that I really loved him. What I wish he had known was I loved him then more than ever.

I was very calm until the day after he died, when I went to get out of bed and, the next thing I knew, I had fainted and been rushed to the hospital by my children. Harry's death was that much of a shock to my system.

Harry may not have been the most enlightened man on femi-

nist issues, but he tried, and one other thing needs to be said for him: his children loved him immensely. His death especially affected Hillary, who was twenty-four at the time and was studying to be an Episcopal priest at Harvard Divinity School, the site of my feminist planning conference a few years before. When Hillary realized that her prayers had failed to save her father, her faith was so shaken that she gave up studying for the priesthood.

My own views on the subject of the afterlife were best stated by my stepfather, Dr. Jean Paul Pratt. Once, when somebody asked him about life after death, he said:

> *I had a little dog whose name was Rover*
> *And when he died, he died all over*

After that... well, we don't know, do we?

Dr. Pratt, by the way, lived to be very nearly a hundred years old. But towards the end of his life, he swallowed a pill which got stuck in his throat; complications set in, and he eventually found himself lying there full of tubes and needles.

That was not life—to him or to me. One morning they found that he had just ripped all the tubes out, and determinedly died. What a wonderful man. In a sense, a decade before anyone ever heard of Dr. Jack Kevorkian, my own Dr. Pratt performed the first "physician-assisted suicide" on himself. I see both men as brave angels of mercy.

Don't think I am against religion. It may offer wonderful consolations to some, but we still have to take things one world at a time. For the foreseeable future, we are stuck in this one—and when Harry died, for the first time in more than thirty years ...

I was single again.

And that, I suddenly realized, meant something entirely different in 1979 than it had the last time I was single, in 1948. For one thing, I was not a divorcee with a slight cloud over her head, No, I was a respectable, independently wealthy widow.

Incidentally, I had always known Harry was well off, but not until he died had I any idea just how rich he was. You may remember, he never would let me see how much he made a year. He certainly didn't starve us, but we could have lived much better than we had! Not that I should complain; the opposite would have been so much worse; think of all the women who thought they were financially secure.

But now—for the first time in my life—I was truly independent, under neither a mother's nor a husband's thumb. Society had changed too, so that a single woman with the means could do just about anything she pleased.

Was I thinking of getting married again?

Heavens, no!

My Life As a Swinging Single In Her Sixties

That doesn't mean I didn't want anything to do with men. For a while, of course, I was in mourning for Harry—but once you've known a good relationship, as ours was at the end, you don't want to be totally alone.

I was a widow for ten years, and in that time, I went out with a wide variety of men. This was the dating experience I should have had as a young woman, but did not, thanks to my mother's manipulation and the state of society at the time.

That is not to say I didn't go out with boys before I was first married—I dated boatloads of them. But we never really got to know each other as people; our performances were as scripted and artificial as the actors and actresses in a Kabuki play. Remember, I was told, back in the 1940s, never let my beaux know that I was smart, or—shudder—that I might have some ideas of my own!

Well, the Patricia Hill Burnett of the 1980s had her own money, her own convictions, her own mind, and she was damned well going to let them all show! My attitude when I was single for a third time was that any man who wanted to be with me better like it—or he could take a hike. After all, as my wonderful friend Sonya Friedman puts it in the title of one of her books, "Men are just desserts."

You've all heard Gloria Steinem's saying, "A woman without a man is like a fish without a bicycle." That's cute, but not quite the way I felt. My feeling was that men were like buses; if you missed one, another would be along before too long.

Wonderful philosophy! Did I always live up to it?

Certainly not!

For one thing, I had been raised a geisha, and old habits die hard. For another, as I mentioned much earlier, I am attracted to a certain kind of man, the kind who is more like John Wayne, say,

than Alan Alda. Powerful, ambitious men, who know what they want, go after it, and are accustomed to getting it.

But the qualities that make for success in the business and professional arenas sometimes aren't good ones for fostering an equal relationship. And most of the ambitious and powerful men of my generation didn't exist in a pro-feminist culture.

Not that I limited myself to men of my vintage—I was almost fifty-nine when Harry died—or older. Having married father figures the first two times out of the gate, I went on a youth movement for awhile.

For several years I was involved with a charming and witty French diplomat who was more than ten years younger than me. What finally happened was that I found myself in a disco at three a.m. and had to ask myself, "Patricia, *what* are you doing here?"

Eventually, however, it was time for the relationship, like all good things, to end. I must say that it took a while to get this across to him in an appropriately subtle French way. Finally my maid and I nicely packed up all the gifts he gave to me and returned them to him. That seemed to be the hint he needed. He is now back in France and we have remained good friends and stay in touch.

Wrinkles are not, by the way, the main argument against dating anyone much older or younger than yourself; lifestyle and cultural differences are. I knew of a single woman in her fifties who kept a cartoon taped to her bedroom mirror. It said, simply: *Never wake up with anyone who doesn't know who Adlai Stevenson was.*

What was, by far, the nicest part of being able to "play the field" again was getting to know a wide variety of male personalities. Married women may have male friends, but only to a degree severely limited by society. Young (and presumably virginal) women of my era were heavily chaperoned.

But I discovered to my glee that there is nothing freer than an honest widow in her sixties... with an independent income. I didn't feel sixty, by the way, and thanks to good genes and a little artificial assistance here and there, I don't think I looked it.

Few people then knew how old I really was, and I have never felt the age that my passport claimed me to be. Even today I feel no more than forty-five ... on a *bad* day.

Speaking of interesting personalities... I went out a few times with Chrysler Chairman Lee Iacocca, who lost his wife, Mary, to

cancer about the same time Harry died. We were never a hot romantic item, but he was a fascinating man; remarkably open about the way he felt about just about everything. Iacocca has a reputation in some circles as a gruff curmudgeon, but I never saw that side of him. On the contrary, he could be quite kind. One thing I will never forget is that perfect strangers were always coming up to him. We could never go to a restaurant, say, without somebody coming up to him with an idea for a car design. He was always very polite, thanked them, and accepted their sketch for a five-wheeled car, or whatever it was.

Eventually, as do so many men of his age and class, he married two much younger women, and went through two messy, public and very expensive divorces.

For a while, I dated a very elegant British lord, and moving along the commonwealth, also went out with an impressive, but hot-tempered Canadian businessman with whom I shared one of the more unique adventures of my life: Being attacked and nearly boarded by pirates on the high seas!

Patricia and the Pirates

You may have gathered by now that I like to travel. But if you think that only means going to developing nations and dictatorships to hold secret meetings with feminists in abandoned warehouses—honey, I am about to disillusion you.

Patricia Burnett also thinks there is nothing wrong with enjoying life.

Such as cruises. The Canadian businessman and I had a chance to test out a brand-new yacht, *First Impressions*, in April 1986, on a voyage in which we sailed the Antilles, from St. Lucia to Martinique, in just over a week. Unfortunately, our cabins were not air-conditioned, but we managed to survive with sea breezes, roughing it through the night on Dior sheets and washing up in the morning with Gucci soap.

Everything went well, until we reached a bay in which we intended to drop anchor for the night. I looked up to see several boatloads of natives approaching our yacht. As they drew closer, we could see that while they had no peg-legs or eye-patches, they were anything but friendly.

There didn't seem to be enough time to begin a serious painting,

so I started taking snapshots to capture the images of either our visitors or our murderers.

"You will give us money! You will give us food!", they shouted. Our captain, a grizzled Frenchman, tanned as dark as a walnut, ordered them to be off.

They responded by cursing, throwing a line over our railing, and trying to board. This was getting serious. Finally the captain brought out his largest knife, pointed it at them, and began cutting their line. They didn't take the hint, so he and the other two crewmen got firearms from their cabin.

The captain fired a warning shot at a half-submerged wreck not far from our ship. "Ping!" the bullet went. He stared at the pirates.

We civilians held our breaths. What would they do? Did they have guns or, maybe, flintlock muskets concealed in the bottoms of their boats? Apparently not, or else we were just too resolute for them: They eventually drifted away, enthusiastically cursing in three languages. We pulled up anchor and searched for a more peaceful cove.

Whew! Guess I'll never know what my ransom would have been ... or if the children would have paid it.

Later, we gave the St. Lucia police copies of the close-up shots of the pirates, though I never found out if they were caught.

By the way, how do I remember all these details so exactly?

I want to let you in on a secret: My memory for facts, figures, and dates is *terrible*. This isn't old age softening my brain; I was like this when I was thirty. It may be the nature of the artistic mind; I can quite easily remember with photographic clarity, the details of paintings I finished decades ago.

Partly as a memory aid, partly just for fun, I started taking a nicely bound blank book with me when I started traveling extensively after Harry died. Everyone has some "down time" on a trip, and I use mine to create an illustrated diary of my adventures, complete with photographs, my own drawings or watercolors, what things cost, and the names and addresses of anyone interesting I travel with or meet.

I get my snapshots developed as I go along, and my journal is always finished the day I come home. You have no idea how fun these are to make and useful to have. If a friend calls and says she is going to St. Lucia and wants to know the best street for shopping,

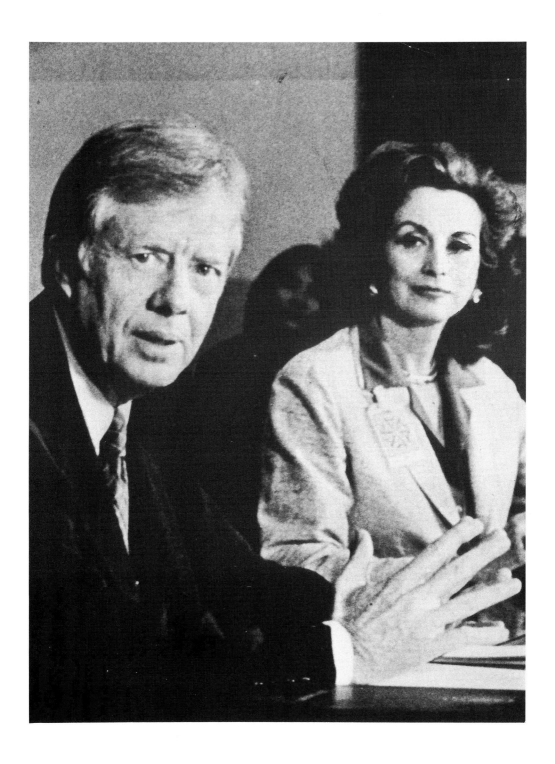

New York Times photo of President Jimmy Carter and me holding a conference on the Equal Rights Amendment (ERA). He invited me to the White House on nine separate occasions.

above
President Gerald Ford,
another Michigander.

left
Coleman Young, longtime
Mayor of Detroit, with my
portrait of him.

above
My most important commission, Indira Gandhi.
I was wearing the sari that fell to the floor.

right
Violetta Chamorro, President of Nicaragua, with me at an International Women's Forum event.

above
Gloria Steinem, Betty Friedan, and me at the NOW conference rally in Detroit.

opposite page
top
Betty Friedan, when I presented her with her portrait.

bottom
Gloria Steinem, while I was painting her portrait at her *Ms.* magazine office in New York.

above
Margaret Thatcher sharing a laugh with me as she poses in front of her portrait for the media in the Royal Academy of Arts in London.

opposite page
top (from left to right)
Melina Mercouri, Greek actress and politician, and Margaret Papandreou, then First Lady of Greece, and me attending a tea in my honor.

bottom
Corazon Aquino and me at the Malacanang palace in Manila.

above
Joyce Carol Oates and me at a
garden party in Detroit.

above left
Dr. Sonya Friedman and me.

middle
Marlo Thomas and me.

left
Marj Levin, my partner in
NOW and other adventures.

in a flash I can tell her the Rue Victor Hugo, between the Boulevard Allegre and the Rue de la Liberte.

Fallen Angels

Somehow I always seem to have slightly tilted adventures. One place I always wanted to see close up was Angel Falls, in Venezuela. Water tumbles down a cragged, 8,000-foot mountain, one of the most awesome sights in nature.

What I had to do was see it as close up as possible. My guide told me it was only an hour's walk down a path to a major viewing point. That sounded fine to me—I was then barely seventy. However, he never mentioned that the "path" was purely a network of intertwining roots, tree-trunk bridges over streams and a few mud-filled sinkholes. Naturally, I was dressed appropriately: one soggy, thoroughly wilted straw hat over a pure silk cocktail outfit. (At least they were silk *slacks*—give me a break!)

Incidentally, I always say that my idea of being sporty is to take off one ring. Well, I got there all right, rings and all, but the mist clouded over my camera. Next I took a wet, rapids-filled boat trip to the base of the falls, at the bottom of the Anyan-Tepay mountain which is their source. This view still wasn't satisfying enough for me.

The solution was clear: I had to hire an airplane. I found a nineteen-year old pilot who had a small, aged passenger plane, which had been so battered that the doors had to be wired shut. My idea was to photograph the falls before the ever-present cloud masses shut out most of our vision. To do that, we had to leave before 8 a.m., not an easy task for this night owl.

But I was determined. We got up, beat the clouds, and my shutter was furiously snapping away. Naturally, I had to tempt fate.

"Can't you get a little bit closer?" I asked the pilot.

He shrugged. *Sure, Señora:* He buzzed towards the falls and *turned the plane on its side,* exactly parallel to the sheer mountain wall. This would have been stomach-churning in any event. Unfortunately, I did not have my seat belt fastened; I had taken it off in order to better maneuver my camera.

Wham! Thud! I fell right down into the passenger door!

Fortunately, the wires held. I survived, I got my pictures, and

came back alive. Later, in my travel diary, I wrote my code word that I often use when I run across some gross outrage against women or feminist principles.

This time, however, I used it to say it all:

Help!

How to Rent a French Villa

Have you ever dreamed of taking a villa in the south of France?

This is where you might expect me to tell you that it isn't really as great as it is all stacked up to be; that you might as well go to Coney Island, right?

Wrong! Take it from one who has been there and—here's the key—even paid for it on her own: it is simply marvelous!

Fifteen years after the historic car trip in which we decided to start a chapter of NOW, my friend Marj Levin and I saw an ad in *Town & Country Magazine*, and rented—sight unseen—the Villa Lou Crissou above Gulfe Juan.

We survived an extremely tight Paris-Nice airport connection and a car rental agent, who, like every car rental agent in Europe, professed to have had no idea we were coming. And we endured the other usual stresses and strains.

All that was worth it when we discovered, at the end of a winding mountain road, a most exquisite villa, hidden among a host of flowers and bougainvillea.

What you quickly learn on such a trip is this: 1) lots of money is a good thing; 2) clothes that seem *avant-garde* by Detroit standards suddenly look far too frumpy at Cannes; 3) even more money is an even better thing; and 4) nice bodies by Detroit standards often look pale and plump (no names, please!) compared to the forest of excellently sculptured mahogany lying on the sands of the Cote d'Azur.

Topless bathers are about as rare in the South of France as sand. After several days, we were lying on the beach at Cap Antibe when Marj suddenly said, "If I dare to take off the top of my suit, will you?" Granted, I was not even sixty-four at the time, but I was a bit daunted, until I remembered my life-long motto:

Never Say No Unless They Ask You if You Have Enough

So, I promptly rolled my suit down to my derriere. We even photographed each other, and lived to tell about it. Those snapshots, by the way, are on public view... in a sealed lead box buried under the highest mountain in the Pyrenees.

French women are often regarded as some of the most liberated in the world. That may once have been true sexually, although there are more myths about sex, than anything else. But as with most things, reality is far more complicated. I winced that summer when I heard that international symbol of French Riviera woman, Brigitte Bardot, quoted as saying, "A woman is not made to live a man's life. A woman is so very vulnerable... a woman is a gentle creature."

On the other hand, I got a bittersweet chuckle out of something said by Françoise Giroud, who was once a French cabinet member, "I only ask that working women have the same right to be mediocre as men."

Whatever that trip was, it was not mediocre. All in all, it was excellent from start to finish, so much so that I decided to do it all again the next year, except this time I got smart. I knew that after a year of talking about how splendid it all was, my family and friends would want to descend on me while I was there. So I rented two villas—one for me and one for company.

One very charming visitor I had told me an even more charming story. Sir Alan Dawtry, a former mayor of Westminster and then the British chairman of Sperry-Rand, had been a fast friend of mine ever since we had met in Palm Beach in 1980. When he found out I was in France, he "popped over" as soon as he could from the firm's international headquarters.

Sir Alan opened my eyes to the fact that while we think of business affairs as dry as dust, the histories of many firms would be more fascinating than paperback novels, if all the facts were told. Every business is, after all, about power and money. And when you have money and power involved, sex is seldom far behind.

Just to prove it, he told me the fascinating story of an heir to an industrial fortune who, or so legend had it, invented both a parachute and an auto-pilot in the early days of aviation. This fellow knew what a self-propelling airplane was good for; he announced to his friends that he and a pretty young wife (someone else's, *mais oui*) were going to be the first couple to have sex in the sky.

Lucky Lindy, eat your heart out. The historic day came, a few

friends in the know gathered… but machines will be machines, and the autopilot failed. The plane had to make an emergency crash-landing, and those on the ground got an eyeful as they saw both the inventor and his socialite friend tumble naked from the airplane!

Later, after he made a few minor adjustments, he took off from England, to demonstrate and hopefully sell his plane in Holland.

Sadly, the Dutch are still awaiting his arrival.

Wonder if the fish ever figured out how to use the autopilot?

Further Adventures of Patricia Among the Commies

You may by now have figured out that I seem to have a knack for being in odd places, and at odd angles at odd times. Sometimes I traveled with the sun, sometimes against it, and sometimes, in small airplanes, more or less at right angles to it.

But an artist needs to work from different perspectives, yes? Looking back, I see that for a committed capitalist I took a lot of trips to communist countries. Once, I went to China as part of a group of twenty-five "distinguished women" (Beijing's description—not mine). We were invited by the government for a three-week tour which was billed as an opportunity to do "research" on the status of Chinese women.

Naturally, it was a government propaganda exercise, but I had fun anyway. When I sent them my resume and a brochure I send to potential portrait clients, I was asked if I would give a portrait demonstration for art students at the University of Beijing (which I grew up calling Peking). Naturally, I was more than happy to do it, and to my great pleasure and surprise I was given as payment a lovely antique box of gold filigree circled by three jade bracelets and encrusted with amethysts.

That thrilled me more than any money would have done. Matter of fact, the only thing that did not delight me about the entire experience was dining on Chinese food three times a day, every day. Finally, one evening in Canton, a glorious change! I was served what seemed an exact duplicate of a fine boeuf Bourguignon, right at a point when I was extremely nostalgic for excellent French cuisine.

"I *must* have the name of this superb dish!" I told my interpreter. She quivered with happiness. "It's called savory dog meat stew," she announced proudly.

I did somehow end up spending far more time in the former

Soviet Union, than I did in any of socialism's branch offices. Traveling in the workers' paradise did take some getting used to, and I suppose there is a file gathering dust someplace that indicates that the KGB felt that Patricia Hill Burnett took some getting used to as well.

Take my jewelry, for instance—which they did, for a time at customs. Now, when I go to more primitive countries I do rough it somewhat; the first time I landed in Moscow, I had only one velvet bag full of nice jewelry with me. However, the customs people had a fit. You would have thought I was a smuggler. Actually, they *did* think I might be a smuggler, or at least thought I might be planning to sell it illegally.

Eventually they gave it back to me, with a friendly hint that if, when I left, I showed up carrying one diadem less than I arrived with, I might find myself building a new trans-Siberian railroad, or something, in February. With my bare hands.

How silly. Patricia leave anywhere with less jewelry than she came with? Not even a socialist could possibly believe such a thing. This is the time to admit that not every idea the communists had was bad, by the way: I took an overnight train trip once between Moscow and Leningrad, only to learn after I had settled in that the sleeping compartments accommodate four persons and are not segregated by sex.

I woke up in the morning to find a strange man sleeping no less than eighteen inches away from me. That was at least interesting, and I couldn't help but wonder whether if Amtrak might show a profit if it revised its sleeping car rules along Soviet lines?

You learn, by the way, how much our conception of beauty is tied to our particular culture. Spend a few weeks on Russian beaches with women whose upper arms are the width of your torso, and you take away a definite impression.

Soviet women, by and large, were not tiny. Once, in Latvia, I had the honor of visiting something new—a sanitorium for weight control. Looking around at a considerable sea of flesh, I told the director that there did indeed seem to be a real need for his specialty. He couldn't have agreed more.

"Yes," he said eagerly. "If you had stayed here for just a few weeks, we would have had you fattened up in no time at all!"

Life on my own, as a widow, you see, was not so bad. Partly this was because I was not really alone; I had my friends, I had my family, one or two gentleman admirers, and perhaps most rewarding and fulfilling of all, I had my work.

Matter of fact, I had two full-fledged careers: one, as an international feminist organizer, spokeswoman, nagger and den mother, and a second as a portrait painter skilled enough to win commissions from women like Indira Gandhi and Margaret Papandreou.

I thought I needed to get married again about as much as a wild cheetah thinks it belongs in the zoo. I fully intended to keep my long-overdue freedom... Until a funny thing happened.

I fell in love.

A Feminist Geisha Finally Gets it Right

Happiness is a matter of choice.

−Carolyn Warner

*T*he first time I ever saw my husband was when he grabbed me in the airport.

Perhaps I should explain...

While I mainly think of myself as a painter, I also like to sculpt in clay and wax and have won a number of awards for my sculptures in bronze. I once even did a very popular bronze door knocker of a fetching young thing who had gone out without any clothes to get the milk ... but that's another story.

Anyway, I had allowed myself to get talked into going to Boston sometime in August 1965, to sculpt the head of a nine-month old little boy. This was quite a chore. Babies, you see, are even worse than fidgety psychiatrists or businessmen about holding still for portrait painters, and they couldn't care less whether you've had any interesting dreams. It is also illegal to give them gin.

I took a suite at the Copley Plaza, ended up spending all week standing over the crib, trying to capture this child's expression while I fed his mother sandwiches. In the end, my expenses were, sigh, more than my commission.

But he was a very precious child, and finally, I finished a clay model of the infant's head. It wasn't quite dry when I was ready to go back to Detroit to have it cast in bronze, so I carried it into Logan Airport on a board.

There I was, in line, trying to maneuver tickets, luggage, and a piece of wood with this wet lump of clay on it. The clay was wrapped in wet towels, and inevitably, before long, it started to slip. Suddenly a huge pair of masculine arms grabbed me and the board in a powerful but gentle embrace, saving the baby. I turned around to see a pair of the deepest brown eyes and one of the most handsome men I have ever seen in my life.

Wow, what a hunk! I thought. He introduced himself; he was Robert L. Siler, at the time a vice-president of the Ralston Purina Co. in his native St. Louis.

I was certainly attracted to him immediately, though at the time I was quite married—as was he. But we clearly were on the same wavelength, and what I think I responded to most was the respect I instinctively felt he had for me, something that had often been lacking in some of the men who were most ardent about courting me.

We chatted a lot on the flight back (after all, he had already proved he wanted to keep my head on straight) and by the time I landed in Detroit, we were friends. Later he came and visited us and got to know Harry and the children.

From time to time, he stayed in touch. He eventually, like so many powerful and ambitious men, went into business on his own, as a highly successful food broker and a consultant to people in the grocery business. Naturally, before I met him, I didn't even know there were food brokers; if I ever thought about it, I probably imagined farmers drove up and backed their trucks to the rear doors of Kroger or Safeway.

Not exactly! The grocery business, I know now, is one of the toughest and most competitive there is. If you want an idea how highly regarded Bob is, I will brag shamelessly, a day seldom goes by without some executive in California or Colorado—or Sao Paulo—calling him to come out and help sort out their company's operations.

Bob was a wonderful friend of our family, and we looked forward to seeing him several times a year when his travels brought him to Detroit or other cities where we would be. We continued to see each other after Harry died. Over the years I realized Bob wasn't happy. Eventually he and his wife were to divorce, and I had come to an astonishing conclusion: after having traveled and dined with more than one eligible man, Robert L. Siler was the one I wanted to be with. Only him.

Why? Well, he was brilliant, charismatic, successful, a strapping six foot four, and one of the wisest and most worldy men I have ever met. The real reason, however, is that I had fallen in love with him. What made it especially wonderful was that he felt the same way!

When he asked me to marry him, it must have taken me ummm... about sixty seconds to decide. We were married in October 1989, nearly a quarter of a century after we met, by a wonderful Episcopal priest, The Reverend Nancy McGrath, who insisted on giving us some pre-marital counseling... which we thought was amusing and a little absurd, since between us we had already logged more than seventy-three years of marriage.

Two people were there who had also been there for both my other weddings; me, of course, and my mother, still going strong at ninety-three and still occasionally trying to dominate me. Bob's mother and dad, a youthful ninety-one and ninety-two, respectively, were also there with quite a few of their contemporaries. Shirley Eder, Detroit's renowned Hollywood reporter, said it best: "Well," she sniffed, "I never saw as many canes at a wedding in my life!"

We had a wonderful ceremony, but did not, however, immediately move in together. He was living in Chicago at the time; I was living in Detroit, we were both in our sixties, and Bob had not yet retired... still hasn't, in fact.

For once, I had not married a man a generation older than myself. On the contrary, I am four and a half years older than Bob—something that makes a lot of good sense, when you consider that women live, on average, seven years longer than men.

What was especially fun was that not long after we were married we went to my fiftieth college reunion, and Bob's fiftieth high school reunion. For a while we had a commuter marriage, seeing each other on long weekends, holidays and vacations, but after two years, we decided we needed and wanted to be together all the time.

Finally, we hit upon the perfect compromise... Bob moved to Detroit.

For a time, we lived in my old house on Hamilton Road, until finally we decided it was time for a change. Everyone should move once every forty-five years, don't you think? Today, Bob and I live in a lovely, large condo in Bloomfield Hills, where the walls of glass make the lighting superb and the sun streams through the windows of my new first-floor studio. Bob and I both have offices below, with two desks facing each other, and two computers side-by-side.

We live together and work together. So is it pure bliss? Certainly not! We are human. Bob Siler is a very bright, opinionated businessman who is used to running his own show. Patricia Burnett has been rumored to like having her own way, as well.

Both of us are complicated and sometimes difficult people. Yet I have never been happier, largely because Bob treats me as an equal.

We have to constantly be careful that we don't start walking over each other—or allow ourselves to be walked over. Yet we are careful, and we are considerate, and we give each other space. I may head for China to attend an international women's forum; he may go off to Arizona to spend a few days with a troubled grocery chain.

The inside of the house, except for his office area, is my domain, to run as I please. The outside is his, and he is a marvelous gardener.

But we make sure we do as much together as possible. Often I travel with him on his longer business trips, and then peel off for a few days and sightsee or visit my children and grandchildren, if any of them are anywhere in the vicinity.

When he goes abroad, I always go along, and sometimes take my own little side trips or go to feminist functions in whatever country we are in while he is busy with business. Later, we make a point of enjoying some of the trip together.

What we have is real, genuine, mature romantic love. It isn't blind idealism by any means. But I really feel that in marriage, if you put forth your best efforts, and you dream that your spouse is going to be all you hoped for, you are likely to succeed.

Why? He or she is so elated at being elevated to a pedestal, that if they are mature and experienced enough, they are darned careful. Having lived a long time makes you value integrity, serenity, constancy, and peace.

Not to mention that most priceless of truths—the knowledge that you alone can make yourself content and fulfilled. No one else in the world can.

The marriage of two mature people is also apt to be complicated by children—his and yours. Bob and I make a point of enjoying ours—while trying to avoid either smothering or being overwhelmed by them. "The only thing that seems eternal and natural in motherhood is ambivalence," Jane Lazarre said. How true, how true!

Now, I have never been ambivalent about loving any one of my

sons or daughters. It is just that when they get into difficulties or are making what seems to you a wrong decision, it is hard to keep absolutely out of it, unless they ask me for advice.

Somehow, while I honestly do love them all equally, I seem to have spent more time fussing over and worrying over my daughters, perhaps to compensate for the fact that, in spite of everything, this is still very much a man's world.

Whatever you say, this remains a culture stamped with the imprint of centuries of sexism, and even the staunchest feminists are bound to be affected by it, and that includes my favorite example—me.

For centuries, men have divided women into two categories: beautiful or brainy. That is one of the things the women's movement was supposed to be against, but I soon more than suspected some of my feminist colleagues thought I was a little dumb. Possibly because I always try to have a smile, because I always seem to be light-hearted—but also, I think, because I had been a Miss America finalist.

Well, eventually I caught myself applying that same misguided principle to my own daughters, with much less justification. When they were children, they were always very pretty girls, and both were bright, but one clearly stood out as brilliant, and the other was seen as more of a traditional beauty.

Terrill, who was two years older, was marvelous at any subject she tackled; she eventually won scholarships to Middlebury College in Vermont and the Sorbonne in Paris. Hillary, my youngest, was lovely as a child, but never managed to make the same grades that her sister got.

Even in my own mind I fell into the age-old trap: *She is beautiful, and naturally, not as bright,* I thought silently. Then one day Hillary came to me when she was a junior in high school and begged me to put her into The Roeper School, which is only for children of exceptionally high intelligence.

"Honey, I'm sorry, but I don't think you can get in. But if you can, I'll support you all the way," I said. We called up and made an appointment with the director, who also was the man who founded the school. He may have been a stern headmaster, but I think he was swayed by Hillary's waist-length blond hair and her considerable beauty. Or perhaps, he saw something in her that her mother was too close to see.

"All right," he said, "I'll give you a try." Now I was worried, because she had been making C's in good private high schools. But Hillary immediately went from C's to A's! Why? Because Roeper expected it of her. No one had ever expected enough of her before. She ended up graduating from Boston University before going on, as you already know, to Harvard Divinity School.

I probably, by the way, have better children than I deserve. My sons are both very dear to me. William Lange, the eldest, is a brilliant man who has dabbled in just about everything from computer science to writing to acting. He is the one real thing of value to come out of my first and very unhappy marriage.

Barry—Harry Burnett, III—was a bit of a handful as a teen during the troubled 1960s. But then, who wasn't? It would have been somewhat abnormal *not* to have been a bit of a rebel in those crazy days.

Eventually he got his act together, went to medical school, married a wonderful woman, and now has a family practice in Colorado and three fine daughters. I have to say, however, that one of the best things he ever did was to marry his wife, Sallie, a psychiatric nurse who earned a new college degree each time they had a baby.

Terrill, who evolved into a noticeably beautiful woman about the same time Hillary evolved into a brainy one, eventually became quite a businesswoman. She has four degrees and is also an "AbD"—she has completed all the work for a Ph.D except her dissertation. For some reason, however, I decided I should push her into law. But she had no intention of following in my footsteps and living out a mother's ambitions.

Finally, she got so tired of my nagging that she said "Mother, you want a lawyer in the family—*you* go to law school!" She does, however, have a Master's degree in International Law and Diplomacy, and married a lawyer—so I guess I have no right to complain. Today, they have two children and live in California.

Hillary eventually became the third generation of women in my family to marry a physician, Dr. Christian Mayaud, a descendant of minor French nobility.

Hillary's life was greatly affected by her father's death, so much so that she left divinity school and turned to art instead. Actually, she had gone into religion more from intellectual curiosity than deep religious feeling, so perhaps she really wasn't suited to be a priest. I certainly can't accuse her of rushing into marriage, by the

way; not only did Hillary and Christian live together before they were married, their nine-month-old daughter Theodora was one of their wedding guests!

How did that happen? Hillary always likes to tease that I forbade any of my children from getting married before they were thirty—which is true. But then she adds that I said nothing against having children first—which is probably also true— and which may be the final proof that I was not destined to think like a lawyer.

Frankly, I'd much rather any young woman choose to have a child before marriage—as Hillary did—than enter into a ghastly union with a man who is essentially a stranger, which, as you now know, happened to me my first time out.

Incidentally, they had a wonderful feminist wedding in our house; *I* gave the bride away, and Hillary's best friend held the child throughout the ceremony. Afterwards, the stunning blond woman priest they had chosen—the same Nancy McGrath who would marry Bob and me three years later—held Theodora aloft.

"If this is how well you do, I want you to have lots more!" she said to everyone's delight. Today, Christian and Hillary have three wonderful children.

When I married Harry, women weren't even allowed to become priests in the Episcopal Church. Today, we also have become quite an ecumenical band; Terrill's husband, Jason, is a Mormon, and Sallie is a devout Roman Catholic.

Once, by the way, a friend asked me, "Patricia! What would you do if one of your daughters wanted to marry a black man?"

I decided to tell her the truth.

"I'd give them a really big wedding," I said. My only concern has always been that my children are happy, and I've done the best I could to see that they are.

More Brushes With Fame

And I'm happy, too—in part because I am still painting.

People in most professions start winding down when they reach my age. Well, that's not strictly true anymore; a friend tells me that Dr. Denton Cooley, the world-famous heart surgeon, is still operating every day, even though he is two weeks older than me. That youngster Bob Dole is gearing up to run for the presidency at seventy-three.

Nevertheless, I am at the time in life when I might allow myself to think, "Gee, I ought to take it a little easy." No chance! Within the last few weeks, four new portrait commissions have come to me, and as I struggle to finish this book on time, I am also painting like mad to make my deadline to finish a portrait of Barbara Walters.

Last year, I painted one of Barbara's frequent interview subjects, Dr. Jack Kevorkian, in his trademark blue cardigan sweater, beside his lawyer and alter ego, Geoffrey Fieger. Kevorkian himself was a true character. The first time we met, he was very nice, but tried hard to shock me in the way a junior high school boy might.

We met over lunch, and he loudly claimed that the parfait looked like pus. Then, he showed me snapshots of his own paintings, which depict pastoral scenes like Santa Claus crushing a baby and a corpse sitting down to eat its own severed head.

I once had teenage sons, so I just purred. When the painting was done, both men loved it, and we invited Fieger and Kevorkian to a large party at our house.

Many of my guests were shocked when they heard that the infamous Dr. Death would be among them—but he was the essence of charm. He helped serve drinks, chatted, and posed for pictures with everybody.

How long, somebody asked me, do I intend to keep painting?

Hopefully, until just before my last breath.

Dancers and singers and actresses usually make their mark at a very young age. Painters, like writers, ripen and deepen with time—and the career of any woman painter who takes time to raise a husband and a family is bound to be slowed.

One of the signs to me that I had really arrived professionally came in the early 1980s, when Governor William Milliken, the longest-serving and one of the best governors in Michigan history, selected me to paint his official state portrait, which would be hung forever in the State Capitol. I named my price—and the governor refused.

"No, no. That isn't enough, Patricia. The going rate for state portraits is $15,000," Governor Milliken said.

You may believe I did my best to give him his money's worth. What even some of my friends don't realize is how serious professional portrait painting is. Not only does it fulfill me, I hope and

believe that my art also is always continuing to evolve and always continuing to improve.

My commissioned portraits of men are usually what I call "Boardroom Style." For women, I like to paint in a style I call *romantic realism.* What that means is that the face and figure of my subjects is realistic, yet the background has a rhythmic movement that flows around them. For me, the brushwork must sparkle and the color be luminous and fresh; it can't look overworked!

Though John Singer Sargent is my ultimate idol, I have been influenced by many, many fine artists along the way. Several deserve mention and credit—that is, if you like my work. Michigan's John Carroll is one; Richard Lahey at the Corcoran Art Gallery in Washington, D.C., is another. I studied in Provincetown, Massachusetts, with Seong Moi and, most important of all, Wallace "Wally" Bassford, from whom I learned so much, especially about painting more freely and less photographically in oils.

I also have had the great honor of lecturing and working for years with John Howard Sanden's Portrait Institute and his National Artists' Seminar.

Sanden, a superb New York portrait artist was the leading force in forming the Council of Leading American Portrait Painters in 1994. Twelve of the nation's portrait artists were chosen to form what was called "an elite corps of contemporary American portrait painting... those most admired by their professional colleagues."

Words cannot really convey how I felt when I was chosen to be one of them.

Provincetown Follies

However, I do have a confession to make. While I take my art seriously, I see comic relief as a very necessary part of life too. I mentioned Provincetown; I rent a cottage nearly every summer in that lovely town on the tip of Cape Cod, to paint and study, mostly with Wally Bassford, and immerse myself in art and artists.

I have been doing this, I just realized, for—*gasp*—forty years! However, while I do work hard, the truth is that my annual Provincetown stay is about far more than art. The town is a true happening, where events straight out of the Keystone Kops or some 1960s' Theater of the Absurd are likely to happen, almost without warning, at virtually any moment. When they do, they thrill the

summer people, captivate the tourists, and provoke immense yawns from the natives, for whom the crazy is routine.

There was the day, for example, when we tried to save the beautiful young model from the homicidal drug dealer. My son Bill and I were having breakfast one morning, a wonderful breeze streaming through an open door, when in wandered a breathtakingly beautiful young woman, absolutely stoned out of her mind.

"I'm being held prisoner across the street by a New York drug dealer," she said. I have to admit, that was more original than saying hello. "I'm a model," she added, "and he's not feeding me a thing, and I am starved."

Mesmerized, Bill gallantly leapt to the stove and cooked something for her. She ate, staring blankly, and when we turned our heads, we found that she had drifted back across the street without even complimenting the tea service.

Naturally, being a busybody, I called the local police. (I was also genuinely concerned about the young woman's welfare.) Provincetown's finest arrived with bravado; sirens wailing, lights flashing. They trooped up on the villain's porch, calling for him to come out. The answer came swiftly.

"Hell no!" a voice boomed from somewhere deep inside. "Do you jerks see the wine bottles hanging from the ceiling in the living room and on the porch?"

The constables peered through the glass. Yes, they could dimly make out the chianti-style bottles, encased in wicker. "They're all filled with gasoline, and I'll set fire to them RIGHT NOW if you don't get the hell away from my house!"

Prudently, the gendarmes retreated behind their police car for consultations. Detective work seemed in order, so they interviewed the local service station attendant. Sure enough, our friend had been investing heavily in five-gallon containers of gas!

That inspired the Provincetown P.D. to call upon Hyannis for reinforcements. After all, those tough Hyannis Port types were used to coping with the Kennedys. Soon, the hardened Hyannis police careened up in more official-looking cars.

They soon began lobbing tear-gas canisters in the general direction of the windows. Naturally, a few hit the wall beside the windows, gassing the policemen, who staggered over to my house, where Bill and I offered them towels and bowls of cool water to wash the burning stuff off their faces. The siege didn't last much longer;

within moments, the suspect burst from his house, waving a long butcher knife.

Happily, the police stormed the half-blind man before he could do his worst. "There's a woman inside!" I called. She was pulled out, seeming no more or less dazed than she had been at breakfast that morning, and then was seated in one of the squad cars. Trouble was, the keys, which had been left in the ignition, had vanished. By this time, a considerable crowd had gathered to watch the show, and someone was clearly such a fan of the police that they didn't want them to leave.

I will spare you the details of the hullabaloo that followed, except to note that eventually the model, still out of it, slipped out of the seat and followed the now-familiar path to my house, to Bill's undisguised delight and my amusement... until it began to dawn on me that I was harboring a fugitive from justice, an arrested person who had escaped. Realizing how dreadful I would look in prison stripes, I called my dear friend, Jack Kearney, a world-famous sculptor, to come over.

Kearney, a rollicking Irish story-teller, assessed the situation quickly. In true Provincetown style he said, "Of course we won't turn her in. We'll take her to the most powerful woman in town, Ione Walker. The police wouldn't *dare* oppose her!"

The plan seemed excellent. The Walkers, who owned a well-known art museum in Minneapolis, had dominated P-Town society for years. We pled with the *grande dame* to help save the fallen damsel, and she at last consented.

"All right," she said reluctantly, "But I insist on looking in the girl's purse before she walks in my house." Sure enough, she found a large bag of marijuana.

"Here," she commanded Bill, "Take this and throw it in the bay!"

Bill, a true child of the sixties, did his best. He took a few steps to the shoreline and *tried* to throw it. Three times he tried... but nothing left his hand.

"I just can't seem to throw all this pot in the water," he sighed.

"DAMN IT, BILL," Ione roared, "DO IT!"

The bag of cannabis sailed towards Europe, flew into the ocean, and sank.

The very next morning, I hunted up Madame Walker to see what more she had been able to learn about our exotic and now

presumably drug-free guest. The mysterious model had not come down for breakfast, so she went up to her room.

Moments later, a startled Ione reappeared. "She's gone," she said. "She must have slipped away and hitch-hiked out of town."

We never saw or heard about her again.

Mailer, Motherwell, and Me

Over the years, I have moved around in Provincetown; quite a number of sets of walls have known me. But I usually kept coming back to a house on the edge of the water. When high tide is up, the waves lap right at the foundation of its wide porch. Low tide causes the water to recede several dozen yards into the sea, leaving a broad sandy avenue on which visitors and town folk can mingle.

Naturally, this extrovert *loved* the chance to bring people together to mingle. By the way, I don't like to namedrop... oh, all right, that's a lie. I do like to drop a name from time to time, especially when I can tell you that my house was right between the homes of Robert Motherwell, the famous abstract painter, and Norman Mailer, the renowned novelist who, by the late 1960s, was becoming as least as well known for his controversial public personality as he was for his brilliant writing.

Curiously, as I soon learned, these two important people never had met—and neither was especially interested in meeting the other.

Abstract expressionist art was not one of Mailer's main interests, and Motherwell, who was more than a decade older, led a very private, introverted, upper-class life, as different from Mailer's highly public parade of wives and children and scandal and celebrity as one can imagine.

Yet time, chance, and a new wife or two mellow such men. Motherwell eventually divorced his almost equally famous wife, the painter Helen Frankenthaler, and married a warm German woman, a photographer whose earthy friendliness nicely complimented his shyness—and may even have melted it a bit.

Mailer, after many rocky marital and extra-marital excursions, met a lovely young school teacher named Norris Church while he was off giving a speech. He fell head over heels, swept her away to New York (and Provincetown) and settled down into what has become twenty years of happily married life, which he celebrates in the dedication of his newest and well-acclaimed book, *Oswald's Tale.*

This pleased me; what pleased this feminist even more was that Mailer, a man who once attacked the entire women's movement in a debate with Gloria Steinem, has helped Norris turn herself into a fine realistic artist and a very popular model.

Finally, I realized it was time for Mailer and Motherwell to meet at last—and I am very proud to brag that I made it possible. Sometime in the 1980s, I gave my annual P-Town party, and invited both without telling either that the other was invited. When they arrived, I introduced them to each other and took them out to my bayfront porch to view the sunset. Hours later, they were still talking—and from then on, they remained fast and respectful friends, until Motherwell's death in 1991.

Patricia, I told myself later, chalk one up for art!

My Motherwell, the Car

Incidentally, I wish I could tell you that my first encounter with Robert Motherwell came after he saw some of my paintings and was so enthralled by my talent that he just had to meet me. Alas, it was nothing of the kind.

We met because of a Volkswagen. Provincetown, by the way, historically has somewhat of an odd relationship with the automobile. One of the biggest happenings anywhere during the 1960s took place when my friend, Jack Kearney, and Danny Banko, a writer, decided to hold a funeral and bury Banko's ancient apricot-and-cream Ford Fairlane. Partly, anyway; its hood was left pointing at a ninety-degree angle, with its lights wired to pierce the night sky.

Mailer devoted a chapter in one of his books (*Of a Fire on the Moon*) to the car's internment. When a new owner decided the car was an eyesore and had it dug up and destroyed in 1995, the removal of what the novelist called "a town monument" caused an enormous controversy. "It was the first machine to die with burial in the land of the Pilgrims and the cod," Mailer wrote when the car was laid to rest.

But I had come to Provincetown a few years earlier, not to bury a car but to paint one. My son Bill had a summer job that year training the dolphins at the town's renowned aquarium, something at which he proved to be superb.

He was then driving the sixties college student's car of choice,

a beat-up little Volkswagen bug. One day, he asked me to turn it into a work of art.

The challenge appealed to me, and I envisioned his car as a mobile encyclopedia of animals and birds—actual ones on the right side, mythical beasties on the left. Bill agreed enthusiastically. Only trouble was that he was rarely home before dark, so we were often working out on the driveway, with Bill holding a massive flashlight while I worked away with Rust-o-leum paint.

Detroiter though I was, it turned out that I had to go to Massachusetts to produce an automotive masterpiece. Suddenly, one night as I was painting, Motherwell appeared from nowhere and stepped like a specter into our circle of light, holding several rare books with sketches of dinosaurs, unicorns, ant-eaters, and other fantastic beasts.

"You must not leave any of this out!" he said sternly. "Your art should be intellectually stimulating, even if it is on a car."

Who was I to disagree?

Night after night the great artist coached me, supervising this weird project until both of us were satisfied and we had become friends.

When it was done at last, Bill drove it to the University of Miami. Suddenly, he looked in the rear-view mirror to see several excited and somberly dressed men chasing after him. Were they from the unicorn anti-defamation society? He slowed to a halt.

"Young man, we are from the Coca-Cola company," one of them said "and we will pay you cash to let us use your crazy car in an ad!"

Next thing I knew, his pop-art car was being seen by TV viewers coast-to-coast... and would you believe they didn't even give Motherwell a consultant's credit?

Solving a Mystery From the Past

Every so often, I would remember the day in Atlantic City when I had come in runner-up to Jo Carroll Denison, the Texas girl who became Miss America, 1942.

Truth is, though I entered on a lark, I never liked being runner-up. The winner of the contest was the one most in demand, for appearances and screen tests, and a chance at real stardom. However, I *was* offered a chance for a screen test—but never wanted it bad enough to memorize the script.

Jo Carroll did. She eventually signed on with Twentieth Century Fox, but her film career never really took off; they were trying desperately to get rid of her Texas accent, this being the non-multicultural 1940s. I think she could see stardom wasn't in the cards for her, and she was coming to the end of her money.

I was visiting her in Los Angeles, and one day, she said, "You know, Patty, I met a man today who has been with Twentieth Century for a long time, and he asked me for a date and… I'm going to get him to marry me."

I suppose I looked startled. She looked determined or sad, I never decided exactly which. "He's the most eligible man I've met here. He's years and years older, but he's my only hope." That very night she came home triumphant.

"He asked me to marry him, and I am going to!" The man was none other than Phil Silvers, the comedian. So they were married.

Years passed. Then Harry and I were in New York and saw that Phil Silvers was starring on Broadway in *Top Banana*. Naturally, I wanted to see both of them, so I sent a note to her and we were immediately invited backstage.

There was Phil, sitting in front of a mirror putting black shoe polish on his bald head so the bald spot wouldn't show. He was so sweet and so excited and happy.

"You know, Patty, this is the answer to a dream," Phil said. "This is the first time my name has ever had top billing, and I can't believe it. I want so much to give Jo Carroll anything that she wants, and this is just beyond anything I had hoped."

At that moment Jo Carroll came sweeping in, wearing a floor-length mink coat that looked absolutely gorgeous. I wasn't exactly the little match girl, but I was in sort of a nice suburban wife's mink, which wasn't half as grand as hers.

Naturally, I was thrilled to see her, because we had been good friends. But she was the picture of misery. Instead of being delighted to see us, she began by wailing, "Oh, I hate New York! It's just too crowded and cold and you've just got to get me out of here, Phil! Take me to California!" she said.

Poor Phil Silvers said, "Honey, I'm working here to make you happy, to get enough money together so we can have a house there." She only pouted.

Not too long afterwards, I learned that they had divorced. Later, he remarried a nice young housewife type and had several daughters.

But I lost touch with my friend and former rival. Then years later, in 1985, I saw her quoted in *Ms.* magazine. Eagerly I wrote to her in care of *Ms.* Finally, to my delight, I received a reply.

"Wow, what an accomplished life you have led!" Jo's letter began. "I have to admit I underestimated you forty-three years ago; I never doubted that you would accomplish what you set out to do and become, but I didn't understand the breadth and scope of your talent and intellect and feelings," she wrote to me.

What little she told me of her own life sounded by turns happy, sad, and mysterious. She said she had two sons and was content at last, having found, a man who had made her life complete. After years in the bustle of large cities, she had found peace at last, in a "perfect little house in the forest atop a mountain. We have followed different stars, but they are bright stars and we have reached for them with determination and purpose... at almost sixty-two, I have found the love and quiet and insight that I was always afraid of before. Isn't life funny?"

Very few things have warmed my heart as much as Jo Carroll's letter. I haven't heard from her since, but if you read this, Jo, I would dearly love to see you again.

A Woman Never **Should** Have Enough!

Between two evils I always pick the one I never tried before.
 –Mae West

Some of us are becoming the men we wanted to marry.
 –Gloria Steinem

*S*ometimes I wonder just what it was we accomplished during my "glory years" in the women's movement. I know what we *thought* we were doing: We were going to shake, rattle, and roll the male-dominated establishment like nothing ever had.

I joined hands with a throng of other women—black, white, old, young, rich, poor, and everything in between. We did not change the whole world overnight. When we took our axes to a structure that men had been building for thousands of years, only little chips flew. *But we could feel it shake,* enough to make us—and them—wonder if its foundations were indeed as strong as they thought they were.

Eventually, when I got copies of the secret files that the FBI and the Michigan State Police kept on me, I learned that they even listed me as one of twenty possible bomb-throwers in Michigan! There were no fewer than forty-one pages in my state file alone.

"By gosh," I thought, "I must have done something good to make them want to follow me around like that!"

But will I be remembered for what I did in the women's move-

ment? Probably not—except perhaps by my daughters, and that's more than enough for me. But I think Betty Friedan will be remembered, and Gloria Steinem, and some other major lights.

What really matters most, however, is that women's efforts to gain full equality in the home and in the workplace are finally successful.

Where are we as a sex today?

I often feel there is much to be optimistic about. No longer can men—in this country anyway—refuse to hire qualified women without explanation. No longer can husbands in the United States admit to beating their wives "because they needed it."

These days, women across the nation have been suing for discrimination in the workplace—and usually winning. When those suits reach the U.S. Supreme Court, two women judges are among those reviewing the cases.

Any powerful male executive who treats women as toys these days is apt to find himself on the wrong end of a sexual harassment lawsuit.

This is real progress, and all of it was a long way off on that afternoon in 1969, when a housewife and portrait painter from Detroit got so mad that she decided to recruit some of her friends and start a chapter of NOW.

That's the good news. But on other days, when I review the latest battlefield maps from the wars between the sexes, I am reminded more of the last time I visited the late unlamented USSR, and was taken on a sight-seeing trip to a zoo. To my great astonishment, I saw a lion in a cage with a lovely little white lamb standing beside him.

"How on earth did you manage that!" I asked in awe.

"That is a symbol of the true peace and freedom of the world's peoples which will be made possible by the triumph of communism," the zookeeper said proudly. "Of course," he muttered, "we have to put in two new lambs every day."

What I fear is that all too many women will still end up being the first lamb. And I have to admit that women have about as much chance at achieving true equality with men—in my lifetime, anyway—as that lamb has of becoming a mature sheep.

To some extent, I am afraid, the women's movement is a war that will have to be fought over and over again, by every generation and indeed by every woman.

Sadly, the more than quarter-century that I have been an active feminist has been long enough for me to notice that whenever we get complacent, whenever we rest on our laurels, some man, somewhere, decides that the revolution is over and they can go back to treating us any old way again.

The worst part is that all too often, they get away with it.

What worries me too, is that the younger generation of women are being lulled into a false sense that they have achieved equality. True, things are a little easier; it is a little less difficult for a woman to become a doctor or a lawyer or a police officer. But it isn't nearly as easy as they are being led to think, and many are being conned.

What is especially discouraging is that so many of them don't even know they are being conned. Far too many women, even college-educated American women in 1995, still have somewhat of a slave mentality. They see relations with men as a game in which you may try to psych your master out and you may even succeed, but at bottom, psychologically, you still see him as your master. And that is the most devastating part of all.

Let me tell you something you may find shocking. What if, way back in 1920, when I was a tiny speck in my mother's womb, I had been able to choose whether I wanted to be a woman or a man? If I knew what I know now, I wouldn't have had a moment's hesitation. I would have chosen to be a man—a white man, naturally. That is, I would have had I known anything at all about society and how it works.

Matter of fact, I would have been crazy to want to be a woman.

That's not to say I really want to be a man, or to act the way men have been acting for most of my lifetime. Not at all! I like what women stand for. I like their decency, sensitivity, and wisdom. But this society says women are second best.

The best thing I think I can say about myself is that I have done as much *as* a woman and with *being* a woman as I possibly could, given my life and times.

I pushed the rock uphill a little bit. I struggled for equality and justice. I picked a career for which I had some talent, but which was also considered by society to be appropriate for a "lady."

Sometimes, I think if I had the chance to do it all over, I would have been far more serious about my schooling, maybe having insisted on studying math and science. Then, I would have gotten a

law degree and run for office myself. After that, I would have devoted myself to passing bills for more equality between women and men.

But as it was, in my small way, I tried.

What's more, I also had a life that was a marvelous adventure.

That's vitally important. Women owe it to themselves to enjoy life. Lord knows that men, especially white men, have been very good about enjoying themselves for centuries. What is the use of equality unless it provides for equal opportunity for fun?

Having it all means exactly that—having it all.

Which brings me to my next great controversial topic: plastic surgery.

I know that there are rumors that I have had a face lift—and it is just not true. Actually, I have had two face lifts and intend to have another soon. Some of my feminist sisters may be horrified, but I am a total believer in cosmetic surgery.

Don't worry; I have heard all the political arguments against it. Many "liberated women" see it as nothing more than one more mark of our exploitation. According to some of them, the only reason a woman would ever even consider getting a face lift, say, is because she has been brainwashed by a masculine conception of beauty.

Well, I say that is silly.

Every woman should consider a face lift—but for herself, not for any man.

There are two very valid reasons to consider cosmetic surgery. First of all, it may not be fair, but women who look younger and better have more success professionally as well as socially. That's not just true for women; more and more male executives are having those eyebags and chin sags tucked these days, too.

Another major reason is psychological; how you feel about your looks has a lot to do with how you feel about yourself as a human being. I had my first face lift right after Harry died, when I was sixty. I think any woman who becomes a widow should consider a face lift, partly as a symbol of the next phase of life.

Having had the surgery, I can't say enough for it! I've now become somewhat of an amateur expert on the world of the face lift, so as a veteran of the knife, let me give you some advice I wish someone had given me. If I get a little gory, forgive me; it's what you don't know, as someone should have said, that can age you.

First off: Do some investigating. You must exercise extreme

care in selecting a surgeon. Some are better than others. When the time comes, you must be awake throughout the operation, so that they can see what your features will look and work like afterwards, and you should stay in the hospital or someplace you can rest as nearly motionless as possible for a few days afterward for the best possible result.

You also want to make sure the surgeon hides the incision in your hair in back, so you can wear your hair up, or cut short. Tell him—or her—to make the incision on the edge of the earlobe, not in front of the ear, so the scar won't show.

To keep the chin-line up as long as possible after your face lift, ask to have the "cords"—the tendons—in your neck tacked up; this can be done by going in through a small incision under the chin. Meanwhile, if your ears are less than perfect, they can be made smaller or flattened down easily at this time.

Finally, a second face lift in five years or so seems to anchor the skin so that it keeps a youthful shape for a longer time. Why am I bothering you with all these details? Unfortunately, not all plastic surgeons bother to tell you these things.

But most of all, I urge you to consider your face well worth the investment. Gather your courage—and within a few weeks, you have taken off years. By the way, one bit of good news is that there is little or no pain during the operation or the recovery process.

Why is it that there are still those who scorn the "frivolous" pursuit of beauty? Let me tell you that recent research has found that good looks are a powerful aid, not only in the mating game, but to professional success and general well-being.

So go for it!

What I wonder about, though, is when and how the feminist movement, one of the great social revolutions in U.S. history, will get its own much-needed face lift.

To the young—women in their teens and twenties, maybe even thirties—the movement now seems hopelessly dated. Feminine clothing has been back since the 1980s; breasts are back; motherhood is in again. Today's young women may never have even heard of the Equal Rights Amendment, nor do they think they need it.

Today's women think they have already won the battle. They assume that they have already achieved equal status, legally and socially and professionally, with men.

However, in a few years they will find they have not won.

Someday, I am convinced we will look back on the 1990s as a time when feminism was not dead, but merely stalled and in need of a little consciousness-raising. When the moment comes to rev it up into high gear, I hope I am there to help kick the throttle. I have reason to be optimistic; my own mother lived to be ninety-four.

Women, as is generally recognized, age much better than men. We adjust to retirement gracefully, because we have always taken care of our own food, our homes, and have learned to build networks of women friends who support us.

Older women were once a pariah group, as far as the media were concerned. That is one area where real progress has been being made in recent years. No longer is every over-fifty woman portrayed as a hag or a granny; just think of women like Raquel Welch, Jane Fonda and Gloria Steinem, if you want to glimpse the future of aging.

We arc all aging—the entire population—and that may be a good thing. We hopefully are coming to an age revolution where we break through the idea of old age as some kind of infirmity, and start to define ourselves as persons, women and men, who are fulfilling our potential in yet another one of life's stages.

What will we call this new stage of life? Some time ago, I read a marvelous essay by Kathleen Madden in which she said there are three ages of women—youth, middle-age, and "you haven't changed a bit."

Well, I have changed more than a bit! For which I thank God, whoever She is.

Here is Patricia Hill Burnett's closing bit of advice to all my sisters:

The best of times is now!

Make peace with what you have to put up with in the world; stand firm by what you can change, and live every day—every single day—as if it were your last.

Every one of us, after all, dies, yet not everyone really lives.

Make sure you do!

I want to leave you with one very profound thought, the truth of which has become more and more apparent to me with each passing year.

It is a truth that transcends feminism. It transcends wealth and poverty, religion, politics—all the great issues of our age. Mark

Twain first said it... but do remember that you read it here last, if not first.

What it all comes down to is this: No matter how famous you are, no matter how many honors you achieve, movies you make or money you earn, one thing, and one thing alone, will determine how many people come to your funeral:

The Weather!

Appendix
Patricia's Immortal Lifelines

*F*rom time to time, everyone needs a little dash of inspiration.

So I want to share with you my "lifelines"—a series of mottos I've invented or collected over the years. Some of them have helped me think through a thorny situation or given me a little balance when I have needed it, more times than I care to count.

Others have provided me with a smile—or a needed ray of sunshine on an emotionally cloudy day. You may well have some favorite lifelines of your own, but if any of mine are of any help to you... I would be delighted!

1. Forgive yourself for everything!

2. When you have love, be grateful—there is no life-time guarantee.

3. If a little is good—more is better.

4. You have to suffer to be beautiful. Glamour is a 24-hour-a-day job.

5. There are no black and white decisions: They are all shades of gray, so don't be afraid of making a decision when you need to.

6. Right or wrong, make a decision *quickly* when needed. Odds are that it will never be absolutely right or absolutely wrong.

7. *Not* making decisions will make you sick!

8. If there is no way you can solve a problem—drop it, forget it, put it aside until you have new information.

9. Listen to your body. If you are tired, rest! If you are hungry, eat!

10. Forgive your enemies, but don't forget their names. If you don't have any enemies, you probably haven't lived a full life.

11. Trust your instincts... they are your right brain talking!

12. Never emphasize your weak points—people will find out soon enough.

13. If you fake a positive attitude long enough, it becomes reality.

14. Try never to say you are sick, tired, depressed, or bored—even if you are. The world doesn't want to know.

15. Never say anything about someone that you wouldn't say to their face—because, sooner or later, they are going to hear it.

16. If you are grounded for a while—at an airport, or with illness or a long wait—make yourself as comfortable as possible, relax, and try to enjoy it.

17. Learn to give in gracefully, but *only* when it is inevitable.

18. Accept people for what they say they are, until the first discrepancy comes along—then be wary.

19. *Love* yourself, for few people will, unless you do.

20. Don't get mad—get even.

21. Remember that regret and remorse and guilt are the most destructive words in the English language.

22. Exercise your mind constantly, learning new skills and information. If you don't, the brain cells will die.

23. Stand as tall as possible. Try pigeon-toed with shoulders dropped and your *derriere* tucked under, then straighten your feet. You will look and feel ten years younger.

24. Cultivate your friendships like flowers. They need to be tended or they will die.

25. Treat your spouse or significant other at least as well as your friends. Do not neglect or verbally abuse him or her.

26. Treat employees with respect and consideration, but not as best friends.

27. Remember, you don't go on a vacation to save money or lose weight.

28. All women are not feminists, and all feminists are not women.

29. Having self-respect means that you have a certain toughness, a willingness to accept responsibility for your own actions. It means to have character.

30. Free yourself from the expectations of others. Stop trying to please others; that becomes a compulsion.

31. Don't sabotage yourself because of fear—fear of success or fear of being visible.

32. Don't look desperately for love—you can live happily without it, as long as you love yourself.

33. Raise your children with "benign selfishness". Be good to yourself, as well as to them.

34. Watch out for the "seafood" diet—where you see food and then eat it.

35. A good reputation is, as Rhett Butler said to Scarlett O'Hara, something people with courage can do without.

I thought I would save my favorite for last:

36. Never say no unless they ask you if you have enough!